IN
PASSIONATE
PURSUIT
A Memoir

ALESSANDRA COMINI

SUNSTONE
PRESS

SANTA FE

Sunstone books may be purchased for educational, business, or sales promotional use.
For information please write: Special Markets Department, Sunstone Press,
P.O. Box 2321, Santa Fe, New Mexico 87504-2321.

Library of Congress Cataloging-in-Publication Data

Names: Comini, Alessandra, author.
Title: In passionate pursuit : a memoir / by Alessandra Comini.
Description: Santa Fe, New Mexico : Sunstone Press, 2016.
Identifiers: LCCN 2016018331 | ISBN 9781632931405 (softcover)
Subjects: LCSH: Comini, Alessandra. | Art historians--United
 States--Biography. | Women art historians--United States--Biography.
Classification: LCC N7483.C567 A3 2016 | DDC 700.92 [B] --dc23
LC record available at https://lccn.loc.gov/2016018331

WWW.SUNSTONEPRESS.COM

SUNSTONE PRESS / POST OFFICE BOX 2321 / SANTA FE, NM 87504-2321 /USA
(505) 988-4418 / ORDERS ONLY (800) 243-5644 / FAX (505) 988-1025

Dedicated to Hildegard Bachert:
challenging mentor, admired friend

CONTENTS

Preface to The New Edition

When I wrote this memoir a dozen years ago, I did not know I would live another dozen years. Now that I have, I need to live another dozen years plus.

The reason? In addition to having more time for music-making with friends, other joyous pursuits opened up to me after I retired from teaching. The first was the email/ Facebook/Skype phenomenon that allowed me to follow the doings of two generations of extraordinary students and to mentor younger colleagues. The second was a search for natural beauty that took me to sites ranging from Alaska to Antarctica. And the third was a merry new profession: writing art history murder mystery novels. As the ads for book signing events say: "Retired Professor Turns To Crime (Writing)." Where do I find the material for these books? In sixty consecutive years of daily diary entries.

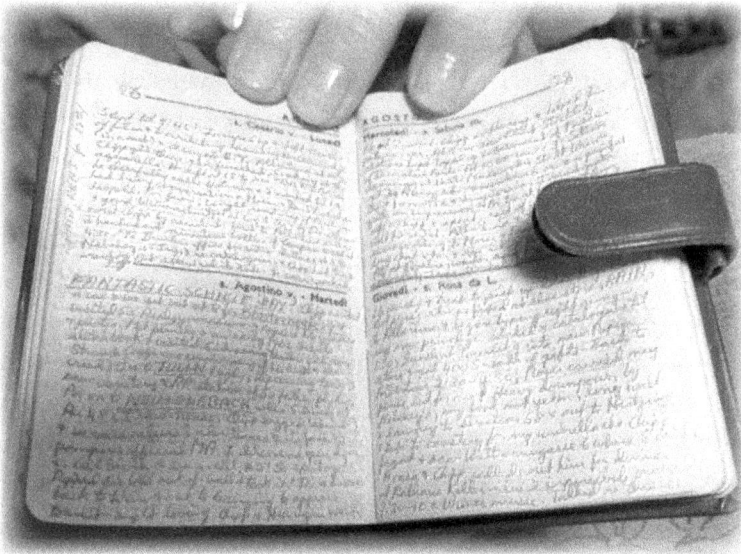

Vienna, August 1963 diary entries.

Pursuing the peculiar characters my pseudonymous heroine, eighty-year-old Megan Crespi, must hunt down across America and Europe has allowed me to mix fact with fiction in a delicious new brew. Music, art, literature, and languages are stirred up in sometimes startling or hilarious combinations. Fifty years after my first visits there, Megan Crespi hunts down stolen Edvard Munch paintings, travels throughout Scandinavia, and copes with the challenges of the Danish, Norwegian, Swedish, and Finnish languages.

Austria, land of my scholarly expertise on artists Gustav Klimt, Egon Schiele, Oskar Kokoschka, and both Mahlers—Gustav and Alma—flexes my Germanic muscles. My Italian heritage lands me in Italy time and again, while my years at Barnard and Columbia lure me back to New York.

The best part of all this travel is that it costs nothing, makes virtually no physical demands, and can be conducted at any time, day or night. It is Internet travel. Gone are the days of going to the library with a handwritten list of urgently needed volumes. Gone are the piles of books on my floor for consultation. The Internet is here! And I am in love with it.

Actual travel since retiring has taken three forms: lectures in Britain and Europe, where I revisited the Blue Mosque in Istanbul that I sketched over half a century ago (see Fig. 18, page 86). Travel in search of natural beauty has taken me to Antarctica, as I followed, one century later, in the footsteps of Ernest Shackleton. This was the most extraordinary trip of my life. The only colors there were blue, white, and one hundred shades of gray. No green. It was enthralling to photograph the fearless, determined penguins on their way to and from the water, and to encounter baby seals on the icy beaches with their enormous, trusting eyes. Three trips to Alaska helped to revive the pristine impressions of Antarctica. I want to go back!

Not all the stars in my galaxy have been bright. I have lost cherished friends and colleagues, all younger than I. One of my brightest students committed suicide. I myself was suddenly struck by a major depression disorder which left me longing to end my existence. During this time of disarray not even my beloved little Maltese doggies meant anything to me. But I found the right physician, and after many trials the correct mix of medications was discovered. Now regal Button and brave, blind Mickey are in Maltese Heaven. Just as Mickey was being put to sleep, he heard the word

"squirrel" uttered by his other mother, Charlotte, and his ears perked up just before he passed.

My earlier scholarly pursuits have produced some unexpected late blossoms. An international symposium in my honor was held in Neulengbach, Austria, where over half a century ago I discovered something no Austrian researcher had thought of locating: the basement cell where Schiele was incarcerated in 1912 and which he recorded in moving drawings and diary notations. Now that cell is the nucleus of a new Schiele museum and Neulengbach has become a tourist site. And in New York my love affair with Schiele came full circle when the Neue Galerie Museum for German and Austrian Art, wanting my "gravitas," invited me to guest curate what turned out to be a 2014-15 blockbuster exhibition, *Egon Schiele: Portraits*.

Pursuing art over the decades has resulted in the collection of art as well and now, as an apprentice octogenarian, I engage in a new activity: giving art away. Early Schiele drawings bestowed on me by his sister Melanie have now made the transatlantic journey back to Austria to a new Schiele museum. More items, including taped recordings I made with Schiele's sisters in the 1960s, are at the Neue Galerie Museum in New York. And the Dallas Museum of Art has received a compelling Schiele self-portrait of 1913 as well as the 1840 life-size marble statue of Lady Godiva by Anne Whitney. Persistent feminists Eleanor Tufts and Alessandra Comini found her neglected in a Massachusetts backyard.

What have I learned in all these decades of exploration and discovery? In the words of *Nature Boy*: "The greatest thing you'll ever learn, is just to love and be loved in return." As for the final mystery, I cannot help but be comforted by the deathbed words of Steve Jobs: "Wow, wow, wow!"

A lifetime of passionate pursuit has brought me an ebullient serenity and precious new friendships. And so I need a dozen more years at least to savor that tranquility and enrich those relationships. My life continues to be what this book declares: I have that which I have given away.

Alessandra Comini
Dallas 2016

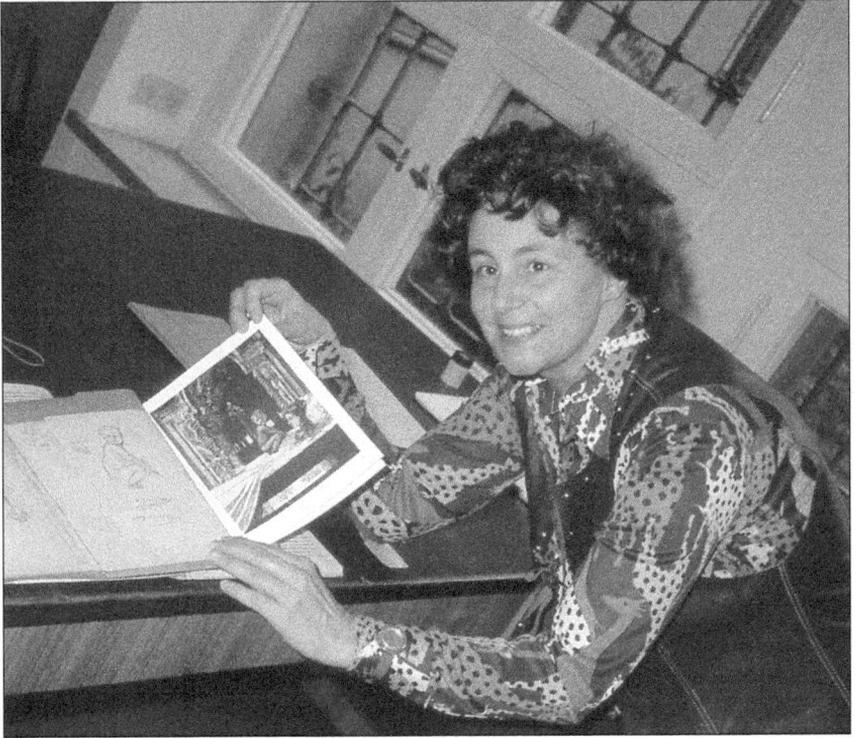

Alessandra Comini

Introduction

THE BASEMENT CELL WAS MOIST AND DARK. Only a small, heavily barred window admitted light. "I feel not punished but purified," wrote the prisoner defiantly in a makeshift diary he was keeping. Finally allowed a few drawing materials, he had begun to record not only his circumscribed surroundings but also his reaction to imprisonment. The year was 1912 and the artist was twenty-one. After languishing three and a half weeks in an Austrian provincial jail, he was brought before a country judge who first chastised him for the "immorality" of his work and then dramatically held one of his confiscated drawings over a candle flame, setting it ablaze. This was the turning point in the intense, tortured life of the Viennese Expressionist artist Egon Schiele, who died of influenza at the end of World War I. He was only twenty-eight.

Half a century later, a twenty-eight-year-old American art historian from Texas, doing research on a master's thesis for the University of California in Berkeley and traveling through Austria in passionate pursuit of that same artist and his riveting imagery, experienced a turning point in her life: she came across and pho-

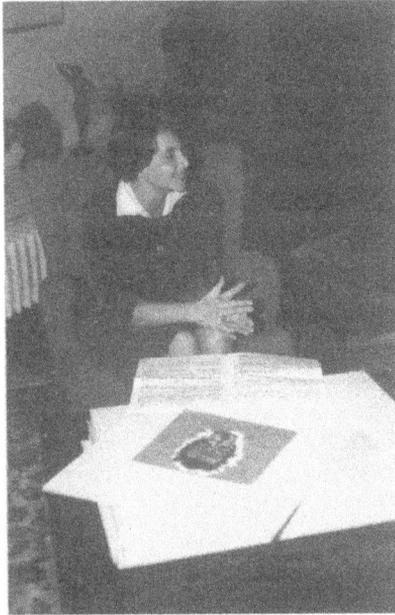

FIG. 1
The author studying an Egon Schiele
self-portrait of 1910 in the collection of
Viktor Fogarassy. Graz, 14 September 1963.
Photograph by Dollie Fogarassy.

tographed the long-since forgotten prison cell in which Egon Schiele had spent twenty-four excruciating days and created some of his most poignant work. In her diary she recorded the exciting circumstances surrounding this discovery, little imagining that her first book would revolve around this traumatic incident in the artist's life.

I was the graduate student who located Schiele's cell so many years ago, and as I leaf through my forty-eight small daily diaries, I realize again and again that the single most productive event in my career as a scholar-teacher remains that fortuitous day in late August 1963 when curiosity and destiny led me to a rural jail cell in the undistinguished Austrian village of Neulengbach and hence into the intriguing world of Egon Schiele's family, sitters, settings, collectors, and works of art (FIG. 1).

Like most American art history students in the early 1960s, schooled almost exclusively in French achievements when it came

to "modernism," I had no knowledge of Schiele's anxious, angular imagery, of his quixotic, dark allegories, or his lyrical landscapes. And in my case I was not overly intrigued by twentieth-century art, having concentrated in the medieval and Renaissance fields while an undergraduate at Barnard College in the 1950s. At Berkeley I had managed to bypass courses on modern art and was already formulating a master's thesis topic. It would be on the face of Christ—tracing the iconographic change in art from clean-shaven to bearded countenance.

And then on the eighth of March 1963 I chanced upon a small campus exhibition organized by Berkeley's modernist art historian, Herschel Chipp, entitled "Viennese Expressionism: 1910–1924." Instantly, I was transfixed by the physical immediacy of Egon Schiele's trenchant draftsmanship and by his relentless exposure of bodies and psyches under tension. For him the dual themes of sexuality and death had been unremitting obsessions—concerns that to me seemed so pivotal to real life outside academia. I became a convert to early twentieth-century art as well as a vicarious Viennese, greedily absorbing the cultural atmosphere of that turn-of-the-twentieth-century Vienna that had nourished not only Egon Schiele but also Sigmund Freud and Gustav Mahler. Just recently I had discovered and fallen in love with the lush, post-Romantic first half of Arnold Schönberg's *Gurrelieder*, and now, at an obscure art exhibition in northern California, I was staring at one of Schiele's compelling studies of the cerebral composer!

This experience ignited a burning resolve to get myself to Austria in body as well as spirit. Although Schiele was new to me, Vienna was not. Seven years earlier, upon graduating from college, I had moved to the fabled, if postwar (Russian sector signs were still on the walls of buildings), City of Dreams to follow my own dream of continuing art history studies. My mentor at Barnard, the Rubens expert Julius Held, had put the idea into my head of studying

where he had once studied, at the renowned University of Vienna. And my parents, although initially regretting that I was not drawn to subject matter having to do with my Italian heritage, had generously underwritten my relocation to Europe.

However, no sooner had I arrived than the Hungarian Revolution of October 1956 broke out, changing my life and that of so many others. This jolting experience threw me off the art history track for several years, and I experimented with professions ranging from secretary in a placement service for physicians to guitar-strumming folksinger. But by that crucial summer of 1963 I was back in academia and eager to return to a city I loved and an artist whose compulsive, revelatory work held me in its thrall. I could not know that the discoveries awaiting me would pervade my diaries and dictate the course of several decades of my life.

1

Vienna was warm and welcoming that June and, thanks to letters of introduction I was immediately allowed access to the dimly lit Studiensaal of the Graphische Sammlung Albertina, home of the world's greatest collection of Schiele drawings and watercolors, as well as the depository for a rich archive of Schiele sketchbooks, photographs, letters, postcards, and pertinent newspaper articles. I worked there daily for six weeks, becoming acquainted not only with Schiele's artwork but also learning to read his handwriting—the old Kurrentschrift, which at first glance looks like a string of Gothic m's and w's all run together. I might have despaired of ever breaking the cursive code except for the fact that formidable help was at hand. Max Mell, a venerable Viennese playwright and friend of my mother, solicitously wrote out a Kurrentschrift alphabet for me.

In July, Julius Held arrived in Vienna along with Professor Harry Bober of New York University's Institute of Fine Arts to teach a joint course on illuminated manuscripts. I accompanied the class on visits to the National Library to observe preservation techniques, and we saw the *Dioscurides* being restored—that magnifi-

cent, sixth-century manuscript on medicinal plants created for the immensely wealthy and learned dowager, Anicia Juliana. We learned that she considered mighty Emperor Justinian of the great Ravenna mosaics as a mere "upstart puppy." I had seen those impressive mosaics at the Church of San Vitale when I was a teenager in Italy one summer, and I marveled at this unexpected insight into the shifting sands of reputation across the centuries.

Julius introduced me to the art historian Werner Hofmann, director of Vienna's new Museum of the 20th Century (Museum des 20 Jahrhunderts), and he in turn sent me to meet the contemporary sculptor Fritz Wotruba, an ardent and articulate collector of Schiele drawings. He delivered gruff salvos about Expressionism's impact on later generations, and I couldn't help but imitate his buckshot style of speech—an acoustical impudence that amused him. It was Wotruba who designed the large bold cube standing on end that marks Schönberg's grave in Vienna's Central Cemetery and which, he told me, is pointedly placed vis-à-vis the Dr. Karl Lueger Memorial Church: "der schöne Karl"—that handsome, popular, anti-Semitic mayor of Vienna from 1897 to 1910 who, nevertheless, courted wealthy Jewish industrialists, justifying his actions with the blunt dictum: "Wer ein Jud ist, das bestimm ich" ("I decide who is Jewish").

Back at the Albertina Museum, Julius gamely helped me decipher Schiele's diary of 1916, patiently reading aloud the as yet unyielding Kurrentschrift for several afternoons while I took notes. Herschel Chipp came to Vienna for a few days and sat with us in the Studiensaal as we continued to peruse Schiele's diary. It suddenly dawned upon us that the mysterious *o*'s populating the diary stood for the number of times the artist slept with his wife Edith. I photographed Julius and Herschel that evening as we sat around a table relating this "scholarly" detection to a bemused Werner Hofmann (FIG. 2).

At the end of July, I accompanied Julius on a weekend flight to Milan where he needed to look at eight unpublished Rubens drawings in the Ambrosiana Library. Because Julius was ever on the lookout to acquire art for J. Paul Getty's new museum in Ponce, Puerto Rico, we also visited several dealers whose Baroque paintings Julius scrutinized with his usual aplomb. I solemnly translated his ex cathedra pronouncements into florid Italian for the gallery owners. Fixated on things Austrian, and Egon Schiele in particular, however, I felt strangely impatient with Italian effusiveness and was eager to climb back inside the intriguing time capsule I had elected to explore in Vienna.

Nevertheless, I did discover a contemporary Austrian artist in Italy: Friedrich Hundertwasser (he later changed his first name to Friedensreich), then living in Venice and highly regarded by the Italians. Reproductions of his wry, brightly colored mosaic-like images were everywhere. I returned to Vienna with twenty postcards

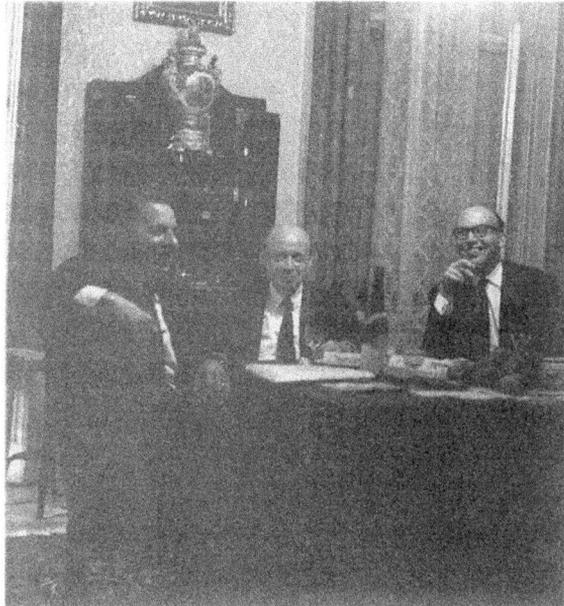

FIG. 2
Art historians Julius Held, Herschel Chipp, and Werner Hofmann. Vienna, 13 August 1963. Photograph by the author.

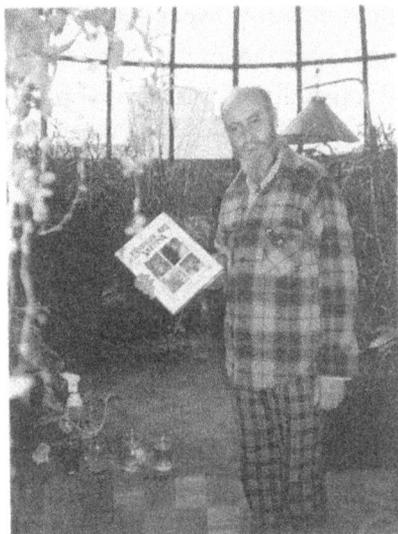

FIG. 3
The artist Friedrich Hundertwasser in front of his urine purification system holding a copy of the author's book The Fantastic Art of Vienna. *Vienna, 13 October 1981. Photograph by the author.*

and wrote him a spontaneous letter of appreciation, declaring how struck I was by his use of decorative motifs that seemed to render homage to Vienna's foremost painter of the Art Nouveau generation, Gustav Klimt. Almost by return mail a charming letter arrived from him, readily acknowledging the Klimt debt and inviting me to visit.

This began an intriguing, slightly combative friendship, in which he tried to convert me to the Zen philosophy behind his ambitious ecology projects in Uganda and New Zealand, and I attempted to demonstrate how sexist his language and outlook were. Three of his kaleidoscopic, multipatterned microcosms embellish the final pages of a book I wrote in 1978, *The Fantastic Art of Vienna*. On a visit to Hundertwasser's Vienna studio three years later, at an urgent invitation to see his "humus toilet," he proudly posed with a copy of the book in front of the tiered plant arrangement he employed to purify his urine (FIG. 3). I treasure his note reporting on a speech he'd just given at the United Nations in December 1983 on the occasion of the release of his specially commissioned United Nations human rights stamp: "In respect to your critique

that I leave out half of humanity in my writings, I used the words 'men and women' instead of 'man' throughout my address."

We discovered we did agree on one thing: that it was a shame the city of Vienna was tearing up the old double-headed eagle bricks paving the Karlsplatz—weighty relics of imperial times past—and we each rescued several of the roseate bricks for our personal collections. The one I mailed back to America is hand-decorated by Hundertwasser with a spiraling balloon, dedication, and date. A few of these bricks can be recognized in the artist's imposing three-dimensional achievement—his slap in the face of "dehumanized" modern architecture with its straight lines, the Hundertwasser Haus of 1985. Located on Vienna's otherwise lackluster Löwengasse in the Third District, it is an imaginative oniondomed fifty-unit apartment complex of roof gardens and cascading terraces graced with shrubs and trees overlooking color-coded flats distinguished by wavy hand-drawn lines and individuated windows. Hundertwasser lived long enough to see it become one of Vienna's most popular tourist sites.

2

Working in the Albertina during that first summer of research in 1963, I realized that eleven of the thirteen known watercolors Schiele had created while in prison were in the museum's collection. I examined them carefully—each one framed in an individual white mat with the Albertina imprint—and took copious notes in pencil. Following Bernard Berenson's connoisseurship example, about which I had just learned at Berkeley, I made an annotated sketch for myself of every artwork, attempting to develop a feeling for the hand of the artist—something that would later be immensely helpful in spotting Schiele forgeries.

Unbidden, quotations from the diary Schiele had kept during his incarceration peppered my dreams as I began to identify with Schiele's imprisonment and the one thing that sustained him, his art: "Yesterday: cries—soft, timid, wailing; screams—loud, urgent, imploring; groaning sobs—desperate, fearfully desperate. Finally apathetic stretching out with cold limbs, deathly afraid, bathed in shivering sweat. And yet, for my art and for my loved ones I will gladly endure to the end." This final line became the title for the

last of Schiele's four prison self-portraits and seems to have marked a turning point in attitude, as with new resolve the artist faced his unknown future.

Self-proclaimed Schiele cognoscenti as well as several of the watchful Albertina guards (who referred to me as "das Schiele Fräulein") took an avuncular interest in my work but—uniformly—everyone counseled me *not* to bother interviewing the artist's two still-living sisters. They were confirmed recluses, did not even speak to each other, and were, in short, crazy—"verrückt." Nothing could have been more of a challenge to me than such negative counsel, and soon I mailed off two carefully composed letters of self-introduction to Melanie and Gertrude, whom I already felt I had gotten to know from Schiele's portraits of them, begging for the privilege of an interview.

While waiting for possible answers to my letters, I decided to explore some nearby Schiele "sites"—first, his birthplace in the small railroad stop of Tulln on the Danube where his father had been stationmaster, second, Klosterneuburg, location of Schiele's school and first drawing lessons, and third, the village where he had been imprisoned, Neulengbach. The art historian Otto Benesch, just retired from several decades as the Albertina's redoubtable director, gave me an extended interview concerning the sympathetic young artist who exactly fifty years earlier had painted him as the seventeen-year-old son in an intriguing double-portrait statement on tensions within a father-son relationship. Benesch had never been to Schiele's prison; in fact, I soon ascertained that no one connected with Schiele—neither his relatives nor his chroniclers—had gone to Neulengbach since the artist's release in 1912.

And so on the morning of 27 August I rented a Volkswagen and drove to Tulln, then to Klosterneuburg, where I sought out the widow of Schiele's first drawing teacher and photographed some of

her husband's work, and finally down to Neulengbach, thirty miles southwest of Vienna. I was armed with a letter of introduction from the Albertina's director, Walter Koschatzky, asking that cooperation be extended to me. This letter on embossed museum stationery turned out to be an unexpected liability, however, when I presented it to the uniformed official on duty at Neulengbach's district court-house. The man read my letter out loud very slowly, emphasizing with mock reverence the words "Albertina," "Direktor," and "Wien." Then, abruptly, he waved me away like an insect, declaring that it was quite impossible for me to enter the building as there were, solemn pause, "wichtige Regierungspapiere" ("important government papers") stored inside. No pleading on my part had any effect, and sadly I walked away.

But not very far away. I circled, then surveyed the grounds from behind a tree. The noon hour struck, and several men, including the unhelpful official, left the building. More people came out, this time cleaning women. I joined them casually, sauntering backward as they walked forward. In another moment I was inside the court-house and next to a staircase that led downward into the dark. I descended and found myself in a damp cellar where, with pounding heart, I "recognized"—and that is the only word applicable—the long basement hall Schiele had mentioned in his diary, "with the rubbish that lies in the corners and the equipment used by the prisoners to clean their cells." The artist had depicted this corridor in his watercolor of 20 April 1912 (FIG. 4)—an image defiantly titled *I Feel Not Punished but Purified!* There was the same dismal band of gray paint running along the bottom of the limy whitewashed walls on both sides of the narrow passageway; there were the rough, heavy cell doors of thick wood; there the same type of long-handled mop propped up on end to dry; and there, wedged above my head, was the wooden support beam Schiele had drawn, only now, fifty-one years later, it was sagging precariously at the center (FIG. 5).

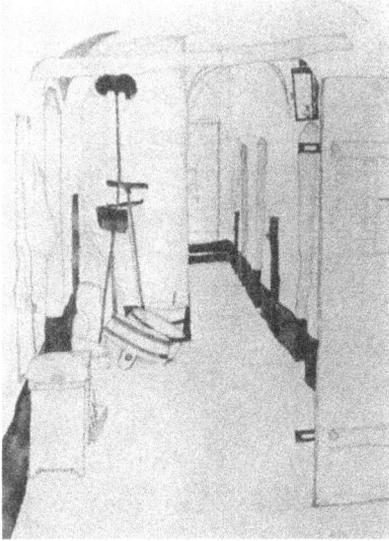

FIG. 4
Egon Schiele, I Feel Not Punished but Purified! (Nicht gestraft sondern gereinigt fühl' ich mich!), *20 April 1912, pencil and watercolor, Albertina Museum, Vienna.*

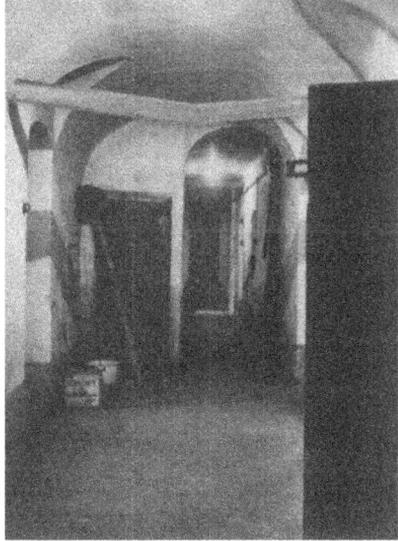

FIG. 5
The basement corridor outside Schiele's prison cell at the Neulengbach District Courthouse. Neulengbach, 27 August 1963. Photograph by the author.

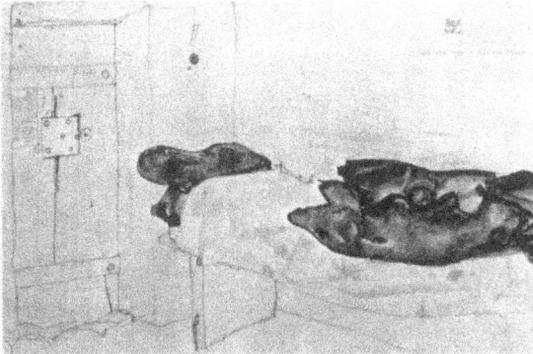

FIG. 6
Egon Schiele, The Single Orange Was the Only Light (Die eine Orange war das einzige Licht), *19 April 1912, pencil and watercolor, Albertina Museum, Vienna.*

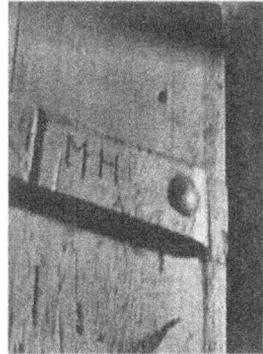

FIG. 7
The door of Schiele's prison cell in the Neulengbach District Courthouse with the carved initials "M H." Neulengbach, 27 August 1963. Photograph by the author.

But which of the six cells had been Schiele's? At the near end of the corridor I opened the first door, still labeled "No. 1," then the door to "No. 2"—and knew instantly that this one had been Schiele's cell. In a watercolor recording his surroundings, *The Single Orange Was the Only Light* (FIG. 6), executed on the first day he was allowed to have drawing materials—19 April 1912—not only had the artist recorded his narrow bunk bed and lumpy blanket, cheered by the single piece of fruit he had placed on top, but with ravenous eyes he had also observed and portrayed every detail of his cell door, including the initials "M H" carved on the upper horizontal band of wood spanning the door. *Those initials are what I saw!* Somehow I was able to hold my Rolleiflex 2.8F camera steady enough to take a time exposure of the door in the dim light (FIG. 7). Blessing my beginner's luck, I beat a successful retreat, noticing on the way that nowhere, absolutely nowhere, was there any sign of the "wichtige Regierungspapiere" supposedly stored in this historic basement. Instead, the six cells contained neatly stacked firewood.

Back at the Albertina, I was able to compare my photographs with Schiele's watercolors and to appreciate the remarkable accuracy of his work. One of the results of this close study of the prison images was that the museum agreed to re-mat the four self-portraits in response to what I had observed in my sketch notes (FIG. 8), that Schiele's deliberate placement of signature, title, and date on those images showing him recumbent and miserable on his cot were actually meant by the artist to be viewed as upright, conveying his psychic as well as physical discomfort.

Another consequence of my discovery was my first article, published the next year in the pages of the museum's new scholarly journal, *Albertina Studien*. Later, my English translation of Schiele's diary, along with fifty-one pertinent photographs and images, became my first book, *Schiele in Prison* (1973), with a sprightly intro-

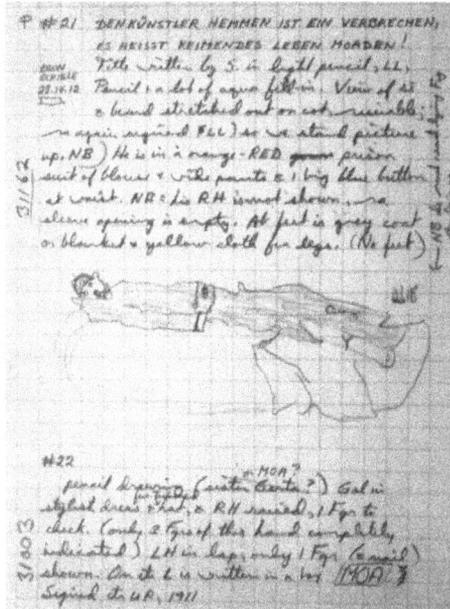

FIG. 8
*Author's July 1963 notes and sketch of
Egon Schiele's 23 April 1912 prison
watercolor,* Hindering the Artist Is a
Crime, It Is Murdering Life in the
Bud! *(Den Künstler hemmen ist ein
Verbrechen, es heisst keimendes
Leben morden!).*

duction by Walter Koschatzky. Twenty years later, Neulengbach caught hold of its moment of fame, refurbished that now infamous basement cell, and turned it into a miniature museum, complete with what Schiele drew (see FIG. 6) and described in his diary: "I know now what a dungeon is—it looks like a dungeon here. . . . Only the button for the electric bell above the head of the bed does not belong. It is present-day, is modern. And so I know that I am not dreaming."

The most immediate result of my having discovered and photographed Egon Schiele's prison cell was a promotion in Austrian nomenclature. Now the Albertina guards referred to me as "die Schiele Frau," rather than "das Schiele Fräulein."

3

A FEW DAYS AFTER RETURNING FROM NEULENGBACH I found a postcard in my mailbox from Schiele's older sister, Melanie. Dated Wednesday, 4 September 1963, and written in a clear, even script, it read:

> Dear Miss! Since I see your great interest in my poor dead brother and his work, I am gladly ready to tell you much more. On Friday 6/9 from 3 o'clock on I will be at the Café Zögernitz Döblinger Hauptstr. I think 80? in the garden or inside the café house. So come there.
>
> <div align="right">With cordial greetings,
Mela Schuster Schiele.</div>

I was honored to be the recipient of this simple message. Greedily I sounded out the delectable words, again and again. The German for "So come there" ran "Also kommen Sie dorthin," and I learned in this manner that one is supposed to add a "hin" to the "dort" with a verb of motion. How could I ever even begin to master German and assimilate the nuances of the singing Viennese intonation?

Bringing along the prison photographs I'd taken in Neulengbach, I showed up at the Café Zögernitz. From Schiele's portraits and archival photographs of the young Melanie I expected to see a rather plain-looking woman and one who was now—at the age of seventy-seven—probably quite fragile. What a surprise to see a tall, straight-backed woman with bright red hair vigorously beckoning to me. After three hours together in the café pouring over my photographs, she spontaneously invited me to go home with her.

We spent the next five and a half hours, with a break for dinner at a local "pensioner's" restaurant, in Melanie's nearby ground-floor apartment at Döblinger Hauptstrasse 77/2—a two-room abode shared with a dachshund named Waldi. The living room contained one large item that sent waves of excitement through me: it was the large, black-framed standing mirror Schiele had taken from studio to studio and used for his many self-portraits (FIG. 9). Timidly I asked whether I might photograph Melanie in

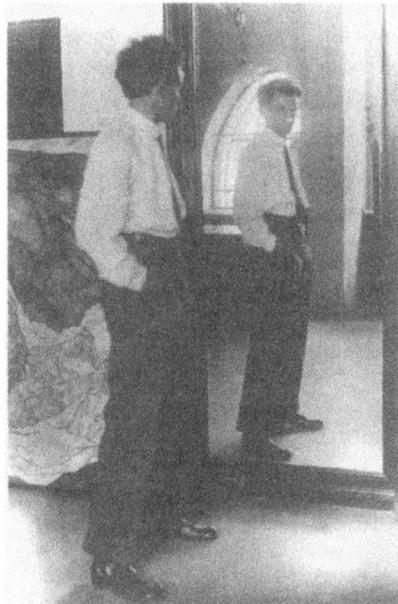

FIG. 9
Egon Schiele before his great standing mirror. Vienna, 1916. Photograph by Johannes Fischer.

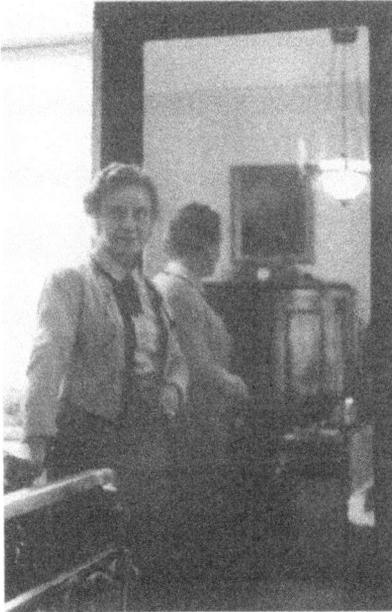

FIG. 10
Melanie Schuster Schiele before her brother's great standing mirror in her apartment at Döblinger Hauptstrasse 77/2. Vienna, 6 September 1963. Photograph by the author.

FIG. 11
The author photographing Schiele's great standing mirror in the apartment of his sister Melanie Schuster Schiele at Döblinger Hauptstrasse 77/2. Vienna, 6 September 1963.

front of it and she obliged good-naturedly (FIG. 10). Then she asked if I would like to photograph myself before this treasured object—the same looking glass that had once reflected the searching countenance of an Egon Schiele—and I did so reverently (FIG. 11).

I learned much about the artist's childhood from Melanie that evening, and before I left, I had been given a wooden toy soldier that used to belong to "Egon" and an invitation to return. In my diary that night I wrote: "Melanie is a powerful, lively, alert, tall woman. She talked readily and long and for the first time I realized that Egon had really been a child genius."

For the next weeks I visited Melanie regularly. Some anecdotes about Egon's early experiences in the art world were tales Melanie

(she pronounced her name: "Me-la-*neeee*") never tired of telling. It is thus in Melanie's emphatic voice that I still hear the ringing answer of Klimt, when one day her seventeen-year-old brother boldly thrust a portfolio of his drawings into the older artist's hands, demanding to know whether he had talent. Klimt leafed through the images in silence, then brusquely declared: "VIEL zu viel!" ("MUCH too much!").

In addition to my visits to Melanie, several intriguing revelations awaited me at the Vienna Academy of Fine Arts, where the precocious young Schiele had studied. While searching for the room in which Schiele's life-drawing class had been held, and guided by one of Melanie's photographs showing the artist in class, by chance I came across not the room but a cavernous closet in which were stored the wooden boxes with hand grips carved in the sides that had served as stools for Schiele and his classmates. I noticed these same uncomfortable "seats" before, in a painting of 1787 by Martin Ferdinand Quadal, depicting the life-drawing class at the Vienna Academy. To think that 120 years later nothing had changed, confirmed for me the validity of Schiele's increasingly bitter complaints about the academy's antiquated curriculum—his reason finally for leaving the school to strike out on his own.

The other academy find I was able to report to Melanie was that in the same ledger of records in which Schiele's entrance examination drawings had been marked "satisfactory," there was, a few pages earlier, the notation "unsatisfactory" entered against the name of another youthful applicant—Adolf Hitler. "At least the academy had high standards," remarked Melanie ruefully.

I also visited Schiele's younger sister, sixty-nine-year-old Gertrude ("Gerti") Peschka. I couldn't help thinking how true to type these two sisters were: Melanie, tall, awkward, and totally without artifice, Gerti, petite, self-confident, and still the coquette. Her son, Anton Jr. ("Toni"), who had been painted by Schiele as a child, was very much the solicitous cavalier to his mother, and dur-

ing my visits he reharnessed Gerti's outbursts in the service of our wide-ranging but often sidetracked Schiele discussions.

Visits to Gerti were far less revelatory than were those to Melanie, whose single-track mind was set on elucidating for posterity any and all details she could recall about her gifted brother. Shortly before I was to return to America, Melanie accorded me the intimate form of address. My diary entry for 26 September 1963 records that moment: "showed Melanie all my new photographs, then we drank 'Brüderschaft,' and pledged the 'Du.' Sad farewell at midnight."

After my first visit to Schiele's sisters in 1963, I returned to Austria the next three summers for more fruitful interviews, which eventually I tape-recorded on a reliable if cumbersome Tandberg from former folk music days. "Aber ich sprech' so ordinär" ("But I speak so commonly") was Melanie's disappointed reaction to hearing her voice for the first time on tape.

Although I could not persuade Melanie to travel with me back to Tulln to visit the family stationhouse by the railroad tracks, we did search out several Schiele sites in Vienna together, including the last two places the artist had lived, and in both cases we were able to talk our way inside to take photographs. The owner of Schiele's final dwelling mentioned that there were some old unframed canvases in the basement, and for a few suspenseful moments Melanie and I nursed the wild hope that we were about to discover some missing paintings. Not so, however; the pictures were of recent vintage and amateurish.

On a research trip spent in Vienna during the winter of 1966–67 funded by the American Association of University Women, the former routine of visits with Melanie was established again. As our friendship deepened, she entrusted me with the task of putting in order the many photographs, letters, and postcards to Schiele in her possession. And she taught me some favorite Heurigen songs,

gleefully helping me spell out the Viennese dialect involved: *Mei' Muatterl War A Weanerin* (*My Mother Was a Viennese*).

Over the course of that winter Melanie lent me a number of Schiele objects, drawings, and watercolors so that I could have them photographed professionally. One of the most unusual items was the artist's death mask, made right after he died of influenza— a poignant last portrait in which one side of the face is taut from suffering, while the other side appears relaxed in death. A feeling of awe overtook me as I threaded my way carefully through silently falling snow toward a distant cab stand at two in the morning with my precious cargo.

That winter the most important piece of family information divulged by Melanie was one that shed new light upon Schiele's obsession with death and sexuality. Melanie explained that her parents married when Adolf was twenty-six and Marie was seventeen, and that immediately afterward the couple took a wedding trip to Trieste where, for the first three nights they did not sleep together. Instead, Adolf visited a local brothel, contracted syphilis, and soon after infected his young bride. He denied he had the disease and would not have it treated. Three stillborn boys arrived in yearly succession, then came a girl, Elvira, who lived to the age of ten before she died from Adolf's lethal legacy. Egon and his two surviving sisters, Melanie, four years older than he, and Gerti, four years younger, were all three unwilling witnesses to their father's conversations with unseen visitors and general mental deterioration. His fits of insanity became more frequent, and he died insane when Egon was fourteen. Awareness of his father's venereal affliction undoubtedly contributed to the preoccupation with sexual exploration that was to become the subject matter of so many of Schiele's drawings.

Not all of Melanie's revelations were this dramatic, but over the years I was impressed by the consistency of her stories. I visited

Melanie every summer for eleven years until her death in October 1974 (she died in her sleep at the age of eighty-eight). She had become a true friend and was interested in my life and career at Columbia University, where I had begun teaching during the years I wrote my dissertation on her brother's work.

When I brought her the page proofs of my book, *Egon Schiele's Portraits*, Melanie relived the events and people of her youth with relish as, unhurriedly and with the greatest of attention, we looked through the illustrations. After saying good-bye at the door to her apartment, we both turned back at the same moment to give each other another hug. Her hair was still red, and her back still straight but her waddling canine companion, Waldi, had died that spring and Melanie's spirit was diminished. Her favorite poet, Goethe, might have judged her an "ordinary" person, but her great generosity of spirit and single-minded dedication to her brother's work made her extraordinary.

4

MELANIE SCHIELE NEVER CEASED to be fascinated by the fact that I hailed from Texas. She asked almost as many questions about my family and formative years as I did about hers. Why were music and languages so prominent in my life? How had I become an art historian? And why one specifically focused upon her long dead brother?

Just how a young woman from "the Wild West" with an Italian surname and no Germanic background was lured into that far away, complex, multidimensional world of early twentieth-century Vienna is a tale in itself. It is a story with meandering chapters that first interlock at the moment of that Berkeley encounter with the work of Egon Schiele. I have traveled so much in search of art, sites, and historic personalities that the results gloss much of what I teach and write still today, as repeatedly I find myself in the company not only of Schiele and Klimt, but also of Goethe and Beethoven, Napoleon and Goya, Ibsen and Munch, Duse and D'Annunzio, Mahler and Kollwitz, Picasso and Nijinsky.

The genesis of my story is an unusual and provocative set of parents, one American, the other Italian, and the peregrinations that

led us from Europe to the United States. So let us look in on them, as I did in several autobiographical tales told in bits and pieces to Melanie over the years.

Affectionate Collisions

One of the staples of my parents' married life, especially after moving to Texas from Europe, had been a perpetual contest to stump the other with an unknown word—a cheerful campaign carried on in five languages. Usually Megan, my mother, won, since English was now the main language in which they battled, but occasionally Tino, my Italian-born father, with his elegant British accent triumphed. Out-punning my American mother, or even me for that matter, was more rare for him, since, as he explained dismissively, "Italians simply don't *think* that way."

How did these two individuals—so different, yet so well matched intellectually—ever connect in the first place? They had met on the Spanish island of Ibiza, where both were living as part of a colony of carefree expatriates from all over the world, and each was initially living with someone else. Tino, named grandiosely Raiberto by his mother Maria Comini, had fled business careers in Geneva and London. By 1933, at the age of twenty-five, he was comanaging a small international hotel on the island while ardently experimenting with what would later become his profession in America—portrait photography.

Megan, born Eleanor Frances Laird in Winona, Minnesota, in 1908, was of Scotch-Irish descent. Her mother, the prudish but musical Alice Timberlake, had married William Hayes Laird, publisher of the local newspaper, who died just before the end of World War I. The first thing my mother did when she came of age, was to have her name legally changed from Eleanor Frances to Megan. "Megan Laird" seemed far better suited to the career of author she had decided upon for herself. She was accepted at Barnard College

FIG. 12
*Wedding festivities of Megan Laird
and Raiberto Comini on a hotel
rooftop. Ibiza, August 1934.*

with what in those days was called simply an "intelligence examination." There she flourished in creative writing and English literature. Within a year of graduating (1929), the dashing example of Ernest Hemingway—who had answered a fan letter from her with cynical advice—lured her to Spain. In Madrid during the early summer of 1931 she worked briefly as secretary/factotum for him until a vigilant Mrs. Hemingway intervened and Megan soon left the mainland for Ibiza.

Here it was that she met the mandolin-playing Tino. She won him by learning Italian quickly. While he was visiting family in Italy she translated Dante's *Divine Comedy* from Longfellow's English into Italian and then back again, hence speaking a colorful if archaic Italian by the time Tino returned to Ibiza. Previous partners were dropped, I was conceived, and a few months before I was born a joyful civil wedding took place on the roof of Tino's little hotel (FIG. 12).

In early November 1934 Megan and Tino sailed to America and went to my mother's hometown of Winona to have me, since they wanted their child to hold American citizenship. By the end of January they were back in Spain, but because they now had a baby daughter to care for—Sandrina, as they called me—they decided to exchange island life for urban stability in Barcelona. But they had not anticipated the rise of Generalissimo Franco.

Upheaval: From Franco's Spain to Mussolini's Italy

Megan Laird was the name with which my mother signed "Diary of a Revolution," the lead article published in the November 1936 issue of the *Atlantic Monthly*—an issue devoted to covering the Spanish Civil War, which had just broken out. We—my parents and I (age two)—were trapped in Barcelona when the street fighting began.

What could one do to get out of the country? The streets became more and more dangerous. In our case salvation came in the form of a troop ship sent in to Barcelona harbor by Mussolini for the evacuation of Italian nationals and their families. As my mother related:

> At last the embarkation on the Principessa Maria begins. It is a horrible, chaotic jam. Men elbow aside women and children in a wild plunge up the swirling stairway. There are no cabins and no beds, only row after row of bunks, in double tiers—hundreds of them, all alike. Here we are, nearly two thousand of us, of every type and variety of the human species, huddled together in all-too-close proximity for the space of thirty-six hours, on a free boat trip between the ports of Barcelona and Genoa. As we slide slowly to our mooring a tremendous cheer goes up from every throat: "Viva l'Italia!" "Viva il Duce!"

My parents would often comment later on the irony of being rescued from the clutches of one fascist only to find themselves in

the thrall of another. In Milan we stayed with my father's family in the large, multibalconied echo chamber of an apartment at Via Pergolesi 11 near the sleepless Central Railroad Station. This reverberating environment, which I visited often after the war, helped me appreciate that aggressive "simultaneity" so beloved by Italian Futurist painters, as in, for example, Umberto Boccioni's busy 1911 canvas *The Street Penetrates the House,* in which courtyard noises funnel upward to the visibly vibrating balconies of housewives.

During the next weeks with growing apprehension Megan and Tino watched Mussolini work his oratorical magic from atop Milan's great cathedral, as thousands of his eager Blackshirt followers assembled in the Piazza del Duomo below. My father's stepfather was minister of agriculture at the time and supervised an experimental farm near the small town of Lodi, where, he insisted, we could live through the Mussolini "fad" unnoticed and unmolested. We left Milan and divided our time between Bellagio (FIG. 13) on stately Lake Como and landlocked Lodi, where I

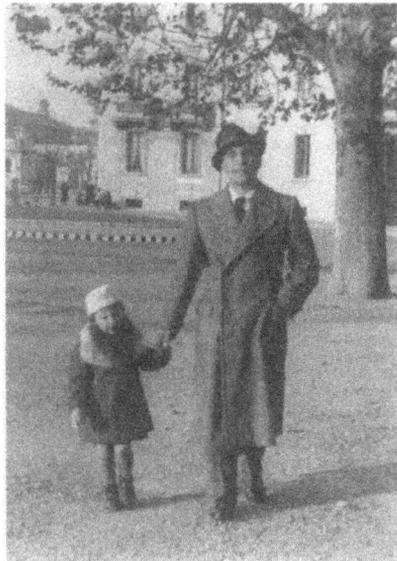

FIG. 13
*Tino Comini takes his
two-year-old daughter Alessandra
for a walk. Bellagio, 1936.*

remember the boisterous brace of hounds my step-grandfather always took with him on our walks.

But after months of watching political events unfold ever more grimly across Europe, my parents wisely decided it was time to change continents, and early in 1937 we boarded a ship out of Genoa bound for the United States. The few household items and photograph albums rescued from Spain were stored in the basement of the Lodi house, where they survived the disasters of World War II.

Minnesota Interlude

Now it was back to Winona and my American grandmother's corner house at 275 West Broadway—a yellow brick two-story building with mysterious cellars (smelling deliciously of apples), sleeping porches, a long attic from which issued an enormous horizontal flag pole awaiting Fourths of July, and a screened front porch in which hung a swinging settee commandeered by me as my own ship sailing between two continents.

The yellow brick house was large, but the mentality within was small: "Just imagine!" my grandmother would hiss, looking disapprovingly out the parlor windows at the neighbor's house across the street: "Don'cha know, they've gone and hung their laundry out to dry again on a *Sunday*!" Megan and Tino hated the confinement of straitlaced Winona, and I think of this when teaching Paul Klee's Sour Etchings done at his parents' home in the stifling atmosphere of his native Bern—especially his parody on excessive formal manners in which two completely nude men bow and scrape to each other, each believing the other to be of higher rank.

My parents also detested Minnesota's cold winters. Nevertheless, Rochester and the Mayo Clinic were within driving distance, and twice that year they took me there to have surgery on my badly crossed eyes. I have no memory of those two operations, but I certainly recall the third and final one, performed when I was eleven

because Megan made the whole experience a wonderful adventure, reading Charles Dickens out loud to me for the two weeks I was required to lie still in the hospital with bandages covering my eyes.

I recovered, but it never occurred to my parents—or anyone else in those days—that their smoking might have health consequences, and in this case it was I who was affected. I can remember concentrating during asthma attacks on the image of two armies—one dressed in brilliant blue uniforms, the other in crimson red—battling back and forth for possession of my lungs. "Take your child to a warmer climate," advised the local physician, and that same week the *New Yorker* carried an advertisement which read: "Looking for that ideal place to live? Consider DALLAS: plenty of sunshine, plenty of opportunity."

My parents needed no further urging. Off we drove in an antique Plymouth for Dallas, two adults and two children (my brother Gian Paolo had just been born), lustily singing the latest Hit Parade tunes all the way—I remember the words to one jolly song: "Hut-sut ralson on the river-raw and a brala brala suet."

Becoming Texan

Within days of arriving in Dallas we had moved into an enchanting house with a row of pear trees growing down one side of the driveway in a neighborhood where it was all right to dry laundry outdoors on Sundays. My parents set up one part of the living room as their music corner and in the evenings concertized for my brother and me—my father on violin or mandolin, and my mother playing the three-quarter-size harp of her childhood, sent on from Winona as a surprise house-warming gift by her mother (FIG. 14).

After the Plymouth expired we all got to have bicycles. Tino opened a portrait photography studio near the institution where one day both Megan and I would end up teaching—Southern Methodist University (SMU)—renowned in the late 1940s for its

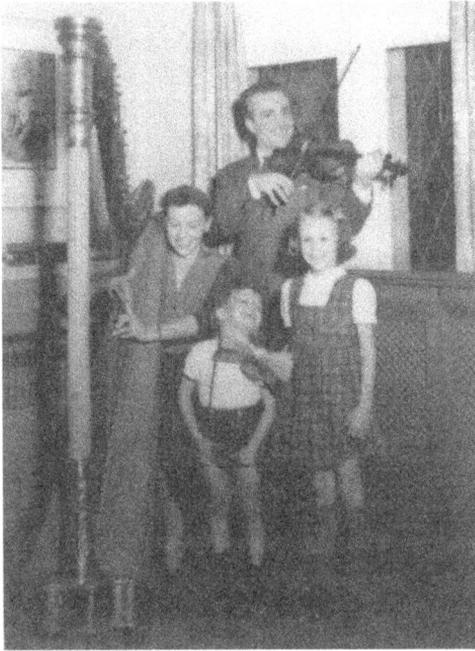

FIG. 14
Family Christmas carols (from left to right): Megan, Gian Paolo, Tino, and Alessandra. Dallas, 1940.

football stars (among them Doak Walker and Kyle Rote). Every morning Tino departed on his red Schwinn bike to photograph his clients, some of whom he alienated by complimenting them on their "pimples" when he meant "dimples." Nevertheless, his charming accent and elegant manner of dress (white suits, white pointed shoes) attracted a steady following, and the artistic quality of his photographs won him many return customers. Soon he was driving to work in a blue Studebaker convertible with the top down, his black cigarette holder held aloft.

"Comini, the Magic Name in Photography" was my father's signature phrase for the newspaper columns full of folksy European wisdom he began to write under the heading "Comini Says." He also sponsored for pennies the eight hours of silence on our classical music station WRR by placing his inexpensive short ad just before the stroke of twelve, solemnly announcing over the slow movement

of Brahms's Second Piano Concerto, "The next hours of SILENCE are brought to you by Comini, the magic name in photography."

When America entered the war it was no longer charming to be Italian, and especially not in Texas. My father's application for citizenship was rejected and only the intervention of influential family friends effected a change of heart on the part of the government. Xenophobia affected me as well. One morning I arrived at the grade school two blocks from our house to find my surname printed on the class blackboard with a large swastika beside it. I ran back home in tears. It was on this day that my parents stopped speaking to me in Italian.

As I became the butt of jibes at school, not only because of a lingering accent but also because of still noticeably crossed eyes, my father told me a great and comforting secret: it seemed that I had been born with the power to become invisible. But I would only be able to use it once in my lifetime, so I must choose the unbearable situation from which I needed to escape with extreme care. So far I have not had to apply this miraculous gift.

As companions, I had the fearless company of Nancy Drew and the Hardy Boys (Megan kept a full supply of the two children's mystery series in her locked cedar closet for use when we were sick), and by the age of eleven I was deep into reading all twenty-four volumes of Edgar Rice Burroughs's spellbinding *Tarzan* series. At any moment I could swing away from danger through the Stygian darkness of the middle jungle (thick vines that drooped from trees lining a nearby creek) to swing back and forth in fine Tarzan style.

That final eye operation at the Mayo Clinic when I was eleven forced me into spending a quiet month recuperating at my grandmother's house in Winona, and it was there that I became absolutely addicted to early evening radio broadcasts of exciting adventure series like *The Shadow, Captain Midnight, Jack Armstrong*, and *Tom Mix*. I loved belting out Tom's twangy breakfast cereal commercials.

The rest of that summer was spent back in Dallas where I passed the long hot evenings (pre-air-conditioning) as I had so many earlier ones: swimming at the brightly lit local public pool and devouring chilled watermelons. We watched for shooting stars, and my brother and I caught fireflies on our front lawn as our parents sat on the front steps smoking, drinking iced coffee, and watching. Then, while we admired our glimmering specimens indoors, our parents would play the latest recordings of songs by Charles Trenet or Edith Piaf—*La mer, Ménilmontant, La vie en rose.*

Sometimes I would improvise on the piano with Tino playing a mandolin or violin obbligato until late into the evening, and yet still sneak out of the house with Gian Paolo for a dip in the now-darkened public swimming pool—just like Tarzan. Years later in a dentist's waiting room I came across an article that discussed how every American *boy* of the 1940s identified with Tarzan while growing up—didn't the writer know that Lord Greystoke could appeal to girls, too?

My parents gave me a stuffed panda, crayons, building blocks, tin soldiers, miniature musical instruments, and Lionel electric trains, but never dolls. Later, as an art historian tracking down and lecturing on women artists of the past, I was charmed by a portrait of the French animal painter Rosa Bonheur done by her father when she was four. Dressed in pantaloons, she leans against a doorway next to a stack of alphabet cards on the floor, a toy soldier enfolded in her arms as she clasps a paint brush in her right hand. She was learning the alphabet by drawing an animal for each letter. In this portrait I recognized the sort of creative education my parents had given me.

Reflecting on my identification with Tarzan, I realize that attempting to emulate his physical prowess may have helped prepare me for some of the more agile feats occasionally demanded by art historical reconnoitering—such as climbing over forbiddingly high walls to

ascertain whether architectural goals lie within, as I did once to photograph the Duino Castle outside Trieste where Rainer Maria Rilke began writing his Duino Elegies in 1912.

Such mountaineering instincts seem to have taken hold early: witness the picture my father developed with increasing horror in his darkroom from a roll of negatives I'd proudly sent back from Italy the summer I was eighteen and supposedly studying Italian at the University of Perugia. There I sat, not in a classroom, but foolhardily perching on the outermost tip of a rocky outcrop overlooking a 1,112-foot drop (FIG. 15). After seeing that photograph Megan telegraphed me to come home immediately. I promised to be more careful and was allowed to remain in Italy for the rest of the summer.

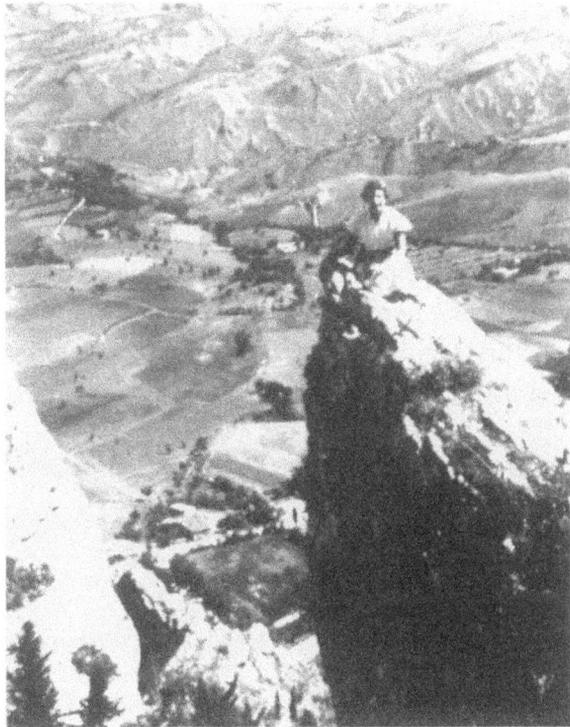

FIG. 15
The author perched on a rocky outcrop of the Republic of San Marino, 1,112 feet above the Rimini plain. Summer 1953.

Observing Tino develop photographs was a memorable treat: the pungent smells of chemicals, the mysterious blackness of the darkroom with its flat vats of fluids, the wire strings overhead from which strips of negatives hung, and most of all, the magic of watching a piece of blank paper slowly surrender up a black-and-white image under the gentle agitation of a wooden paddle. Sometimes the emerging likeness was of me, since Tino habitually employed me as experimental subject for his ever-increasing array of cameras and lights. This continuous documentation of my childhood carried over into my own adult obsession with photographic evidence.

Images of Megan still vividly visit my mind today—twenty-odd years after her death. Sometimes she appears as the debilitated, wheezing old woman who sat for hours hunched over her downstairs desk, supporting her chin on interlocked fingers as she reread all the heavy green volumes in her complete set of Dickens, exclaiming with pleasure and literally wearing the skin off her elbows.

But more often Megan materializes as the ardent, sparkling brown-eyed, ever-questioning guide of my childhood who never let me get away with vagueness of language (I: "Mommy, at school they all say . . . " Megan: "And *who* are 'they?' ") or obliviousness to my surroundings: "Look at that side of the room; now look away. How many persons in the picture on the wall?"—a useful game in doctors' waiting rooms and one that would sensitize me for my as yet undreamed-of profession as art historian.

5

It was also Megan who, deeply involved in dance lessons her-
self, enrolled me in classical ballet classes during my grade and high
school years. During summer sessions at the Edith James School of
the Dance such illustrious and temperamental dancers as Nikita
Talin (who eventually settled in Texas) and Alexandra Danilova
would give guest classes. I can still see Nikita impetuously pouring
small chilled cans of grapefruit juice over himself to counteract the
Texas heat and hear Danilova's high-pitched command: "Sur le cou
du pied!" My parents befriended Danilova ("Choura" she asked to
be called), who found a little bit of Old World atmosphere in their
home, and she often came to dinner that summer.

Perhaps because my first love in the arts was ballet, I find myself
continuing to investigate and draw upon the world of dance, espe-
cially in my teaching, hoping students will become as involved as I.
For instance, each spring when facing a new class on Sources and
Styles of Modern Art, in order immediately to secure the attention
of two hundred apprehensive undergraduates, my opening pair of
slides beams up two dramatic black-and-white portraits of Vaslav

Nijinsky. Created just two years apart by the American artist Franz Kline, the earlier image shows a readily recognizable Petrushka with sagging body and sad face; the later picture, done in 1950, the year of Nijinsky's death, displays a dynamic hieroglyph of action, the broad impasto brushwork laid down at collision speed. Quickly we move to the next pair of slides: electrifying photographs of Nijinsky in *The Afternoon of a Faun* and of Michael Jackson in one of his jerky gyrations; the obvious lesson of prototype and legacy is permanently absorbed.

In the mid-1980s I was given a similarly simple and indelible lesson by the choreographer Agnes de Mille when she visited SMU to receive the Algur H. Meadows Award for Excellence in the Arts. After an exceptionally articulate acceptance speech characterized by profundity as well as passion, she met a long line of admirers, talking to each one individually. When my turn came I found myself blurting out a tortured question about whether it was really possible to combine the time-consuming politics of a university career with the career itself. Her emphatic answer: "Work! Just work!"

Following that advice has been its own reward. Long ago I fashioned a life rule for myself that I dare to pass on to the more idealistic students who come my way. I call it the Three Ls—Living, Learning, and Loving, and sometimes I suspect that perhaps my classroom lectures in art history are really just subversive attempts to mold character and pass on one simple truth—that life is so precious, each day of it must be spent living it, learning from it, and loving, loving life, others, and oneself as well.

A shy student once came to my office hour to ask a question urgently on her mind: "How can I get a passion? You know, a passion like what you have?" I thought of what one of Schiele's sitters, Friederike Maria Beer-Monti, told me when I earnestly asked her what she was doing at the age of twenty-three when Schiele painted her. Her response was so immediate: "What was I doing?

Nothing! Just LIVING—going to the theater, to art exhibitions, to the opera."

I, too, because of my parents' example, thought that life, that is *real* life outside school, was also just LIVING. More and more performers visiting Dallas ended up at our house for dinner. The delicious menu, jointly prepared by Megan and Tino, was always the same: cold vitello tonnato with guests' names spelled out in capers on top, followed by hot gnocchi in a tomato sauce that had simmered for four hours, and for dessert warm zabaione—egg beaten with sugar.

Actors

Our focus on dance shifted to theater when Margo Jones, the innovative stage director, inaugurated her theater-in-the-round in Dallas and asked my father to become the official photographer (FIG. 16). A special building was constructed at Fair Park (site of the annual state fair) and was a resounding success—the greatest since Sarah Bernhardt played *Camille* to an overflow tent in Dallas in 1906. For many seasons during my early teens actors from New York and California cheerfully graced the Dallas floorboards. Tino lovingly documented every dress rehearsal, from Shakespeare's *The Taming of the Shrew* to Tennessee Williams's *The Glass Menagerie*, and his glossy black-and-white photographs were hung in the theater

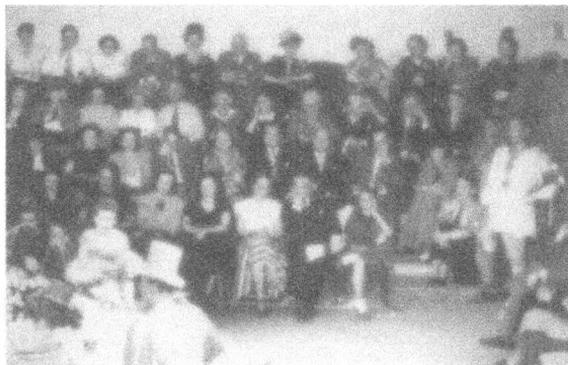

FIG. 16
Director Margo Jones (seated on the stairs at the right) watching one of her theater-in-the-round productions. The author is seated in the front row with her parents. Dallas, 1948.

lobby where people studied them during intermissions. A number of the regular repertoire actors began showing up at 3505 Beverly Drive (my parents' final home—a pale brick two-story affair much like the Winona house).

Two of these personalities became cherished friends. I adored the wonderful couple George Mitchell and Katherine Squire (seen in various television episodes of *The Alfred Hitchcock Hour*). George and Katie were vigorous talkers, especially George, who was the first Irishman I'd ever met. His talent for tale telling was prodigious. He claimed that the Irish, the Italians, and the Jews, of all peoples in the world, had a special bond because they were the best raconteurs and singers. He would demonstrate the latter by singing the same song (what else but "My Wild Irish Rose"?) three times, with Irish, Italian, and Central European Jewish accents, leaving his listeners helpless with laughter. It was fun to learn about such apparent stereotypes in this manner, and an exciting thought occurred to me: since I was already part Italian and part (Scotch-)Irish, might I not also be part Jewish? After all, my father didn't know who his real father was. He *could* have been Jewish, couldn't he? I pestered my parents about this for years.

The ethnic self-admiration club formed by George Mitchell and my father inspired the ever-creative Tino to put together a little illustrated book on *Italian Facial Expressions and Gestures*. He photographed himself enacting emotions ranging from fear to outrage. The most memorable image for me was "Oca!" ("goose!" meaning "stupid!")—a swift sequence of hand gestures that involved first pulling the skin down underneath the right eye with the right forefinger and then vigorously slapping the tip of the right elbow with the open palm of the left hand.

Artists

If the seasonal stream of visiting actors and their spontaneous declamations increased my admiration for drama, the local painters

who became my parents' friends piqued my appetite for the visual arts. Donald Vogel, who later opened a gallery featuring Rouault's heavily impastoed preliminary oil studies for the Miserere series, joined us every weekend for picnics at White Rock Lake, where my parents had a sailboat—a twenty-three-foot Star. It was thrilling to stand at the jib of the boat as we sliced through the waves at full speed, and Don's shouted analyses of the ever-changing light on water held me transfixed, as did the observations about perspective murmured by the landscape artist Ed Bearden, who occasionally took me along for informal drawing lessons during his forays into the Texas countryside.

Jerry Bywaters, a regional artist of repute whose directorship of the Dallas Museum of Fine Arts would survive a scandal concerning "that Communist Picasso's" works, gave me a filing job at the museum the summer I was fifteen, and it was exhilarating to be in such daily proximity with roomsful of "real" painting, sculpture, and artifacts from different cultures. Soon I was creating images for my own miniature museum in the attic at home, lining the walls with brightly colored, reductive images à la Picasso (I thought), accompanied by displays of especially interesting rocks, matchbook covers, and bottle caps. Tino cheerfully provided canvases, oil paints, frames, and encouragement, and some of my more ambitious oils were displayed at his studio. Occasionally he came home brandishing the money he'd obtained for me from an impromptu sale.

The collection in our attic was augmented, at Megan's suggestion, by changing exhibitions grouped around various themes such as animals or self-portraits, and the recollection of these challenging childhood projects has prompted me to assign fantasy exhibitions to graduate students in SMU's Arts Administration program—giving them the experience of writing grant requests and catalogue entries, as well as attempting to put together a compelling show. Over the

years some intriguing, if not necessarily blockbuster, proposals have been developed, such as "Bathing with Great French Painters" and "Celestial Circles from William Blake to Adolph Gottlieb."

One of the first art historical undertakings I assumed upon switching from Columbia to SMU in 1974 was to tap local as well as national talent in designing fantasy exhibitions for an issue of *Art Journal* of which I was guest editor. This brought me into contact with the collectors Patsy and Raymond Nasher, who enthusiastically responded with an amusingly ambitious scheme—three-dimensional site map included—that featured great monuments of the architectural past, from the Egyptian pyramids to London Bridge, all of them transported magically to Texas. How aptly this farsighted fantasy presaged the Nashers' intrepid pursuit, acquisition, and transportation back to Dallas of the giant pieces of twentieth-century sculpture that now form part of the Nasher Sculpture Center gift to the city.

Musicians

The dancers, actors, and artists who left their mark on me were not the only visitors to my parents' home. Foremost for me, in awe of their accomplishments, were the musicians. Cesare Siepi, whose suavely evil Don Giovanni thrilled Dallas audiences just as it had New York ones, heard there were a few Italians in town and was given my father's telephone number. They got on splendidly, and soon he, too, became a regular visitor during the Metropolitan Opera visits to Dallas, devouring gnocchi with us in the kitchen. He bet my father that he could insert Tino's name into one of his performances. He did so with gusto and no libretto-altering danger in the first act of *Le nozze di Figaro* when he sang "Se vuol' ballare signor contino," wheeling to face the audience and gesticulating meaningfully toward where we were sitting as he separated and drew out the "con" ("with") and "tino" of "contino" ("little count").

When the Greek pianist Gina Bachauer arrived in Dallas to play in SMU's McFarlin Auditorium, a violinist friend of my parents', Lanham Deal, arranged to bring her to our house to unwind after the concert. But he had a little surprise in store. In cahoots with my parents, he had tuned down by a half tone the second E above middle C on the Steinway grand in our living room. That evening after Bachauer had had a chance to relax, Lanham asked her to accompany him in one of his favorite pieces, "The Last Rose of Summer," and please to play it in the key of E. They commenced, and when the crucial fourth note—the high E—sounded, Lanham played it flat with a straight face and so, involuntarily, did Bachauer, who also maintained an absolutely straight face throughout the ear-wounding performance. Cheerful bedlam broke out afterward, as Bachauer identified the culprit who had tampered with the tuning.

A demeanor just the opposite of Bachauer's characterized the backstage actions of another musician who became friendly with my parents: the singer Patrice Munsel, whose husband happened to be from Winona, amazed us by jumping up and down and wriggling her hands vigorously behind the wings just before she went on stage to sing at our Starlight Operetta Company one summer. She explained afterward that she needed to rev up in that manner in order to exude the instant sparkle necessary before an audience. (Later, as a teacher-"performer" myself, I have resorted to similar devices.)

The new Hungarian conductor of the Dallas Symphony Orchestra, Antal Dorati, came by my father's studio for a publicity photograph and was brought home by Tino that same day. He, too, reappeared for dinners and once told us a moving story of returning to his parents' flat in Budapest right after the war. From the street he could hear the sounds of their string quartet playing. He let himself in through the front door and, although his parents beamed with joy at the sight of him, they silently motioned to him

with their bows to take a seat until the movement they were playing was finished. How I hoped later that I might come across Dorati's parents when, as a student in the Vienna of 1956, I was involved in helping to evacuate refugees during the Hungarian Revolution.

Another musician frequently present when Dorati came to dinner was the tall, imposing principal cellist of the Dallas Symphony Orchestra, Lev Aronson, who as a Latvian Jew had been interned in concentration and extermination camps during the war. Deprived of his instrument and forced into slave labor, he survived by mentally playing through his repertoire each night. Lev prided himself on his knowledge of languages, and he and my father delighted in continually one-upping each other with esoteric proverbs in foreign tongues, many of which I eagerly wrote down as pithy insights into human nature.

Lev's adages were mostly in Russian, and I tried to memorize them all, especially after he began teaching me cello one summer. He acted out each musical theme we addressed, and I can still see him staggering dramatically across the room to the beginning notes of the great Antonín Dvořák cello concerto. At that point in my life I knew for certain I would grow up to be a cellist.

6

THREE SCENES HAVE LODGED PERMANENTLY in my mind from the summer of 1949 when Tino exultantly took the family back to Italy for the first time since the end of the war. These vignettes gave me lasting insight into the Italian mentality—something I would later have to deal with as an art historian in search of obscure sites and works of art.

We sailed from New York on the S.S. *Independence*; realizing how scarce American cigarettes were in Europe, my parents had crammed their steamer trunks with two dozen cartons of cigarettes. When we lined up at the customs desk in Genoa after disembarking, an impressively uniformed official signaled my mother to open up her trunk. Obediently she unlocked it and helpfully pulled open a drawer. It contained the cigarettes. Tino glared at her (he had hidden *his* cartons inside clothing). The customs official glared at her even more ferociously. "Why, *why* did you put them on *top* where I could *see* them?" he asked her indignantly. "If you had just put a blouse over them, a sock, anything! But now I've *seen* them and I have to charge you tax!" "Yes, yes, va bene, that's all right," answered Megan deferentially.

The agitated official and my father exchanged exasperated glances and rolled their eyes heavenward. "Go back," commanded the official finally. "Go back and repack. Then return to me here." Megan did so, and this time no offending contraband assailed the eyes of the conscientious customs official as he cautiously opened the drawer.

Moments later we were surrounded by my demonstrative grandparents—Nonna Maria and Nonno Mario—who covered us with wet kisses and whisked us toward a grinning chauffeur named Cleto, who drove their large black Lancia sedan with characteristic Italian excitability and dexterity. Within seconds he had tied our steamer trunks to the top of the car, and we were off for Milan, where more loudly affectionate relatives awaited us at the Via Pergolesi apartment.

After two weeks we left by train for Rome, relieved to escape the suffocating attention of our relatives. Our hotel rooms overlooked a busy square full of cars and pedestrians, and one morning I walked into my parents' room to see Tino standing by the open French doors of the balcony gesticulating silently. All of a sudden his cheeks turned bright red, he sank to his knees in midgesture, and quickly crawled away from the window on all fours toward the bed. "Tino! What on earth are you doing?" cried Megan, following his trajectory of retreat with wonderment. "Oh, I was just watching two men making a gesture I had completely forgotten about, so I was copying it when suddenly they both looked up, saw me imitating them, and began shaking their fists at me," Tino replied breathlessly.

We children had been promised a trip to the catacombs, and, indeed, the experience lived up to all the ghoulish sights Megan had prepared us for, with rows and rows of widely grinning skulls carelessly stacked on either side of the long tunnel through which our gregarious guide was leading us. Gian Paolo and I loitered slightly behind. Wouldn't it be fantastic to have a tooth from one

of those skulls to show friends back home? We inched toward one of the more gap-toothed victims of long ago. Tino spotted us and whispered urgently to Megan: "Tell the children *not* to take a thing. I've already got something for them."

That afternoon back at the hotel Tino dramatically unwrapped part of an Early Christian cranium that had involuntarily exited the catacomb with him. We were in awe while Megan vacillated between outrage and fascination. At dinner that evening Tino suddenly took sick and threw up at the table. The next day on the train up to Florence he began perspiring and looking very white, speaking hardly at all. That evening he went to bed with a high fever. At three in the morning Megan woke me and told me to get dressed; we had to go out on an errand. My father had awakened in a delirium, begging her over and over again to "give the brainpan back." Tenderly we rewrapped the purloined trophy, silently exited the hotel to the astonishment of the night clerk, and walked quickly to the Ponte Vecchio over the river Arno where, accompanied by a solemn incantation of "earth to earth, dust to dust," we carefully released the dishonored relic into the black waters below. When we returned to the hotel Tino's fever had broken. For the rest of his life he liked to tell the story of the power of what he called superstition (and Megan called conscience).

7

THE ARTS—such an integral part of life in my parents' home—were relegated to minor subjects at the institutions I attended in Dallas. In the public junior high school I attended for a year, Texas history was emphasized over world or even American history, to the dismay of my parents. Crudely illustrated comic-strip-like brochures on the Alamo are the only "textbooks" I can recall. Football games seemed to be the school's primary focus, and my initial enthusiasm for the sport diminished upon learning that I could only be a cheerleader on the sidelines.

Alarmed at the growing repertoire of coarse language I was picking up, my parents took me out of public school at the end of the year and enrolled me in the Hockaday School, a private girls' school in town. The students were an interesting mix of boarders—some from foreign countries—and day pupils like me. I liked this school much better. Everyone wore distinctive green and white uniforms with matching green and white saddle shoes, and during play periods we could choose our own activities—strenuous volley ball matches or skillful jack competitions carried out on the

wooden floorboards of our classroom. Every few weeks a new fad took hold at school: we passed sewing needles horizontally through the tough skin of our palms, competing to see how many needles one could "wear"—seven and eight at a time. The trick was to keep them in all day and avoid detection by our teachers.

Classes were small and the teaching stimulating. We studied Latin with an exacting, petite woman with short white hair called (in the Southern manner) "Miz Grow." Every year she staged a sumptuous Latin Banquet for which we dressed in homemade togas and entered the dining room following Roman tradition on our "dexter pedi" ("right foot") for good luck. We learned about the Roman statesman Cato the Elder, his hatred of the African city of Carthage, and how he concluded every speech to the Senate, regardless of the topic, with the admonition: "Carthage must be destroyed!"—a handy phrase we girls delighted in shouting at each other during athletic events: "Delenda est Carthago!"

In spite of Tino's hostility toward priests and religion in general, it was decided that I would be sent to a local Catholic institution for girls for my four years of high school. Uniforms were mandatory— this time a spiffy blue and white combination with corresponding saddle shoes. Situated out of the city in what was then still the countryside, Ursuline Academy was run by nuns of the distinguished Ursuline Order, and their handsome black habits and distinctive starched white wimples enchanted me at first sight. I passed an initial interview with the keen-eyed principal Mother Dolores Marie Ramsey but had trouble with the application form, since it asked what religion I was, if not Catholic. I could not think of the names of any specific denominations, nor could I decide whether the general category of "Protestant" was spelled with a "d" or a "t." I opted for "Prodestent" but was accepted anyhow.

I loved the classes at Ursuline—four years of Latin and courses in French, philosophy, logic, and religion. And I became more zeal-

ously Catholic than my baptized schoolmates, devoting every Sunday to bicycling to Catholic churches all over Dallas. Would I be struck by a bolt of lightning if I—a pagan—joined the devout who knelt before the altar to receive Communion? I never found out. Watching the priest dip wafer after wafer into a chalice of wine with his bare fingers, then lay these same dripping wafers on the outstretched tongues of the faithful kneeling at the altar railing, seemed patently unhygienic to me, and I had more fear of germs than of God.

Now and then my enthusiasm was misplaced. For instance, one morning at school I noticed that the public address system in the principal's office was switched on with a microphone standing invitingly by. The door was open, the office empty. I tiptoed in, picked up the microphone, and announced in sepulchral tones to all the classrooms: "GOD SEES YOU." "God sees you TOO, Sandra Comini," immediately answered Mother Dolores Marie, who had been returning folders to a file cabinet behind the door.

Little by little I "reformed," however, no longer whistling in the halls out of pure good spirits ("ladies don't whistle"), ceasing to turn my collar up as a sign of sartorial rebellion, earning gold bows for academic grades if not blue ones for character, and serving as president of the Mission Club (travel to distant places apparently already on my mind). In spite of only average height, I seemed to be an effective guard on our active basketball team, and because of my "fiery nature" (according to our drama coach), I was assigned the role of a knife-wielding French revolutionary in the bloodcurdling play *Song at the Scaffold*. (Decades later I would gratefully consult this play while researching Francis Poulenc's *Dialogues of the Carmelites* for a lecture at the Santa Fe Opera.) I was even entrusted with the editorship of our senior yearbook, a responsibility I took very seriously, inserting loving drawings of

students and rosaries intertwined, and for which the school won a national award. The description next to my photograph in the annual read: "Scintillating, 'pizza,' puns, artistic and dramatic ability, unpredictable, flute, Interlochen."

8

Wishing to expand my vistas beyond Texas, my parents decided I should spend the summer before my senior year in high school at the National Music Camp in Interlochen, Michigan. Everyone, students and instructors alike, wore uniforms of dark blue corduroy knickers, long white socks, and white shirts. We were divided by age and sex into small groups of sixteen or so and assigned to rustic cabins lined with double-decker beds spread throughout the forest that surrounded the main buildings.

Not only music but also theater, dance, and the visual arts were taught. I was not yet proficient on any musical instrument, and so I attended, that first of two summers at Interlochen, as an art student, analyzing the compositional mass of fruit and bottles stacked up for students to render into geometric shapes. Not much of interest to absorb in that class, it seemed to me, but later I would appreciatively recall my still-life exercises when seeking to fathom the ingenious teaching methods of Vasily Kandinsky and Paul Klee, who used similar traditional devices to extract untraditional rhythm, volume, and line from their Bauhaus students.

Outside the art classroom there was a whole world to learn about in the musical atmosphere pervading the pine-scented grounds. Choir, band, and orchestra performances took place in outdoor auditoriums almost every evening, and during the day dozens of music students practiced individually in secluded sylvan spots. We all came together at lunchtime, lining up hungrily to get into the cafeteria, and the musicians stashed their instrument cases in large bins just inside the entranceway. Soon I was skipping lunch, lingering in order to be alone with the bins and their seductive contents. It turned out that my cabin mates were all musicians, willing to let me try out their own instruments.

However, no one in our cabin played the instrument that interested me the most—the flute. Aside from the purity of sound and silver simplicity, the decisive appeal for me was that, unlike a cello, it packed up small enough to carry anywhere. When I telephoned my parents to ask about switching from art classes to beginning flute lessons, they agreed almost immediately, commenting that building up lung power on a wind instrument would certainly benefit anyone with asthma. For the rest of that summer I reveled in mastering the basics of fingering, tone production, breath control, and sight reading.

My cabinmates encouraged me and also introduced me to the fun of duet and ensemble playing. Natalie Silverstein from New Jersey, already an excellent pianist and singer, inspired me to join the Interlochen chorus with her and to compose as well. She also gave me a book, *Basic Judaism*, and wanting to be just like her, I studied it fervently, relishing the idea of converting to the Jewish religion until I was told that Orthodox Jewish males recite a daily prayer thanking God for *not* creating them women. Another volume, lent to me by a girl from California, introduced me to India and the alluring world of gurus and Yoga. The book was *Autobiography of a Yogi* by Paramhansa Yogananda, and I can still

visualize his long-haired, exotic image on the cover. Several of us began to sit around in the lotus position in front of our cabin, where we discovered this was the perfect attitude in which to devour the gallon cartons of vanilla ice cream we could buy at the tiny camp store after evening concerts.

Musically, I progressed enough to persuade an approving Megan and Tino to allow me to continue flute lessons back in Dallas, and the following summer I returned to Interlochen not as an art student but as a music student with my own silver Haynes flute, practicing outdoors (in trees) and advancing during the weekly "bloody Friday" tryouts to second chair in the junior-high-school-level band. My parents retained an embarrassing LP of the Sibelius symphony we recorded that summer in which I came in a half beat too late during an entry for two flutes playing in thirds.

Of greater impact than any progress on the flute made that second summer in Interlochen was the continuous exposure to classical music. I still recall the thrill of attending rehearsals for the massively orchestrated Berlioz *Requiem,* with sixteen kettle drums lined up along the front of the stage and clusters of brass players distributed with tremendous effect under the trees framing the large outdoor auditorium. Nightly concerts under the stars introduced us to a rich cross section of choral and symphonic literature, and we proudly wore our Interlochen rings, embossed with the opening notes of a pulsating, nostalgic theme from Howard Hanson's Second Symphony. That silver ring meant as much to me as the red and gold class ring I received upon high school graduation in 1952.

Five decades later, in 2002, my sister Adriana persuaded me to attend a fiftieth high school reunion at Ursuline. I went reluctantly but was charmed to find so many of us essentially unchanged and quite recognizable after half a century. Our principal, Mother Dolores Marie Ramsey—a vigorous ninety years old—laughingly

recollected her retort to my "GOD SEES YOU" announcement on her microphone. Adriana had been born during my sophomore year, triggering extreme interest in details of the birth process on the part of some of my classmates. I was urged to ask my mother what giving birth to a baby had been like. Her instant answer generated an equally instant but lifelong decision in me never to produce a child: "Well, darling, it's like trying to push a grand piano through a transom."

9

THE SUMMER AFTER HIGH SCHOOL GRADUATION passed quickly, including the magical weeks back at Interlochen, and soon it was time to begin college. Megan had graduated from Barnard in 1929; I was destined to graduate in 1956, if all went well. Some of her teachers were still there, and she urged me to look them up—Mrs. Gertrude Stabenau, who taught German, and an instructor of English, Professor James Brewster—"I think he's emeritus now," mused Megan. The whole family, Japanese Spaniels included, accompanied me to the local Highland Park Railroad Station on the day my train departed for New York City. I was dressed in a pale blue jacket and matching skirt, and a private compartment had been reserved in my name for the two-day, two-night journey. "All a-BOAHRD," shouted the conductor, folding up the metal train steps and jumping on board himself. It was heart-wrenching to see my mother suddenly burst into tears as she waved at me from the platform and to watch my father sprint alongside my window as the train slowly pulled out.

What should I do next? Go to the dining car and eat. I was led to an empty table, but facing me at the next table was a serviceman

in uniform, his head bandaged, and an older man who seemed to be taking care of him. I paid them scant attention, as I had brought my own company with me to the table—a just-purchased piano-vocal score of Bizet's *Carmen*, my favorite opera at the time, and one I had decided to memorize. The Overture and Act One occupied me during the whole meal, and I continued to work on it back in my compartment till late that evening. I dreamt in French that night: "Sur la place, chacun passe, chacun vient, chacun va."

The score accompanied me to more meals in the diner, usually within sight of the two men I had first noticed, and the last evening, just as I was returning to my compartment, the older man who had been attending the soldier came up to me and pressed a crisp $20 bill into my hands, saying: "Please accept this, Miss. My patient, the soldier over there, has been observing you, and thinks you are off for your first year at college, yes? Well, he wants you to have this as spending money." I protested the extravagant gift, but the doctor said in a serious, low voice, "Do take it; he is prone to depression attacks if he feels rejected, and we don't want that, do we?"

And so I arrived in New York early on an autumn morning with an extra $20 bill pulsating in my purse. That very day I located an exciting area in midtown Manhattan—Forty-Eighth Street, lined with music shops—and purchased a $19 set of dark wooden bongo drums—an instrument I had never even heard of before that day.

The bongos came in handy almost immediately. An "Introduce Yourselves" evening was held for the freshmen after we'd been there a week, and by that time I had already met and joined forces with a music major who would become my best friend—a girl from Muncie, Indiana, named Isabelle Emerson. She was an accomplished pianist and a committed fan of José Iturbi. We decided to introduce ourselves as a musical duo that evening, and with no sense of modesty to hamper us, we gave what can only be characterized as a deafening performance of Manuel de Falla's "Ritual Fire

Dance," with Isabelle ripping through the rousing torrent of notes on the piano while I whacked the heck out of the two bongo drumheads with my fingers, palms, elbows, and chin. Instant fame burst upon us. Our reputation for being "terribly interesting" was clinched when a few weeks further into the semester we decided to combine our two single rooms, making one a bedroom and the other a jungle music room. "Please send fish nets, animal skins, tropical plants and musical instruments," we petitioned our parents. Tino sent me an accordion.

Isabelle and I signed up for some of the same courses—geology, government, and a mandatory class of forgettable title which grimly purported to address the "problems of modern womanhood." It featured guest appearances by Barnard's president, the redoubtable Millicent MacIntosh, who horrified us with references to her "five Caesareans"—fortifying my resolve never to have children.

A course on medieval Italian art and architecture given by Professor Marion Lawrence, who would become a dear friend in my graduate-school days, was as memorable for the flat pronunciation she gave all Italian names (including my own) as it was for the wonderful artworks and sites—all of which she had visited.

She could be formidable when it came to art matters. Years before the much-admired giant terra-cotta *Etruscan Warrior* at the Metropolitan Museum was declared to be a modern forgery, Marion Lawrence had been convinced that it was a fake. Unable to persuade anyone at the Met, she lost patience while eating in the museum cafeteria one day, purloined a sign designating types of sandwiches, and parked it ostentatiously in front of the statue. "Baloney" read the sign, and it remained in place for days before being noticed.

Because I had already studied logic and philosophy at Ursuline it was tempting to take more courses in these subjects, perhaps even to major in philosophy. So I signed up for an intriguing-sounding

class called Symbolic Logic with a benevolent Professor Joseph Brennan. At first it was a breeze, as we rehearsed syllogisms, identified major and minor premises, and discussed correct or false conclusions, but two weeks into the course mysterious mathematical symbols were substituted for English sentences and I was hopelessly lost. Only then did I notice that my classmates, most of them boys from neighboring Columbia College, were all math majors. I barely passed and the work-scholarship on which I had come to Barnard was in jeopardy.

One day as I was walking across the adjoining Columbia University campus past the flag pole, I noticed that the flag was lowered and a sign declared that a professor whose name I recognized had passed away. Immediately I telephoned Megan with the sad news: "Mommy, your beloved professor Emeritus has died!" Her response bewildered me, "Which one?" and it was only then that I learned "emeritus" was not a surname. This spurred me to take a fifth year of Latin, studying the odes and epodes of Horace, and soon I was denouncing anything or anyone irritating in scornful tones: "Odi profanum vulgus."

I struck up acquaintance with a red-haired boy who was a drummer in a dance band, and he offered to show me how bongo drums were really played. We went to his drafty, cold fraternity house where he gave me a comprehensive explanation of the technique of bongo drumming. I was freezing but too absorbed in the percussion lesson to notice any bodily discomfort. Around ten o'clock he asked, "Do you have a curfew?" I had just sneezed and thought this was a sweet way of asking if I had a cold—kerchew! "Oh, no, not at all," I assured him. About midnight he escorted me back to my dormitory, and there I was met by an irate house mother who informed me that I had broken the 10:30 p.m. curfew for freshmen. A new word was added to my vocabulary, and I was grounded for two weeks.

One activity for which exception was made during this and other grounding periods was participation in the university choir. We rehearsed every weekday from 5:00 to 6:20 p.m. in the basement of St. Paul's Chapel on the Columbia campus near Amsterdam Avenue, galloping back through campus toward Broadway and across to Barnard just in time to slip into the cafeteria, which closed for dinner promptly at 6:30. The fruits of these musical labors were presented on Friday evenings, when we sang a Lutheran service, and on Sunday mornings, when we participated in a High Episcopalian service. Isabelle and I had auditioned for the choir during our first week of classes, qualifying as altos under the demanding but stimulating direction of the debonair organist-choirmaster with thick, jet-black hair and pale white skin, M. Searle Wright.

The handsome chapel with its red brick Catalan arches, fine acoustics, and friendly basement offices packed with intriguing sheet music provided us with a sheltering second home. The choir practice room was warm and cozy, and our straight-backed chairs were distributed in a half circle around the grand piano, from which Searle smartly rehearsed and conducted us. For four years we were proud members of the choir, benefiting from the ambitious musical programs staged by Searle, who held forth so authoritatively on the Aeolian-Skinner organ that is the pride of St. Paul's Chapel.

One of the slightly older altos, Lillian Marston, a professional viola player from Scarsdale, was placed next to me because she had a true alto voice and was a fine sight reader. She had a square jaw under which, on the left side of her neck, was a permanent brown mark from playing the viola. I was overwhelmed with admiration and desperately longed for some mark of my own to distinguish myself as a "musician." We became friends when she learned I was taking flute lessons. My Interlochen teacher had directed me to one

of New York's most renowned flutists, Frances Blaisdell, and I went by subway every other week down to an elegant apartment building off Columbus Circle for a private lesson.

"Let's play some chamber music," Lillian proposed, and we began meeting in the main parlor of Brooks Hall to try out trios by Jean-Baptiste Loeillet, with Isabelle at the piano and Lillian retuning her viola to play the violin part. We attended a flute recital by my teacher at St. Paul's Chapel and loyally sat in the front row, thrilling to the soaring quality of her beautiful tone as it rose up to the dome. Right after her final bow, Ms. Blaisdell made a beeline for me, shaking her finger menacingly: "Sandra Comini! You have *got* to stop squirming and tapping your feet—it's most disturbing and it's not even in rhythm!" My surprise and chagrin knew no bounds. And now I strive to remember this each time I am distracted by a front-row wriggler in class and find myself tempted to chastise the unconscious offender.

The caroling at local hospitals we engaged in as part of St. Paul's Chapel Choir inspired me, that first year at Barnard before we all went home for Christmas, to suggest that some of us freshmen girls form a group to serenade the president of Columbia University, who had just accepted the Republican nomination for the next presidential election. I took my accordion along, and Isabelle and I led a group of classmates over to the president's house on Amsterdam Avenue. We began singing to my three-chord accompaniment, and soon lights came on all over the house, the front door opened, and there stood a beaming Mamie and Ike Eisenhower. "Do you know 'Rudolph the Red-Nosed Reindeer'?" asked Ike. We obliged lustily if enharmonically, and a flashbulb went off in my face—members of the press had arrived. The next day I was nonplussed to find my photograph in the *New York Daily News*, accordion strapped to my chest, serenading the Eisenhowers. Two evenings later my parents received an ecstatic phone call from

my grandparents in Milan: the picture had been reproduced in *Il Corriere della Sera* (Verdi's favorite newspaper), and my name was included in the write-up with the designation, "una ragazza italiana" ("an Italian girl").

The following week my mailbox yielded a large envelope containing the sheet music to "Rudolph the Red-Nosed Reindeer" from its publisher, with a note saying: "Miss Comini—next time General Eisenhower asks you to play this song you'll have the music."

10

R<small>EGRETTING THAT THEIR DAUGHTER</small> had so little opportunity to speak Italian, my parents proposed that I spend the summer after my freshman year at Barnard in Italy.

Tino had been encouraging a family friend, Dina Long, to learn Italian, and so the plan was hatched that the two of us would sail to Genoa, spend a few days with my grandparents in Milan, and then proceed down to Perugia, where the purest Italian in Italy was spoken, to enroll at the renowned Università per Stranieri (University for Foreigners) for the summer.

On the crossing we acquired Italian suitors only too eager to teach us Italian. Mine was named Ellio, and he was the leader of the ship's orchestra—a status that thoroughly impressed me, as did the starched white uniform he wore.

This linguistic tutoring (accompanied by an occasional sudden hug) prepared me for a similar, but platonic relationship with the handsome son of the family with whom Dina and I stayed in Perugia—Aldo Stornelli. He was all of twenty-eight with pale white skin, jet-black hair, and a thin, aristocratic nose. Every

evening after dinner he took me out for gelato and a stroll around the upper or lower city. He recounted the story of two dogs coming upon a piece of meat. The first one, who spoke only pure Italian, grabbed the delicious morsel and held it tightly in his jaws. The other dog, from Perugia, asked the first dog what it had in his mouth. "Carne" (meat), he answered, dropping the morsel as he enunciated the word. The Perugian dog snapped up the prize and held it firmly in his mouth. The first dog, thinking to trick his rival in the same manner, then asked what he had in his mouth. The crafty second dog answered in pure Perugian dialect through tightly clenched teeth, "Ciccia!" (meat!).

Meals in the Stornelli household were times for learning what constituted good manners (hands always visible on the tablecloth, rather than hidden in one's lap), and I still remember the firm reprimand occasioned when I sat down at the table whistling a tune out of sheer good spirits: "Non si fischia alla tavola, signorina!" (One does not whistle at the table, Miss!). Benign approval descended upon me, however, when I returned to the house one day with a beautiful light brown cello, bought at the local market for the irresistible price of $18. I was given a small room in which to practice it and the flute, and soon my attendance at the university fell off. It seemed to me that I could learn much more by myself or in the company of the conscientious, courteous Aldo, with his captivating store of Italian lore and dialect.

The stifling, crowded bus excursions provided by the university to sites like San Marino (see FIG. 15) inspired me to secure my own transportation, and when my parents sent along a new installment of funds, I spent almost the entire sum on a small, motorized bicycle called a Paperino (gosling). From then my days were occupied with exploring the hilly Umbrian countryside beyond Perugia in ever-widening circles. I would return from my outings in the early evening, passing cheerful women and men

walking home from the fields, and fending off the droves of flying insects that gathered as night fell.

Although the Paperino did not have the speed of a Vespa, it was a liberating instrument, and my excursions became more far-ranging: north to Gubbio with its medieval stone houses perched on a slope, then much farther north to the former Byzantine outpost Ravenna on the Adriatic coast to admire the stunning sixth-century wall mosaics in San Vitale (FIG. 17). There an ancient rivalry is played out in which the commanding figure of Emperor Justinian, who ruled Ravenna long-distance from Constantinople, although centrally placed within his retinue of soldiers and clerics, is subtly overlapped (look at the feet!) by the local archbishop Maximianus in a subversive statement of provincial primacy. This was the same Justinian so detested by the dowager Anicia Juliana, I would learn during that memorable class with Julius Held and Harry Bober on the *Dioscurides* in Vienna.

Another Paperino excursion took me east to Assisi where Professor Lawrence's Barnard class came to life as I gazed in admiration upon Giotto's scenes from the life of St. Francis—especially the episode in which he preaches to such attentive birds. And

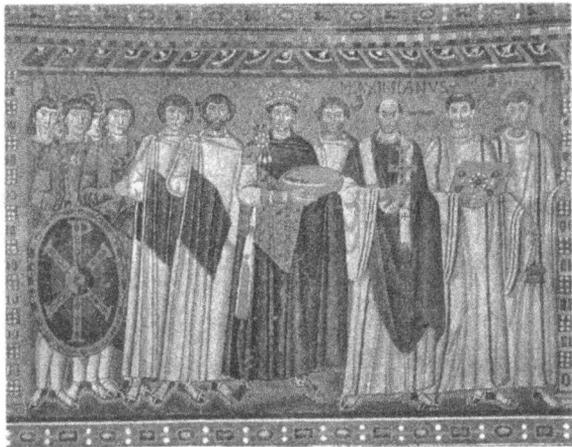

FIG. 17
The Emperor Justinian
and His Retinue,
*ca. 547 A.D., mosaic,
San Vitale, Ravenna.*

finally I headed south, first to Deruta, source of the traditional pottery so familiar to me from my parents' home, then farther down to Orvieto to look at Luca Signorelli's dramatic *Last Judgment* in which condemned souls are roughly tossed or borne down to hell by grinning winged devils—much like the evil flying monkeys in *Dorothy and the Wizard of Oz*.

After a month of day trips, often coinciding with picturesque celebrations of local saints' feast days, I made an overnight stay in Siena to witness the boisterous Palio, that horse race dating back to medieval times in which colorfully dressed jockeys from rival neighborhoods ride bareback around the semicircular Piazza del Campo. The short race of three laps can take less than a minute, but it sparks citywide festivities lasting for days. At the jaded age of eighteen, I couldn't be bothered to climb the 553 steps of the Campo's slender Torre del Mangia, but on a return visit exactly half a century later, I made up for that lapse of curiosity and was richly rewarded by a spectacular view of the whole city of Siena. Looking down upon the labyrinth of sunlit and shaded streets radiating out from the Campo, I was vividly reminded of the clarity of that object lesson served up long ago by Ambrogio Lorenzetti's frescos in the adjacent Palazzo Pubblico: the *Effects of Good and Bad Government*, in which streets lead to logical outlets in the *Good Government* allegory and to dead ends in the *Bad Government* fresco.

Could the little Paperino get me all the way to Rome? The idea became an obsession, and I resolved to find out. Packing only a minimum of belongings, I bade farewell to Dina and the Stronellis, promising to be back in a week or so, and rode slowly down the Perugia hill toward Todi and then continued south along the ridges sloping down to Terni, where a sudden torrential rain forced me to take shelter underneath the canopy of a deserted fruit stand. A few minutes later a motorcyclist traveling in the opposite direction pulled up, dismounted, and joined me under the canopy, peeling

off his wet shirt and swearing lustily—"Madonna sifilitica!" (Syphilitic Madonna!). We exchanged glances of commiseration. He attempted to talk to me, but I merely nodded in sympathy, staring ruefully out at the downpour. Now he confronted me, hands on hips, leering into my face, and asking if I wouldn't like to pass the time making love with him. "No!" I shouted, but his pestering persisted, and finally there was nothing else to do but jump back on the Paperino and head out onto the road in the driving storm. Hot tears of indignation blended with the cold rain pouring down my cheeks, and I felt—for the first time in my life—vulnerable.

I tried to lift my spirits by belting out one of the cheerful songs I'd heard my grandmother sing in Milan, *Ciribiribin*. That worked, and so did the dawning realization amid thickening traffic that I was approaching the outskirts of Rome and the Porta del Popolo. I stopped just outside the historic gate to take it all in. A few hours later, after tooling down the Corso and recognizing some of the monuments and churches I'd first seen with my family in 1949, I headed for the railroad station in search of an inexpensive hotel. The one I chose, encouraged by the sight of a fellow American tourist checking in at the front desk, turned out to be in the heart of the red-light district, and so I spent the evenings leaning out of my window watching the passing scene with fascination.

During the day I visited some of the seven hills and most of the major outdoor tourist sites of Rome on my Paperino, admiring the Villa Borghese park, the Protestant Cemetery, the giant Bocca della Verità carved stone face just within the entrance porch of Santa Maria in Cosmedin (a backdrop for Audrey Hepburn and Gregory Peck in *Roman Holiday*, filmed that very year), Hadrian's Tomb (known to me from Puccini's *Tosca*), the Pantheon and its dozens of resident cats, the Colosseum and nearby Arch of Constantine, and the sprawling Roman Forum with its shady architectural nooks. I returned to the Forum most days to snack on a lunch of fresh rolls,

cheese, sparkling mineral water, and a peach while eavesdropping on the multilingual guides lecturing to passing tour groups.

After a week of sight-seeing in Rome and absorbing Roman dialect: "Aniam a maniam" (Let's go eat), a new question entered my head: could I make it to Naples? Not unless I sold the Paperino, for I was almost out of money, and this was what the hotel porter advised me to do, warning me in stern tones that the autostrada to the south was no place for such a puny little bike. I reluctantly sold it and left for Naples by an afternoon train, admitting to myself that it was a relief to be traveling by a more conventional mode. A youngish and atypically red-haired Italian man in my compart-ment—the only other occupant—had been studying me earnestly and began making polite conversation in an Italian laced with infinitives, apparently his helpful way of addressing foreigners. It turned out he was a policeman returning to Naples from a holiday up north. I asked him about dialect expressions, and we began singing well-known Neapolitan songs like *Cuore Ingrato* together.

The time passed quickly, we laughed a lot, and soon the train was pulling into Naples just as the sun was setting. "Where you to stay?" he asked pleasantly. "Oh, I don't know yet; I'll look for a hotel near the train station." His face clouded "By the *stazione!*" he exclaimed angrily. "No, you *not* to stay there; it to be dangerous for you in such a neighborhood." I immediately grasped what he meant, but was unperturbed. "How dare a young girl like you to come Naples without knowing where she to stay?" he continued scoldingly, still in infinitives, and I was impressed by his sincerity. He insisted upon escorting me by streetcar to the pensione of a friend of his uncle and quietly made arrangements for me to stay there at a moderate rate. "I to fetch you after work tomorrow and to show you Naples," he said in farewell.

For the next three days he showed up every afternoon and took me on walking tours all over the city. We always ended up sitting

on rocks beside the great curving Bay of Naples. I listened long and hard to his accepting description of the "noble poverty" that so characterized his city. On my final day in Naples I was not allowed to return to the train station by myself; no, he "to see me off safely back to Perugia," and so he did, with a serious, very long shake of the hand. Although I have returned to Naples several times in pursuit of art historical objectives, it is this awkward visit in the company of a gallant red-haired carabiniere that I cherish the most.

I returned to America at the end of that summer of 1953 with a cello and a heightened appreciation for my father's native land.

11

THE WORK-SCHOLARSHIP on which I had come to Barnard entailed an unusual job: every weeknight from nine to midnight I operated the Brooks Hall elevator, sitting on a tiny leather drop seat behind the gear box that had a brass lever with which I could control not only the speed of movement but stop the car flush with the landing. This, and opening or closing the sliding gate with suitably creaky flourish took some practice, and I prided myself on perfect landings and smooth, if breathtakingly fast, rides. I met a lot of upperclassmen here, and the well-lit cubicle was also a perfect place to study while waiting for passengers.

One of my German class assignments was to read the ball scene from Goethe's *Sorrows of Young Werther* in which the dreamy, self-absorbed hero observes a sudden thunderstorm through a window with Lotte, the young woman who is the object of his undeclared love but is engaged to another man. Giving way at last to extreme emotion, he blurts out the single word: "Klopstock!" They look at each other in silent, mutual understanding. But nowhere in my hefty German dictionary could I find this word "Klopstock," and as

tears of frustration blurred my vision, the Gothic font of the German text began to wiggle and wave before my eyes, further frustrating me.

Shaking with ill-concealed despair, I soldiered on at my elevator post, developing a sudden hatred for the recondite German language. None of the passengers could help me, and only the next day in class did I learn that "Klopstock" was not a forceful German idiom for "I love you, I must have you immediately or die," but rather the name of a once popular author whose nature poetry was instantly recognizable—if you were a late eighteenth-century reader.

My love for the German language was soon revived, however, by the fact that my class on Italian Renaissance art was being taught by a professor from Germany with a thick Teutonic accent, Julius Held. Not only did his plosive pronunciations of Italian names and expressions such as "Now lookkkk hehrrr" rivet me, but so, too, did his authoritative introduction to matters of connoisseurship and collecting, the distinction of regional schools, and focus on iconography. He told us that we, too, could learn to identify "hands" and make discoveries in antique shops, galleries, and secondhand-book stores. Never before had I encountered a subject that seemed to draw from so many fields, that incorporated so many subtopics, that required knowledge of different languages, and that depended as much on educating the eye as well as the mind.

Our visits to New York museums under Dr. Held's guidance were revelations, as we—and the guards—listened to him hold forth effortlessly about the physical as well as stylistic aspects of various works of art, inserting pithy asides on the history of the institution we were in, and mentioning pertinent European counterparts and collections. I became possessed by the image of everything Held stood for—art history, perpetual research, discoveries, languages, travel, Europe! Furthermore, he was Jewish, and that held tremen-

dous appeal for me. (My childhood longing to be able to declare I was at least part Jewish had been intensified after World War II by learning about the concentration camps and reading Anne Frank's diary, which had just been published in English during my freshman year at Barnard.)

How could I come closer to the towering entity of knowledge that was Julius Held? His very name—Held—meant "hero." I decided to adjust his Italian plosives. Waylaying my hero in the hall after class one day I began the campaign, sweetly pointing out that Piero and Pollaiuolo did not need to sound like pistol shots. He was amused, we fell into step, and a lively discussion accompanied us out of the building and down adjacent Claremont Avenue to the apartment building number 21, where he invited me to walk his dog with him.

This was the first of many walks, and soon we would met regularly to exercise the dog. I learned that Held had a Swedish wife, Pim, who was a restorer of paintings, and that they had two young children, Anna and Michael. He heard that I played the flute and expressed his regret at never having learned a musical instrument. I volunteered to give him recorder lessons, and this brought me into the hallowed inner sanctum—his large apartment—where I was welcomed by lovely, gracious Pim. Dinner invitations followed, and soon I had struck up a playful friendship with his children.

Now and then I would babysit for the Helds, and at Thanksgiving they invited me to ride out with the family to their country home in Marlboro, Vermont. Listening to Pim's lilting Swedish accent, I expressed admiration for the many languages she spoke. Her unassuming response impressed me: "But dear, it does not matter how many languages a person speaks; what matters is that the person has something to *say*."

The genial family outing fortified our comfortable relationship, and thereafter I was often invited over to 21 Claremont Avenue.

The apartment's long entry hall was like an art gallery, lined with framed prints and drawings by contemporary as well as past artists. For the first time I realized that one could become a collector, as well as an historian of art. Dr. Held introduced me to some of the wonders of his vast library as well, painstakingly showing me his collection of illustrated incunabula and explaining how engravings, aquatints, dry points, and lithographs differed from each other. He easily translated the Greek, Latin, German, Dutch, French, and Italian frontispieces we examined, and my admiration for him and the intriguing world of art history intensified. And so I declared a major in art history—a field never mentioned in high school or even by my parents. After the disastrous experience of Symbolic Logic, it was a relief to exchange the realm of philosophy for that of art.

But I did not neglect music at Barnard. Along with Isabelle, I took sight reading with Alice Mitchell, conducting with Rudolf Thomas, and composition with Otto Leuning, who was very proud of playing a wooden flute. In homage to him I later acquired a 1904 black wooden flute made by Haynes—ideal for playing Baroque music.

A growing interest in instrumental music emboldened me to compose, during my sophomore year, the entrance music—scored monophonically for piano, flute, oboe, and drums—for an annual Barnard event: the Greek Games. This was a ritualized athletic competition between the freshman and sophomore classes in which participants displayed their competence at a variety of ancient sports. My balletic form as a discus thrower had won a "Nike"—Victory—my freshman year. The highlight of the Games was a chariot procession around the indoor arena in which two rival teams of "horses" (four girls harnessed to a chariot) pranced or pulled to the shouted Greek commands of their charioteers, who occasionally had to reprimand in cajoling Greek tones a

reluctant horse. The jubilant cry "Nike!" has remained in my active vocabulary.

My sophomore year was filled with activity. Twice a week I went to Bellevue Hospital in response to a radio ad asking for volunteers. I wore a nurse's aide uniform and helped with patients and their relatives, many of whom spoke no English. The challenge of communicating with them was stimulating and required inventiveness, but the mounting pressure of classwork and homework, and especially the demands of choir practice prevented my continuing this experiment in social work for very long.

Our St. Paul concerts were impressive, and one Easter both Isabelle's and my mother visited New York and came to one of our Sunday services. We were indignant when they stole out during the sermon to have a smoke, thereby missing part of our oratorio. But they made up for this by plying us with food at our local Schrafft's restaurant and taking us to concerts and plays downtown. One memorable experience was a characteristically idiosyncratic performance of Bach's *Goldberg Variations* by Glenn Gould in Carnegie Hall, where we sat in the last row of the top balcony with binoculars following his every move.

Back in Dallas, during the summer of 1954, and now a dedicated art history major with a burning need to speak the language of my hero Held, I announced to Megan that I wanted to take beginning German classes. They were offered at SMU, just a few blocks from where we lived. "Well, *you're* not going to learn a language *I* don't know," she responded with a competitive sparkle in her eye, and so we both signed up for a class that became the delight of our summer. By semester's end Megan had developed such enthusiasm for the new language that she decided to continue with it, and soon she was asked to replace an instructor who took sick. This began her career as a language teacher at SMU, teaching first German and then introducing Italian, which so grew in popularity that she

established a Department of Italian and even hired additional instructors—an achievement that earned her a *Cavaliere 2a classe* from the Italian government twenty years later.

During my junior year at Barnard I made good friends with a fellow art history major, Julie Misrahi, who had a wonderful talent for drawing wry scenes of fantasy creatures and plants. A native New Yorker, she mischievously enjoyed affecting a Brooklyn accent. Julie's father was a professor of medieval French, and this brought a new dimension of appreciation for things French into my life. Portugal was Julie's other love, and so I began to take an interest in the singer Amalia Rodriguez and her dramatic fado songs with the "zh" sounds of Portuguese, so close to yet so different from Spanish. Julie's aunt lived in a spacious apartment near Seventy-Second Street, and we were occasionally invited to spend the night there on weekends, away from the noisy Barnard dormitories. We luxuriated in our own private room where we could listen undisturbed to Elvis Presley's new hits, "Blue Suede Shoes" and "Heartbreak Hotel."

And I was now studying two languages: German with Megan's former teacher Mrs. Stabenau, who guided us through Lessing's sobering *Nathan der Weise*, and Italian with the vivacious Maristella Lorch. She dragooned her students into exciting commedia dell'arte improvisations on the stage of nearby Casa Italiana—associated in my mind with Lorenzo Da Ponte, who ended up in New York teaching Italian at Columbia College, his illustrious past as Mozart's librettist almost forgotten.

12

THE SUMMER OF 1955 before my senior year at Barnard was not spent back in sweltering Dallas, but in Europe and mostly in Italy. Nonna Maria, my recently widowed grandmother, was longing to see her five-year-old granddaughter Adriana, who had been born since our last family visit. Knowing we could endure the demonstrative, overly solicitous Nonna for only a few days, Tino devised the scheme of sending us "for health reasons" to Riccione, a peaceful seaside town on the Adriatic, with only a brief stop in Milan on the way. A leather-bound journal I kept during that eventful three-month sojourn was illustrated with earnest watercolor images highlighting the funny or cultural events of each day.

At Riccione we quickly established a routine of sunning, swimming, and playing anagrams, coming indoors only to eat or sleep. The beach chairs were all within unavoidable earshot of a loudspeaker system that blared "I Love Paris" relentlessly, and we were surrounded by Germans.

By the tenth unremitting day of sand and sunshine Megan could stand the vacuous place no longer. Spreading out a large map of

Europe on the floor, she invited us to help her decide upon the fastest sailing route from Riccione to Greece. As we eagerly studied the map, Megan suddenly gave a whoop of joy, and pointed to another spot on the map, saying: "Oh! Well, as long as we're going to Athens, we might just as well go to CONSTANTINOPLE; it's only a stone's throw away." Two days later, on the Fourth of July, we took an early morning train to Rome, deposited Adriana with a family friend, and headed for the Turkish Consulate, where Megan miraculously wheedled forth the necessary visas before our afternoon flight to Istanbul.

The next four days were spent exploring the exotic city that spans two continents, visiting museums and bazaars. In the covered Great Bazaar we acquired Turkish puzzle rings, which later became the bane of our trip, as Gian Paolo took them all apart and no one could put them together again. We bought intriguing spices at the Egyptian Bazaar and crossed the Bosporus by ferry for a stunning panoramic view of the city.

But the highlight of our stay was visiting the mosques that I had just learned about at Barnard—the multidomed one of Süleyman the Magnificent and the huge Hagia Sophia (disappointingly dark and faded inside) with its four framing minarets. Most stunning of all, behind an incongruous fountain given to Turkey by Kaiser Wilhelm II, was the Blue Mosque of Sultan Ahmed I. I sketched (FIG. 18) and rhapsodized about it in my diary:

> After slipping on some sandals over our shoes, a leather door covering was lifted up and we stepped into another world, a blue world. Turkish stalactites dip down from the dome into the corners and arch joinings and the whole of the interior is covered with inlaid tiles forming all known geometric and floral shapes, all done in a beautiful sky blue which at times seems to cut into and at other times seems to be oozing out of the white background of the walls and ceilings.

The entire stone floor is covered by Turkish rugs and the interior is cool and quiet. From any point the whole of the interior can be seen and hundreds of windows on the side walls, smaller domes and large dome let the daylight flood in and reflect the blue in a dazzling, shimmering way that defies looking straight at a window for more than a second. I did not have the audacity to try to think inside this building, I just opened all my senses and absorbed.

Early the next morning we boarded a small Italian ship, the *Barletta*, for an overnight voyage to Athens. By 8:30 that evening we were sailing through the Dardanelles strait and Megan reverently pointed out that Lord Byron once swam across this four-mile channel, the Hellespont.

Amazement overtook me when we reached the Acropolis. There in Pentelic marble were the edifices I'd studied in class—brilliantly white, standing out against a sky so acutely blue that it seemed to

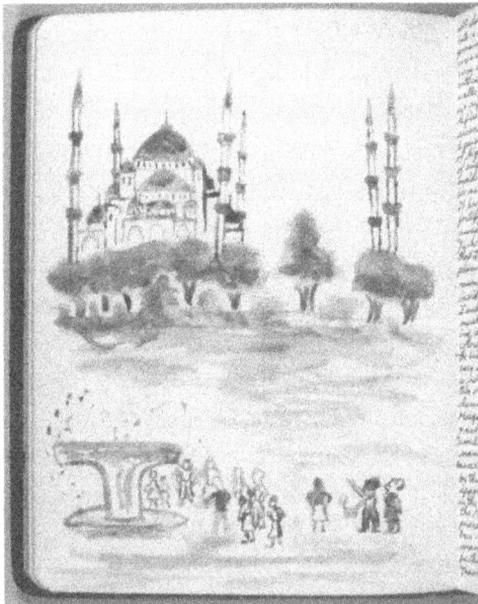

FIG. 18
Watercolor by the author of Kaiser Wilhelm II's fountain before the Blue Mosque. Istanbul, 6 July 1955.

nibble away at the massive columns. Now I could understand why the Greeks corrected this visual impression of concavity by endowing each column with that slight bulge called entasis. The Propylaia really was a functioning gateway, the Parthenon seemed enormous, and the Erechtheion with its caryatids was fascinating. We stayed on top of the rocky height all afternoon, drinking orange sodas and memorizing the near and distant pine-clad views.

That evening I curled up with a scary crime novel, *Donavan's Brain*, feeling that my own needed respite. We explored further afield the next few days, taking tours to other cities. As we piled out of our bus to hike up to the theater site of the ancient city of Corinth, a white-haired lady who remained on board lamented: "All my life I've wanted to see Corinth, and now I'm too *old* to walk around it." Her sad complaint haunted me, and I vowed that day to do as much traveling as I possibly could all my life.

A few days later our funds gave out, so Megan bought us return passage to Italy on a Greek ship, traveling fourth class at $30 a head. The food on board was fourth class as well (vile tasting eggplant), and after an overnight voyage we were happy to arrive in the port of Brindisi, guarded by old and new fortresses, and take the train up the boot of Italy to Riccione. We congratulated ourselves on having temporarily escaped our resort prison.

Back in Riccione ferocious anagram games helped pass the monotonous days until at last a black Lancia arrived from Milan with Tino and Cleto. By dinnertime my father had observed enough of Riccione hotel life to declare: "Let's get out of this place!" We made an excursion to Ravenna, where I admired the mosaics at San Vitale I had seen two years earlier, and again I was fascinated by the sly politics involved in the iconographical interplay between the local archbishop and the distant emperor. On the road back we stopped at Sant'Apollinare in Classe to admire the Ravenna sarcophagi. My Barnard art history classes were coming to life that summer.

As compensation for the Riccione "mistake," Tino offered to relocate us to another town for the rest of the summer; this time it was one he knew from personal experience—Stresa, up in the north of Italy on Lake Maggiore. But first we would make a brief excursion up through Austria to Heidelberg, Megan's and my romanticized goal ever since that beginning German class of the summer before. Our departure from Riccione a few days later was overshadowed by a cablegram from Dallas informing us that the director Margo Jones had suddenly died.

Reminiscing sadly about Margo on the long car drive up north, we stopped at Gardone to tour Gabriele D'Annunzio's intriguing if self-aggrandizing villa and amphitheater with attractive Lake Garda as backdrop. A motto emblazoned on the entrance gate read: "Io ho quell' che ho donato" (I have that which I have given away)—an eccentric aphorism I found intriguing and worthy of emulation. A magnificent circular mausoleum was being constructed above the villa to house the body of the great decadent poet who had in turn lavishly housed his car, warship, and airplane on the villa grounds. By way of Bolzano we drove farther north past snow-capped mountains to Innsbruck, encountering bands of boisterously singing students with feather-tipped hats who roamed the streets at night. Then, on to Munich.

Still badly scarred by bombing, central Munich in 1955 was a busy patchwork of temporary one-story cement buildings and historic monuments. I went to the Haus der Kunst, where artworks from the pulverized Alte Pinakothek had been moved, studying the German primitives up to Dürer. Then I walked into the Peter Paul Rubens room where I was instantly converted into an ardent admirer. It helped that Rubens was Dr. Held's subject of expertise and that I could recall what he had to say about the sensuous, opulently painted canvases, particularly *The Drunken Silenus*, which I later discovered had also impressed the young Picasso.

By the thirteenth of August we were in Heidelberg, toured the castle high above the city, took a boat excursion on the Neckar River, and listened with enchantment to a group of students singing "Ich hab' mein Herz in Heidelberg verloren." We wound back down to Italy by way of medieval Freiburg and the spooky Black Forest, then to Lucerne, where we bought cuckoo clocks. Here in William Tell country, Megan instructed Cleto to drive to the village of Altdorf, where the Swiss patriot shot the apple off his son's head. Then we descended through the breathtaking Saint Gotthard Pass to glistening Lake Maggiore.

We spent our final two weeks in Europe cheerfully installed at an old-fashioned lakefront hotel in Stresa. The array of art and architecture I had seen up close that summer was encouraging confirmation of my choice to pursue a major in the inspiring field of art history.

13

THE DEATH OF ALBERT EINSTEIN and a gripping performance of a new Broadway play, *The Diary of Anne Frank,* capped my junior year at Barnard, but I remember very little about my final year except for a demanding senior seminar in art history taught by Marion Lawrence. By then classes were of less importance than life, and much of my free time was spent in museums and used-book stores, at concerts and plays, or exploring Manhattan, especially the Village. The remainder of my time was taken up by Pierre Schoenheimer, a graduate student who spoke fluent French *and* German. He enjoyed the luxury of his own car and sometimes drove me out to New Rochelle for dinner with his parents. They got a kick out of placing Yiddish texts in front of me to read out loud, and we all laughed at my halting, incorrect pronunciation.

During my time at Barnard I had kept in close touch with my actor friends from Dallas days, George and Katie Mitchell. Their permanent home was a diminutive white house overlooking the Hudson River near Nyack, New York, and occasionally I was asked out for the weekend—a welcome relief from city life. They pointed

out the house where Helen Hayes lived, just down the highway, and I listened in admiration as every morning they rehearsed lines for one of their forthcoming plays. They both had to fly out to California for a television filming in May of my senior year, and I was offered not only their house but also their car. This vacation from Barnard, preparing for final exams and cooking exotic dinners, was a wonderful time before graduation.

Gian Paolo came up with Megan to witness the event and shyly stood between Isabelle and me as we posed proudly for the camera in our flowing black gowns and mortarboards. A few days later Julie Misrahi joined us for a train ride to upstate New York to visit Megan's "Professor Emeritus," Dr. Brewster, who had taught English at Barnard back in the 1920s. In retirement he had become an accomplished amateur painter, and looking at his landscapes reinforced my interest in making art as well as researching it.

I was back in Dallas for two weeks following the Brewster visit and participated in a street fair with several oil canvases and twenty watercolors; several of my "musician" portraits sold.

I was elated and added the money to funds my parents gave me for the next chapter in my life—graduate study at the University of Vienna. Julius Held had written ahead to two prominent colleagues there, Karl Maria Swoboda and Fritz Novotny, and I had been accepted for the fall term, which did not begin until mid-October. Megan and Tino arranged for me to sail to Europe on the S.S. *Constitution* out of New York. On 19 June 1956, loaded down with dozens of records and my flute, along with sage advice from Julius, I was seen off by my loyal Barnard friends Isabelle and Julie.

Grüss Gott Vienna

Eight days later I landed in Genoa, visited the Nonna in Milan for a few days, and then boarded the overnight train to Vienna—a

twenty-four-hour jerky trip via Venice. An amiable fellow Dallasite, Jimmy Mathis, who had been studying piano in Vienna for the past year, secured a room for me, and I headed straight there, filled with excitement and a little apprehension.

My living quarters on the corner of Argentinierstraße 2 in Vienna's Fourth District consisted of a single room, with communal toilet and bathroom down the hall. Boasting not only a comfortable bed, large, cozy couch, real fireplace, oil paintings on the wall, and a desk, it also contained a grand piano. But the best feature of this, my very first apartment, was the two sets of tall double windows that opened onto the Karlsplatz and Fischer von Erlach's Baroque masterpiece, the green-domed Karlskirche, with its twin Trajanesque columns on either side of the entry. The theatrical spectacle of the building with its exotic facade and great square full of people and cars held me in its thrall, and I spent hours propped up on the little mattress of my windowsill watching life go by.

Within the week I had bought my first car—a used white Fiat 1100 station wagon—and through the musical circle of Jimmy Mathis, I acquired a group of vivacious American and Austrian friends. I roamed all over the city and also explored the beckoning outlying districts—Hietzing, Grinzing, Beethoven's Heiligenstadt, Nussdorf, and the Kahlenberg summit with its panoramic view of Vienna and the Danube. Then, with some of my more adventurous new friends, I began to drive farther afield: Graz, Linz, Salzburg, Munich, where I hastened to see Rubens's *Drunken Silenus* again, and down to the Wörther See near Klagenfurt.

Recrossing the high Alps of the Hohe Tauern Range on our way back to Vienna, the little Fiat began to emit a terrible odor and belch black smoke, and then it came to a permanent halt. The car had not run out of gas; the motor, drained of its last remaining oil, had simply burned up. But no one had ever mentioned to me that

automobiles require oil as well as gas. We limped back by train, and before the end of September I had acquired yet another used car— an Opel Caravan station wagon complete with oil gauge—thanks to my parents' boundless patience.

I also acquired new lodgings. Tired of my niggling, nosy landlord and longing to be closer to the countryside, I joined forces with a piano student from Arizona, and on the first of October we moved into the second floor of a villa out in the northwestern Eighteenth District, at Bastiengasse 107. A glassed-in sun porch ran around the side and back of the house overlooking a garden with cherry trees, and our pianos and bedrooms were at either end. A few days after we moved into the villa Tino arrived from Milan to check on his daughter. Realizing with relief that my male housemate was gay, he approved of the new arrangement and took us to see a rousing performance of *Fledermaus*. Two days after he left Vienna it was time to register for classes at the university.

"Inscription," the procedure was called, and it was a mystifying ordeal for foreigners. I joined forces with an enterprising black singer, Doris Holland, and somehow we got through the trying initiation. My art history advisor, Gerhard Schmidt, whose field was medieval art, gave me a schedule that ran from nine in the morning until seven in the evening every weekday. I was enrolled in eleven different lecture courses. I was also required to take a pro-seminar with Dr. Schmidt and a Haupt Seminar with the illustrious Dr. Swoboda, who informed me that because my German was not yet fluent, he would wait to call upon me for a whole month—a kindness that kept my eyes fixed on the calendar.

Along with Doris, I had assigned myself extracurricular participation twice a week in the local Bach Society, and soon found the choir practice sessions far more stimulating than the dry lecture readings at the university. There, at the Kunsthistorisches Institut, the most exciting thing was a conveyer belt elevator called the

"Pater Noster" because that is whom you were likely to invoke as you jumped on or off a moving series of platforms that went upward and downward within an open shaft. Herbert von Karajan came to rehearse us for a performance of Handel's *Messiah*, and I was flattered to be among more than a hundred chorus members reprimanded by him for singing with too noticeable a Viennese accent: when we came to the opening phrase "Uns ist ein Kind zum Heil geboren" (the chorus "For Unto Us a Child Is Born"), he abruptly stopped us after the word "Heil" (salvation) and yelled indignantly that it was not to "Heul" (howling), but for "Heil" that the child was born.

After choir practice a group of fellow Ausländer (foreign) friends and I regularly went for egg rolls at an inexpensive Chinese restaurant on the Porzellangasse owned by convivial Dr. Chang. This became my second home, and by the time my birthday came around in November, Dr. Chang surprised me with a circular egg roll "cake."

Back at the university things were made a bit more palatable because Gerhard Schmidt took a bemused interest in me and invited me to visit a Heuriger tavern in Grinzing to taste the year's newly drawn-off wine. We were joined by some of his former P.O.W. friends (they had all been interned briefly as teenagers at the end of the war), and in the crowded garden a Schrammel-Quartet of violins, guitar, and accordion played nostalgic music. This was my first exposure to songs performed in Viennese dialect—the canorous nuances of which Melanie Schiele would later patiently help me acquire.

A week later I was happy to be chauffeur for a four-day research trip Gerhard and his assistant made to photograph medieval manuscripts at the Abbey of St. Florian near Linz. This was my first involvement with photography in the service of art history, and with growing respect I watched the two scholars at work with flood

lamps and tripod. A further treat was contemplating up close the monastery's celebrated altarpiece with evocative night scenes painted by the Danube School painter Albrecht Altdorfer in 1518. Driving along the Danube on the way back to Vienna, we stopped to admire the Baroque Abbey of Melk, perched high above the river on a cliff. It was a wonderful introduction to Austrian art and architecture under the guidance of my good-natured tutors, and probably I would have committed myself to medieval manuscripts or Baroque architecture but for the intrusion of a grim political event that affected us all.

Hail the Hungarian Revolution

During the Hungarian Revolution and its immediate aftermath, thousands of Hungarians flooded into Vienna fleeing the Russians who occupied their nation on the fourth of November in order to crush a mass insurrection. My diary entry of 30 October noted tersely: "Listened to radio about Hungary," and by the time I'd returned from Gerhard's abbey tour, the exodus was in progress.

Volunteers were badly needed to help feed and clothe the 5,000 new arrivals pouring over the border every night into Austria. Most of us students at the university stopped attending classes and began helping out at a clearing center in Eisenstadt and in a Quaker-initiated refugee camp near Vienna at Traiskirchen, distributing food and clothing. "Túl kicsi" I learned meant "too small" in Hungarian, and "Dohanyozni Tilos," "No smoking." Soon the International Red Cross took over, and we had hundreds of flannel shirts to give away. I always tried to find the warmest clothing to disperse, but one pretty girl to whom I had given an especially thick, bulky sweater waved it away with a frown. I stared at her uncomprehendingly for a few moments, then on sudden intuition asked, in English: "Sexy?" She nodded vigorously, yes! I offered her a thin pullover one size too small, and she grabbed it, beaming with pleasure.

FIG. 19
*The author and her Opel
Caravan station wagon fitted
out with a Red Cross banner.
Eisenstadt, 30 November 1956.*

An older man with a long, leathery face told me he was a poet, then lamented that his profession could do him no possible good outside Hungary—who can read Hungarian? Nevertheless, he maintained adamantly, it was impossible to continue living under the repressive Soviet domination. We had first conversed in German, then Italian, and finally he repeated his story in Hungarian for fellow Flüchtlinge (refugees). It was fascinating to see how his demeanor changed with each language: blurted monotone in German, with head hung down and arms flaccid; lilting and gesticulatory with eye contact in Italian; dramatic and self-assured in Hungarian, with head held high, eyes ablaze.

Because I had a station wagon and had "organized" an official red and white Austrian Red Cross banner (FIG. 19), I was able to drive right up to the Austro-Hungarian border at Nickelsdorf several times a week and bring back refugees to Vienna. From there they scattered to all parts of the globe, a few even to Dallas, as "relatives" of my family, whose surname—Comini ("Komini?")—sounded vaguely Hungarian to overworked Austrian officials. Those who did not leave Vienna immediately I introduced to my beloved Chinese

restaurant. Part of the forty-two page single-spaced typed letter I sent home describing everything I had witnessed was, owing to my mother's initiative, published in the 15 January 1957 issue of the *Christian Science Monitor*. Here is an excerpt:

> At the time I write this there seem to be almost more Hungarians in the city than Viennese. They are everywhere, on all the streets, walking aimlessly up and down, crowding around the newsstands when a new edition of the paper *Hungaria* comes out. They have money for nothing else, but they miraculously acquire enough to buy the Hungarian paper. It is the first truth they have read in 11 years, as one of them told me.
>
> People planning to escape from Budapest follow their normal pace of life for a few days, so as not to arouse any suspicion, and then suddenly, without saying good-by even to their closest friends or neighbors, and without taking a single thing with them—they don't dare wear even an extra jacket, so as not to attract attention on the street— they go out for a stroll, which ends up at the train station. There they get on the train and ride out of Budapest as far as the trains can take them. Because everyone, from porters to engineers to brakemen, is a collaborator, the Russians would have to replace them all before there could be any checking the exodus. I asked if there were a big black market on train tickets. No, on the contrary, no one even had to buy tickets. Everyone just got on the trains until there was no more standing or holding-on room, and then the trains pulled out.

The jarring encounter with real life forced on me by the sobering events in Hungary changed how I felt about the study of art history. At the university our classes were all about cultures of the past, and here I was witnessing a traumatic, important, living *present*. My diary for the end of 1956 contains a passionate outburst,

written in Italian for greater import: "ALLORA, lo studio della storia dell'arte *non* sarà la mia vita." (Well then, the study of art history is *not* going to be my life.)

How wrong I was! Art history *would* be my life, but only after more enriching detours and then finally only on my own terms—colored by the desire always to recognize and seize upon connections between past art and life *now*. I have managed to make these links, and now my parting words to classes at the end of each semester are: "Remember not only how much you have learned about art history, but also how much art history has taught you about the world, about others, and most especially... about yourself."

The Spanish Civil War and the Hungarian Revolution certainly were the two political upheavals that most affected my life. And music was the constant that sustained and connected the chapters.

Although I dropped out of the University of Vienna in 1957, my education continued in double-quick time as I spent the next seven crammed months devouring Austrian newspapers over breakfasts at a café near the Opera House, exploring secondhand-book stores, art galleries, and museums during the day, playing the flute and continuing to sing in the Bach Gemeinde in the early evening, and going to concerts, operas, and the theater at night. Dramas I had found weighty in German class at Barnard now sprang to life at the elegant Burgtheater on Vienna's Ring: Goethe's *Iphigenie in Tauris*, Lessing's *Nathan der Weise*, and Schiller's *Maria Stuart*. I attended a riveting German-language production of Eugene O'Neill's *Long Day's Journey into Night*, and a volume of his complete plays became my bedside table companion, along with a pocketbook edition of Mozart's letters in lively, slightly off-color German.

I heard established singers like Elisabeth Schwarzkopf and Erna Berger, and young pianists like Jörg Demus, Paul Badura-Skoda,

and Friedrich Gulda in solo recital evenings, and became an ardent fan of both Karl Dönch and Christa Ludwig in their weekly appearances as Don Bartolo and Rosina in *The Barber of Seville* at the intimate Redoutensaal Theater. I went to every performance, bought and memorized the German libretto—charmingly cumbersome compared to the more liquid Italian—and photographed scintillating moments in the opera from my front-row seat so faithfully that one evening Christa Ludwig patiently held her final bow for my upraised but not quite ready camera (FIG. 20).

Not once during all this exposure to the cultural life of Vienna did the name or work of Egon Schiele enter my consciousness. He had not yet been discovered by the art history establishment, or by me.

Twice I broke away from Vienna to visit the Nonna briefly in Milan. Compared to drab postwar Austria, Italy seemed extraordinarily colorful and relaxed. On my second visit, in May 1957, Tino also arrived in Milan from America, bearing novel gifts such as roll-on deodorant sticks and multivitamins. Visiting various museums in Milan, especially the Brera, and adding to my growing library of art books and postcards from museum stores, I began to feel the lure of art history again. When I came across a reproduction of Angelica Kauffmann's *Self-Portrait Hesitating between the Arts of Music*

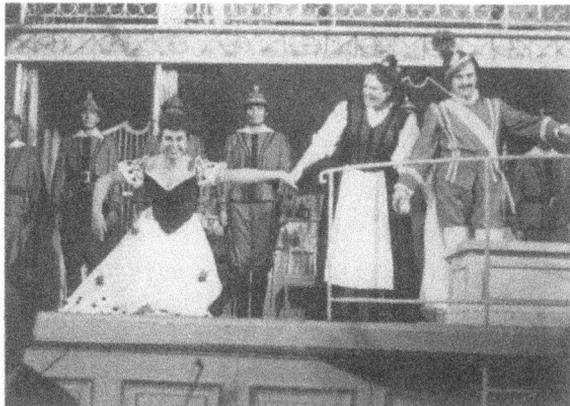

FIG. 20
Mezzo-soprano Christa Ludwig as Rosina in Rossini's The Barber of Seville, *prolonging her final bow for the author's camera. Redoutensaal Theater, Vienna, 14 June 1957.*

FIG. 21
Angelica Kauffmann,
Self-Portrait Hesitating
between the Arts of
Music and Painting,
ca. 1760, oil, Yorkshire,
Nostell Priory.

and Painting (FIG. 21), I recognized myself in the eighteenth-century artist's dilemma. Talking this over with my father, a plan was hatched that I would return to America in August, study languages, and look for a job in New York.

A month later I was back in New York sharing an apartment with Isabelle on 108th Street off Broadway not far from Barnard. The Shanghai Restaurant on Broadway near 125th Street became my new second home, and I began interviewing for jobs.

At home over the Christmas holidays and still without a job, I had a searching talk with Megan and Tino about my future. They suggested not going back to New York but instead making a new start on the other side of the country. How about California, perhaps San Francisco. Apologetically, I telephoned Isabelle with the news I wouldn't be returning to New York. My parents staked me to an airplane ticket and one night at the Sir Francis Drake Hotel in the heart of downtown—after that I would be on my own. With tremendous excitement I began, eleven days into the year 1958, the next chapter of my life, one that would be dominated by one of Angelica Kauffmann's two choices—music. But never could I have predicted what sort of music. Or that I would ultimately exchange it for art history.

14

MY FIRST DAY IN SAN FRANCISCO was spent looking for an inexpensive place to live and the second day in search of a job. By the third day I was successful in both quests. There was an opening at the attractive, Spanish-style YWCA residence. And one of the two positions an employment agency sent me to interview for came through. I would begin in one week as secretary at a placement service for physicians, West Coast Medical Agency on Market Street, for the huge sum of $300 a month. I applied for a social security number and while waiting for the job to begin explored the length and breadth of the city, bought some flutelike instruments in Chinatown, and discovered a movie house that showed two films for the price of one. I saw fourteen absorbing movies that first week in California while devouring popcorn dinners.

By the second week I had met so many interesting girls at the YWCA that movies were replaced by long meals with prolonged after-dinner coffee, intense talk, and anagrams. Soon I had formed an inner circle with three comrades: Dolores Schumacker from Mississippi, Silvia Torre from Ecuador, and Lili Jensen from

Denmark. Dolores and I painted competitive oil portraits of Lili with her long blonde hair, and mine, à la Picasso, showed her with two heads.

When I received my first week's paycheck for $56.88 I invested a portion of it at a used LP warehouse called, seductively, *Sea of Records*. I also heard Emil Gilels play a concert, went to an Italian *carnevale* in Washington Square, and witnessed the pyrotechnical Chinese New Year Parade along Grant Avenue. At work my boss complimented me for catching on quickly, and I applied myself with gusto to the task of typing and mimeographing physicians' résumés.

Meanwhile, I was filling up my room at the YWCA with more LPs and metal shelves, as the collection I'd left in New York caught up with me. Lili was teaching me Danish—an intriguing language punctuated by glottal stops. This first exposure to things Scandinavian would later propel me into becoming knowledgeable enough to teach and write about Scandinavian art.

Easter vacation brought me home to Dallas on a whirlwind visit and I received a grand gift from my parents: a 1955 green and white Ford Victoria with an extra wheel mounted on the rear. Back in San Francisco life expanded. Every weekend Dolores, Silvia, Lili, and I took off in the car to explore wondrous new places like Yosemite, Death Valley, Crater Lake, Virginia City, and spectacular Lake Tahoe. During the workweek I spent my lunch hour haunting *Sea of Records* and cramming my room with more bargain finds until the floor began to sag under the weight. The director of the residence club called me in: I would either have to divest myself of some of those albums or move.

Lili shared my indignation, and we decided to search for an apartment. Within days we found an attractive three-room dwelling with garage and an upright piano at 2085 Sacramento Street. We rented a television set and had the piano tuned. I set up

a little painting area in the living room and worked there in the evening. But soon this activity would be overshadowed by an unanticipated turn of events.

"Un bel dì" my diary designated the eighth of September that year. Exploring a downtown pawn shop during my lunch hour, I bought a classical guitar—case and capo were thrown in for free, all for $20. I hunted down some instruction booklets and set about learning the guitar. Henceforth my evenings were dedicated less to painting and more to figuring out chords and strums.

I became interested in folksingers like Pete Seeger, Burl Ives, Josh White, and Odetta, and began collecting their recordings. But I was spellbound by a record I found featuring Cynthia Gooding singing Turkish, Spanish, and Mexican songs. The songs were stirring and diverse; the plucking and rhythms exciting. It took weeks, but I learned every one of them, even the mysterious Turkish numbers. I didn't realize it yet, but I was preparing myself for a career as folksinger.

Mexico

My parents invited Lili to come to Dallas with me for Christmas that year, and she survived the experience of a Texas/Italian family holiday with hush puppies for breakfast and gnocchi for dinner. Her worker's visa expired in two months, and she would have to leave America, she told us sadly. As always, my parents had a creative suggestion. Why didn't the two of us go to Mexico to live for a while? No visa needed there. We could get by inexpensively and study Spanish, and I could find a guitar teacher. Despite the fact that I had just received a $25 raise back in San Francisco, the lure of living in a foreign country proved stronger than the daily grind at the mimeograph machine.

At the end of February, a Mayflower truck picked up our belongings, including my large hi fi record player and fifteen crates of LPs,

and we headed for Dallas by way of a leisurely tour of Southern California, the Grand Canyon, and New Mexico—my first exposure to Georgia O'Keeffe country. As it was considered dangerous for foreigners to drive in Mexico, we left the car behind, and on the eighth of April 1959 my parents deposited us at the local Greyhound Bus Station for the two-day trip south to Mexico City.

And so a new epoch began, filled with daily Spanish lessons at a downtown Berlitz School and amplified by investigation of the sprawling city. I was enchanted by Diego Rivera's extensive murals in the National Palace—so crowded with people and motifs yet so instructively fathomable. I didn't find a guitar teacher, but every evening typed up the lyrics and worked out the chords to more songs. I became acquainted with the piquant mixture of folk and fantasy motifs I would later encounter in the work of Frida Kahlo. The rows of shriveled mummies at Guanajuato, irreverently bounced around by our jaded guide, haunted my dreams for several nights, and I gained a greater respect for the hold superstition has on folk imagery and song. All of these colorful early experiences would influence the decision to include Mexican art in my survey classes later at Columbia University—something not done in those days.

In July we took a leave of absence from Berlitz and traveled to the seaport city of Veracruz, then by slow train through the jungle to the Yucatán cities of Mérida and Progreso. We visited Mayan ruins and climbed the pyramid at Chichén Itzá, but by August it was time to return to the States, as Lili had to sail for Copenhagen.

New York

I drove Lili to New York and saw her off on the S.S. *Gripsholm*. Then I decided to stay on, as almost immediately a fascinating job came my way: working at the Columbia/Princeton Electronic Music Center for the Russian composer Vladimir Ussachevsky—a professor of music at Columbia University and a colleague of my former

composition teacher Otto Leuning. My job was to take dictation at random times from Ussachevsky (adding the definite articles he left out) and, during regular working hours, to build up a tape library of the thousands of tones and noises extractable from the RCA Sound Synthesizer housed at the Center on 125th Street and Broadway. Milton Babbitt from Princeton was a regular user of the synthesizer, and a number of distinguished visitors came to see the Center, including, on 9 November 1959, two composers from Russia: Dmitry Shostakovich and Dmitry Kabalevsky. Ussachevsky greeted them in florid Russian and demonstrated the synthesizer's amazing abilities, and then we served hot tea in glasses. The two Dmitrys were enchanted by this Russian gesture and expressed their relief at not having to consume yet another American cocktail.

Once again I shared the apartment on 108th Street with Isabelle, who was yearning to earn a living in music. Encouraged by Ussachevsky, she decided to apply for a Fulbright to study organ in Germany and we spent several evenings recording her audition tapes on the St. Paul's Chapel organ, tapes that Ussachevsky with his technical expertise made sure were faultless. Back in our apartment almost every night we worked our way through Bach and Handel sonatas for flute and piano.

Still intent on practicing the art of painting, I rented a small room in the apartment house directly across the street where I set up a studio and worked every day, producing cheerful images of animals and musicians. The building superintendent, a young Canadian named Jack O'Field, struck up an acquaintance and initiated me into the funky delights of playing the five-string banjo. I pondered just what it was in life I really wanted to do—perhaps become a folksinger? Isabelle was intrigued as well, and we began to spend evenings learning to play the five-string banjo and the twelve-string guitar under the tutelage of Jack and his even more talented roommate, Patrick McKelvey—whom Isabelle would later marry.

Making art meant looking at art, and I explored the New York museum and gallery world with new appreciation. Herbert Mayer, owner of World House Gallery, a short-lived establishment stocked mostly with his personal collection of works by Paul Klee, invited me to drive upstate to Colgate College with him to hang the Klees in a loan show. This exposure to the artist's technical wizardry roused me to experiment with different shoe polish rubbings on glossy paper, mining nascent images through layers of color with the tip of my brush. New images in oil began to adorn our apartment—an oboe player, an organist—and this musical theme was further enhanced by the gift of a balalaika from Mr. Mayer and the loan of a string bass and drum set from other friends. Jazz and blues sounded alongside Bach and Handel.

Vladimir Ussachevsky had been born in Manchuria and could speak a clipped Chinese to the waiters at our favorite Shanghai Restaurant. He told of making hoards of dumplings during the winter and burying them in the snow, where they could be quickly dug up, fried, and served to visitors. Everything was always in crisis mode with Vladimir, and my time was continuously subject to "emergency" errands and meetings. Sometimes we would edit his tapes until four or five in the morning. Vladimir was twenty-three years older than I and a huge bear of a man, but in his helplessness concerning practical matters he was irresistible. In March 1960 one of his electronic music pieces was to be performed by Leonard Bernstein and the New York Philharmonic, and my job expanded to mimeographing orchestra parts, helping place speakers at the television rehearsal in Carnegie Hall, and splicing tapes of the concert.

Scandinavia

By August, spurred on by the affecting music I'd heard on a brief vacation with Vladimir and my family in Jamaica, I decided I would

become a collector of folk music like the great American scholar Francis James Child. But I would do it in Scandinavia with Lili as my guide. Isabelle was off for a year of study with the organist Helmut Walcha in Frankfurt. My brother was also in Germany, stationed at a U.S. Army base near Stuttgart. So there were many reasons to return to Europe.

On the fifth of August 1960, armed with flute, guitar, five-string banjo, and a Tandberg tape recorder, I sailed for Copenhagen on the S.S. *Kungsholm*. My self-assigned mission of collecting and learning folk music from different countries kept me occupied in Europe for an entire year and exposed me to quite a number of major and minor museums. After several weeks inspecting the sights in and around Copenhagen, Lili and I picked up an Opel station wagon in Frankfurt, visited my brother and Isabelle, and then began an ambitious Scandinavian odyssey. We visited Lili's parents in Århus and crossed Denmark from west to east, with a stop at Hans Christian Andersen's birthplace/museum in Odense. We drove up through Sweden to the university town of Uppsala, where August Strindberg had been so unhappy as a student, and back down to Stockholm. There an Ingmar Bergman movie festival was in full swing, and I fell in love with the lilting cantilena of the Swedish language.

From Stockholm we boarded a huge car ferry for the overnight crossing of the Baltic Sea to Finland, land—literally—of thousands of lakes. We explored Helsinki for a few days (I learned that all Finnish words are pronounced with the accent on the first syllable, thus *Hel*-sinki), and then, under the uncanny illumination of the September aurora borealis, headed north by way of Turku, Tampere, and Rovaniemi, where local police insisted we overnight in their small station house rather than camp out at a park.

There was one recurring staple on the bewildering restaurant menus in Finland: "opperraburger"—hamburger with fried egg

on top—and we gratefully ordered it for breakfast, lunch, and dinner. A genuine Finnish word we relished saying was "Suomi," the country's name in Finnish. To hear a Finn pronounce that word was quite moving, as it always seemed to be uttered with such affection, even by the somber band of Gypsies with their horses we encountered crossing one of the lakes on our ferry. We headed north beyond the Arctic Circle because I was eager to visit a Lapp village and tap into a possible folk song tradition. The village of ten uncommunicative people was a disappointment, but it was thrilling to come upon Lapps walking along the highway in their fur-trimmed leather clothing and to see their herds of reindeer.

After crossing the Finnish border into northern Norway, we finally reached our goal, Hammerfest ("verdens nordligste by"—world's most northern city). The only folk music I was able to hear was sung by two Israeli lodgers at the local youth hostel, but we explored the rugged fishing port with shop facades painted in cheerful, primary colors and scrutinized the local catches of fish. My own Hammerfest catch was not fish but a warm duffel jacket with drawstring hood, my uniform for the following months.

Our next destination lay hundreds of miles to the south, Bergen—birthplace of a prodigious collector of folk music, Edvard Grieg. The long trek down the western coast of Norway with its steep fjords led us to a mystery of nature that happens once every few years: a lemming migration. There were so many thousands of the small furry rodents making their suicidal dash across the highway to the sea that they formed a dark river of tremendous force. Our station wagon was literally lifted up and carried a few inches toward the North Atlantic before we were able to drive beyond the mighty current! When we finally found a hotel in Mo i Rana, dozens of little corpses littered the entrance.

We continued to descend southward, sometimes by ferry, admiring from the heights of the small mountain Akslafiel the town of Ålesund with its fishing boats tied up on the main street. The mountain roads became even more dramatic as we neared Bergen by way of the great Hardanger Fjord. Grieg's picturesque hometown lived up to its reputation, with an odiferous fish market surrounded by the multihued houses that distinguish former Hanseatic league towns.

A few days later we reached Oslo. There we took in cultural institutions ranging from the Kon-Tiki Museum to the city's impressive National Gallery with a whole roomful of paintings by Edvard Munch, whose angst-filled images I would later realize had a tremendous impact on Schiele. One evening we attended a performance of Henrik Ibsen's *Hedda Gabler* at the National Theater, and I was elated to discover I could understand much of the dialogue. What I could not yet possibly know was how often I would revisit Oslo for rewarding research on Munch and Ibsen.

Italian Intermezzo

In mid-October I flew to Milan for a reunion with my father who was once again visiting his mother. In that foreign, agitated Italian atmosphere ("SUONA il telefono!" the Nonna would shriek helplessly any time the phone rang), Tino and I got an attack of American nostalgia and found ourselves composing what in those days were called Negro Spirituals—he on mandolin, I on guitar. We wrote down music and lyrics to songs with titles like "God Gave Noah the Rainbow Sign," and a few months later the Bishop College Choir of Texas recorded our songs for an album entitled *Comini Spirituals*, overenunciating all the words we had found so genuine when sung with dropped "-ings." We also designed a new sort of mandola with an extended sounding board shaped somewhat like a snail and commissioned a luthier to build

it. The "snail" mandola became the logo for a second record of our compositions, recorded by Gian Mario Guarino and his orchestra in Milan.

Pausing in Holland and Belgium

I returned to Denmark equipped with sheet music from Milan's great music store Riccordi, then, traveling through Germany, Holland, and Belgium, Lili and I headed to Paris, where we intended to live for a few months studying French. The bustling city of Amsterdam held us for a week, as we visited the Rijksmuseum, Rembrandt's House with the artist's etchings intimately displayed, and the Anne Frank House. There I was aghast to observe a group of bored Dutch schoolgirls being led on a tour. They were teenagers, about Anne Frank's age at the time she died, and I quietly expressed my surprise at their blasé attitude. Their teacher sighed and said it was often this way on school tours—the students simply did not want to hear anything about how life was during the war. However, a few years ago things had changed. When I returned to the Anne Frank House it had annexed an adjacent building in which visitors were guided into a "room of tolerance" with video images of people being turned away from local night spots based on how they looked or dressed. This contemporary example seemed to hit home with the new generation of now-solemn students touring the house.

Amsterdam was also a convenient base from which to explore other cities richly endowed with art, and we traveled to museums in Utrecht, Leiden, The Hague, Delft, and Rotterdam to admire the Dutch masters. I also came away with some promising collections of Dutch folk songs.

In Belgium we visited Rubens's ornate house and spacious atelier in Antwerp and studied the precision of early Flemish painters at the Brussels Museum. We traveled to the seacoast town of

Ostend to gape at the crowded studio of James Ensor, the reclusive forerunner of Expressionism who had spent his life above his mother's souvenir shop painting grotesque carnival figures. And then, driving on to Ghent, we marveled at the Van Eyck brothers' crowded *Adoration of the Lamb* altarpiece. In Ghent I dropped a postcard to my parents into what I thought was a mailbox. It arrived one year later—the receptacle was a fire alarm.

Paris

"Alooo, coooookie!" a friendly guard waved us through at the French border and we spent a day admiring the portal sculptures of Amiens Cathedral. Then on a chilly winter day in early November we drove into the heart of Paris, past the Arch of Triumph and down the crowded Champs-Élysées, searching for Charles Trenet's Ménilmontant district until I came to a stop in Montparnasse.

Wearing my Hammerfest duffel jacket with its fur-trimmed hood over my head, I entered residential hotel after hotel, inquiring about long leases. My command of French was poor, but my sense of dignity abundant and this combination led to an unfortunate impasse, since every time I asked the rental price for an attractive-sounding apartment, I would be told the figure, and then, without fail, the proprietor would immediately address me in the intimate "tu" form, asking if I understood. Taking instant umbrage because of my advanced age, I indignantly walked out each time, not realizing that what sounded to me like "tu comprends?" was actually "tout compris" (everything included).

The last hotel had a revolving door that thrust me back inside the lobby, occasioning hysterical laughter on the part of the hotel personnel at the reappearance of the pointy-headed sight I presented. Not until the next day, with indignation replaced by mortification, was I able successfully to negotiate, in yet another Montparnasse hotel, for an apartment. It had two bedrooms, a kitchen, and a bath-

room, all for $133 a month, *tout compris*. Our address for the next four months would be 207, boulevard Raspail. It was practically across the street from number 242, where Picasso had lived with a view of the Montparnasse Cemetery out his back windows.

The next few days were spent settling into our new lodgings while I typed a twenty-page letter to my parents with carbon copy to Ussachevsky recounting our Scandinavian adventures. Then a regular schedule commenced: Berlitz French lessons; museums; opera; ballet; exploration of the city by foot, metro, and car; movies; flute, banjo, or guitar practice; and the typing out of the words to new folk songs and the tape recording of perfected ones. For Christmas Lili and I traveled by train to Milan, where, to the delight of the Nonna, we were joined by Gian Paolo and Isabelle for a most musical Christmas, as we had all brought instruments with us. It had been a wonderful year.

Prague

Equally wonderful was the following year, 1961, as my pursuit of folk music continued in other cities and countries. In February Lili and I were in Frankfurt visiting Isabelle. I strove to expand my repertoire of German songs, some accompanied on guitar, others on the five-string banjo. March found us behind the Iron Curtain in Prague, where Lili's sister Rita was working for the Danish Embassy. Loudspeakers were everywhere, blaring out political messages, and anywhere we parked the car, with its USA emblem, a small crowd gathered to gape at us. Rita's office and apartment were bugged, so if we had something controversial to say, we said it over the flushing of a toilet. Despite the drabness of the city under Communist rule, there were some colorful aspects, such as Gypsies and the National Pawn Shop, where I succumbed to a lute guitar and a bass lutina for $24—trophies for my folk music collection.

Two sights in Prague have lingered long in memory: the beautiful Charles Bridge with its twisting Baroque statues spanning the Moldau—that river portrayed in Bedřich Smetana's surging tone poem, *Ma vlást*—and the Old Jewish Cemetery, crowded with multilayered graves and sagging, tilted tombstones. It had been left intact by Hitler as example of an "extinct race."

Reentering Germany a few weeks later, we had a suspenseful moment at the Czech border when my copy of Ayn Rand's *Atlas Shrugged* aroused the suspicion of a guard, but finally we were waved across and returned to Frankfurt with my two new string instruments. In the meantime, Patrick McKelvey, loaded down with guitar and banjo, had arrived from America, and he and Isabelle had gotten married. The rest of our Frankfurt sojourn was consumed by working up a joint repertoire for the folk music café we might open in America someday. But not before Lili and I fulfilled our final project of touring the British Isles in our quest for authentic English folk music.

London and Beyond

On 26 March 1961 we took the car ferry from Ostend to Dover and a few days later were comfortably installed at $84 a month in two sunny front rooms of a private home in southeast London. That week we saw the play *Ross*, about Lawrence of Arabia, and a lively South African musical *King Kong*, the infectious theme song of which I still remember—"That's me, I'm he, King Kong." We visited various museums during the day and went to the theater or concerts at night. The bookstores on Charing Cross Road were an exciting discovery, especially huge Foyles, where I invested in my own copy of Cecil J. Sharp's *One Hundred English Folksongs* and set about learning some of the ballads. But my favorite browsing area was semirural Hampstead Heath on the outskirts of the city, where both Keats and Freud had lived. (Their homes now provide intriguing didactic displays.)

Short trips to the bookstores of Cambridge and Oxford yielded more musical finds, and by May we began an ambitious car trip that took us through Wales, across by ferry to Ireland—where the drabness of Dublin contrasted sharply with the colorfulness of the speech—then back to England and up through the Lake Country to Scotland and Loch Ness. At Inverness I bought a set of bagpipes and was sent for instruction on how to play them to the "keeper of the castle." Continuing up to Thurso and the northernmost tip of the island of Great Britain, we sailed across to Kirkwall on the treeless Orkney Islands where we saw Bob Hope in the film *Paleface*—welcome comic relief from the somber stone tower remains dotting the cheerless, rainy landscape.

A sunny exception greeted us down south in Cornwall, however, when we explored the little harbor town of Gilbert and Sullivan fame, Penzance, the castle on Saint Michael's Mount, and craggy Land's End. Thirty-four years later, in pursuit of women artists rather than English ballads, I would return to Cornwall to linger in the picturesque artists' colony at St. Ives with its green lookout hill. I inspected a newly opened branch of the Tate Gallery and admired the studio and sculpture garden of Barbara Hepworth. Her solemn work, when viewed in its barren, rocky Cornwall context, seems innately tied to the prehistoric menhirs dotting the peninsula's weathered headlands.

By the end of June 1961 we had returned to Europe and were engaged in a tour of the museums and sights of the two Berlins. The Berlin Wall had not yet gone up, and one could easily walk unchallenged into East Berlin, still full of World War II rubble. It was there that the newspapers of 2 July headlined the news of Ernest Hemingway's death—an event that seemed to bring all Berliners and tourists together. But soon it was time to go back to America. On 31 July I sailed from Bremerhaven for New York and continued straight to Dallas, eager to initiate my new profession as

folksinger. And, indeed, I was hired for a few gigs. The owner of one club was an enterprising singer named Ron Shipman, and by the end of the year we had teamed up as a musical duo, working out rousing versions of old chestnuts like "Joshua Fit the Battle of Jericho." Our New Year's resolution was to assail the walls of one of the country's fabled folk music venues, the Purple Onion in San Francisco. "All this is yours," my little sister printed on a note she left with her piggy bank on my bed, when she overheard our parents talking with me about funding for the California trip. I had discovered the note soon after she'd gone to sleep, but many hours later when I went to bed, the note and piggy bank were gone— Adriana had changed her mind.

San Francisco

Ron Shipman, his wife, and I departed for San Francisco at the beginning of February 1962—the year that would witness my metamorphosis from folksinger to art historian.

The transformation was hastened by the fact that a case of poison ivy contracted during a roadside picnic on the drive to San Francisco so completely swelled up my eyes, nose, and mouth, that our audition at the Purple Onion had to be cancelled. The Shipmans, intimidated by the bustling Bay Area, returned to Dallas but I remained, trying to figure out how to make a living in folk music. I had a thousand blue mailers printed up announcing the existence of "The San Francisco Folk Music Society" and advertising my availability as guitar/banjo teacher, folk song entertainer, and organizer of hootenannies. The mass mailing brought a few results, including a gig at the Fairmont Hotel's Tonga Room, a friendly phone call from Lee Hayes of the Weavers, and six earnest guitar students.

My corner apartment at 1400 Sacramento Street was ideal for giving music lessons and had plenty of space for a painting studio

as well. I applied for temporary work as a Kelly Girl and was assigned a hectic but enjoyable job booking passengers on the S.S. *Yarmouth* for cruises to the World's Fair in Seattle. I liked the work, often labored overtime at the exciting rate of $3 an hour, and was soon hired full-time at $450 a month as "head berther," training other bookers.

And yet when I saw an advertisement in the newspaper for a position teaching art history at San Francisco State College, I applied for the job. After all, I'd been an art history major at Barnard and had visited many major museums in Europe. The four professors who interviewed me couldn't have been nicer, but they kindly informed me that other applicants had master's degrees and were therefore more highly qualified. I was chagrined: why, after dropping out of the University of Vienna during the Hungarian Revolution, had I never even *thought* of returning to academia for a master's degree?

15

It was this revelation that propelled me to enter graduate school at the University of California in Berkeley in the fall of 1962. I signed up for a variety of classes and seminars, but with a concentration in medieval art. Two distinguished heavyweights in the field—Jean Bony from France and Walter Horn from Germany—offered an intriguing, yearlong joint seminar on the circle versus the square in architecture, beginning with Early Christian and ending with Gothic churches. Each student was to present two reports, and mine was the first one. It was a disaster, as I literally looked for decorative circles and squares, not realizing we were supposed to address them as modules in the bay systems that ordered the interior space.

I was allowed to redo my paper and made up for the blunder in my second report, but I fretted for quite a while that perhaps, at the advanced age of twenty-eight, my brain was already deterio- rating. At a cheese-and-wine party given by our professors one of the female students tipsily confided to a few of us: "I don't want to *be* an art historian; I just want to *marry* one." Her frank admis- sion appalled me, but I certainly empathized with her apprehen-

sion, especially under the brilliant but arcane guidance of Bony and Horn.

Nevertheless, feeling increasingly at home in the medieval field, I began during the spring semester at Berkeley in 1963 to formulate my master's thesis topic on the face of Christ. But it was another face, the tormented one of Egon Schiele's in that modest campus exhibition of Viennese Expressionist drawings, which would henceforth hold my unswerving gaze. Art history became my life, morning, noon, and night. And eventually it assumed three different forms: traditional, revisionist, and, in a return to my other love, musical iconography.

Schiele Sitters

In Vienna, after my discovery of Schiele's prison cell in 1963, I realized that even though forty-five years had gone by since the artist's death, some of his other sitters were still alive and ought to be interviewed. In fact I had already consulted one of them—the formidable former director of the Albertina Museum, Otto Benesch, who still prowled the museum halls with stacks of books under his arms.

Otto Benesch

During the extended interview he gave me concerning his experiences with the artist, I noted that Otto Benesch had lost none of the bony, slender height indicated in Schiele's portrayals. To my query about whether Schiele was political, he responded: "No, none of the artists of that time were seriously interested in politics—with the exception of Oskar Kokoschka, who was really serious and acted with extreme courage during the war. Schiele was not a socialist; he sometimes depicted but did not crusade for the poor."

Only in one area did I later disagree with this distinguished Rembrandt scholar who through his writings had introduced Schiele to an international public. That was concerning the possible influ-

ence of modern dance on Schiele's pantomime-like gesticulation in his photographs and self-portraits. Benesch, thinking perhaps of the flowing Art Nouveau lines of the waltzing Wiesenthal Sisters, who were all the rage in turn-of-the-century Vienna, said no. But I found a convincing parallel between the angular movements characterizing Schiele's self-portraits and those of the contemporary Expressionist dancers Harald Kreutzberg and Mary Wigman.

Friederike ("Fritzi") Maria Beer-Monti

By far the most informative of Schiele's sitters was Friederike Maria Beer-Monti. Her life-size oil portrait had been painted by both Schiele and Klimt—and in that order, as she emphasized to me when I first visited her on 23 August 1963 in the large apartment that her family had owned since 1904. Daughter of the prosperous owner of two stylish nightclubs and schooled in Belgium and England, she was a member of Vienna's artistic elite and deeply involved in the cultural life of the city. To my question as to what Schiele was like, she answered readily, "He was tall, thin, shy, and quiet. He spoke with the Viennese intonation but not in heavy dialect. He dressed normally but even so he stood out in a crowd. One could tell there was something unusual about him: that fantastic head of hair! Those outspread ears! He really appeared rather spectacular."

"Fritzi," as I was soon asked to call her, also described her own spectacular way of dressing during those pre–World War I years. She wore exclusively the hand-printed geometrical style fabrics created by Vienna's fashionable arts and crafts studio, the Wiener Werkstätte. "I was so wild about their products that every single stitch of clothing I owned was designed by them." This preference for the decorative style provided motific foil in both Schiele's and Klimt's images of her, and Fritzi's vivid reminiscences of the sittings proved invaluable for my understanding of the two dramatically

FIG. 22
Richard Martin, Director of the Costume Institute at New York's Metropolitan Museum of Art, and the author examining the "Turkish bloomers" worn by Friederike Maria Beer-Monti in Klimt's 1916 oil portrait of her. November 1995.

opposed portraits—Schiele's of 1914, all angst-filled psyche; Klimt's of two years later, all immobile, sumptuous facade. Fritzi later gave the pair of black, blue, and white Turkish bloomers she was wearing in the Klimt portrait to the Costume Institute of the Metropolitan Museum of Art. Years later, thanks to the intervention of a former Columbia classmate, Richard Martin, who had become director of the curatorial department, I photographed Fritzi's gift. Gingerly handling the garment with white gloves, we discovered that it still bore the distinctive Wiener Werkstätte label (FIG. 22).

Mrs. Beer-Monti lived in New York City's Greenwich Village and was visiting Vienna when I first met her. After I began teaching at Columbia we often saw each other, and just as I had done with Melanie, I was able to show her the photographic material for my dissertation on Schiele. Some additional material and a great deal of helpful information was provided by this lively woman who still dressed dramatically (now in Hawaiian muumuus) and was still so committed to the art of "just LIVING."

Eva Steiner Benesch

Back in the halls of the Albertina during the fall of 1966, I met a third Schiele sitter, Eva Steiner, the widow of Otto Benesch. As a

little girl she had been sketched by the artist but was not particularly interested in recalling the experience. However, she did invite me to her art-filled apartment, which was nearby. There she spoke animatedly to me about the psychological riddles with which Schiele's double portrait of her husband and father-in-law—an art-collecting "Chief Inspector" for the imperial railroad—had presented. She admired how Schiele had intuitively divined Heinrich's lack of understanding for the spiritual world toward which his son's thoughts and glance were directed. After a great deal of imploring she produced a photograph of Otto as a young man—an image that handsomely matched the serious, sensitive one of Schiele's creation. My original impression that the artist had identified with Heinrich Benesch's scholarly young son was reinforced.

Adele Harms

In contrast to the comfortable life Eva Benesch was living in the heart of Vienna's First District, the next sitter I met lived in the adjacent Eighth District in one room of a gloomy apartment building where she eked out a living as the concierge. In keeping with façade-fixated Vienna where still today appearance seems more important than reality, the tarnished shield on her door read grandiosely "Ada Del Harms." This was Schiele's sister-in-law, Adele Harms, who was seventy-six when I met her in November 1966. Our first interview lasted six hours, and she progressed from polite cordiality to agitated reflections on the fact that her mother, Schiele, and everyone else had preferred her beautiful younger sister, Edith, to her. She stressed how well-educated Edith was (like Egon, she had died of influenza in 1918), that Edith spoke English and French, and that her sister did not at all resemble the passive, doll-like depictions created by Schiele.

Adele confirmed Melanie's accounts that Schiele waved provocative, sometimes nude, self-portraits out his studio window at the

two Harms girls who lived across the street. In general he acted, Adele said, "like an *apache*" (a hooligan), suddenly jumping out from bushes and bombarding them with notes and letters until they agreed to go to the cinema with him. When Edith married Egon she became his model until she got "too fat," but Adele allowed that she, too, had served as a model for her brother-in-law, posing not only for intimate drawings but also for "naughty" photographs for which she had peeled down to her underclothes.

"And I also sat for him in the nude," she volunteered in hushed tones for me and the tape recorder, producing two provocative photographs taken in Schiele's Hietzinger Hauptstrasse 101 atelier in front of the great standing mirror. Before I could get up the nerve to ask whether she might allow me to reproduce one, she tore them up in front of me, announcing in a theatrical stage whisper: "But you are the only person who shall ever see these." As consolation she presented me with two of her petticoat-revealing photographs—both of which were reproduced in the "Schiele Photograph Album" I appended to a third book on Schiele's imagery published ten years later.

Painfully conscious of how much her appearance had altered with the passage of time, Adele would not let me photograph her. Like Schiele, she seemed to have an obsession with erotica, frequently and abruptly bringing the conversation around to sex. She commented matter-of-factly on her elderly father—of whom Schiele had painted a sympathetic, dignified portrait—"Mein Vater, wie alle Deutschen, war bisexual" (My father, like all Germans, was bisexual). In my diary I wrote: "She is a bit crazy, but her single cot touches my heart. She even cried when recalling her mother's preference for Edith."

A few years later "Ada del Harms" was forced to move into the Steinhof Sanatorium ("Pavilion 25, for ever," she wrote me), where

the ephemeral fame she had acquired as Schiele's sister-in-law hardly helped to allay her loneliness.

Erich Lederer

It was also in the year 1966 that at long last and with some trepidation I met a Schiele sitter whose reputation for being difficult preceded him. This was Erich Lederer, long a resident of Switzerland, who in his youth had been the subject of an oil painting by Schiele. Erich was the son of an important patron of the arts, August Lederer, who maintained residences in Györ, Hungary—where his distillery was located—and in Vienna. Erich's mother, an amateur painter, had been a close friend of Klimt's, and the family owned the largest private collection of Klimt oils and drawings. Erich was fifteen when Schiele arrived in Györ in December 1912 with a commission, arranged by Klimt, to spend the Christmas holidays painting him. Schiele referred to Erich as a young "Beardsley," and I had already found ample evidence of this in chatty letters preserved in Melanie's collection. The boastful outbursts of a high-spirited adolescent, the letters were devoted almost exclusively to detailed accounts of bizarre sexual adventures, written to impress a confidant with a penchant for things erotic. Now, as I flew to Geneva to meet the author of these letters, I wondered how much affinity he would still bear to the young man of fifty-four years ago.

Swiss chocolates and a note of welcome were waiting in my room at the Hotel Bristol where Erich had lived with his wife Lisl for the past several decades. The couple appeared at 7:30 p.m. to take me to dinner, and I met a tall, elegant, soft-spoken woman and a short, portly man who moved with deliberate slowness and whose heavy black glasses contrasted insistently with his silver white hair. The only physical resemblance to the Erich of Schiele portraiture was the "long, aristocratic face" described by the artist in a letter. But the psychic similarity to the prurient "Beardsley" of

former times revealed itself almost immediately. No sooner had Erich ordered dinner than he turned to me and demanded in a loud, imperious voice, "Tell me, young lady, do you shave under your arms?" Only later that evening, when Erich settled down to examine the visual material assembled in layout form for my dissertation, did he abandon his impudent personal questioning and concentrate on Schiele. I sneaked a photograph of him as— engrossed and silent—he carefully examined my photograph of one of the artist's exquisite portrait studies of him.

A pattern was established over the next few days. We would meet after breakfast and slowly walk, by way of newspaper kiosks where the latest in "hot girlie" magazines were kept under the counter for him, to an imposing hotel-like bank. There, in a vault, were Erich's vast collections of Schiele and Klimt drawings. We spent the day looking at them. There wasn't much Erich could or would tell me about Schiele's personality, or what it was like to be his sitter, but certainly this opportunity to study and take notes on so many Schiele drawings was well worth the trip.

On a rare visit to the City of Dreams a few years later, Erich—by his own enthusiastic account—was ogling a teenage Japanese tourist while walking along the Ringstrasse toward the Kunsthistorisches Museum when he tripped and, in an effort to break his fall, flailed out at the young woman—"Her breasts were hard as tennis balls!" Such were the stories I endured in the company of Schiele sitters, and even more racy conversations were foisted upon me by some of the Schiele collectors I met during those years.

Schiele Collectors and Enthusiasts

The largest and most important private collection of Schiele oils and drawings in Vienna had been assembled by an ophthalmologist who kept the works in his large house at Coblenzgasse 16 in Grinzing. Dr. Rudolf Leopold was famed for being hard to meet, and so, becoming

more complicitously Viennese by the day, I contrived to accompany two different scholars on pilgrimages to his collection. The first was with Herschel Chipp, who had come from Berkeley; then four days later I returned with my former art history professor at the Kunsthistorisches Institut, Gerhard Schmidt, who was writing a book on modern Austrian art. The fact that I had engineered *two* visits to see his collection amused Dr. Leopold, and he invited me back for a dinner of *gefüllte Paprikaschoten* (stuffed peppers—the same menu offered to Gustav Mahler when he began his courtship of Alma) and was sent home at ten o'clock with fresh peaches from his garden.

Three wonderful sets of confidants and supporters shared the joy of my Schiele researches in Austria during my years of friendship with the artist's sisters: Walter Koschatzky, director of the Albertina Museum, and his wife, Trude; Christian Nebehay, proprietor of the Antiquariat Nebehay, and his wife, Renée; and Viktor Fogarassy of Graz, one of the country's foremost collectors of Austrian art, and his wife, Dollie.

The Koschatzkys

It was Walter Koschatzky who had so generously allowed me to work in the Schiele archive after hours, and as we became better acquainted, invitations to dine upstairs with him and his wife in the beautifully furnished director's apartment occupying the top floor of the Albertina became more frequent.

Trude, a slender, vivacious woman who looked very much like Audrey Hepburn and was simultaneously sophisticated and childlike, was exactly my age. She had an intuitive understanding of people and situations and was touchingly proud and supportive of her adored Walter, who was fourteen years older than she. They were considered "outsiders" in Vienna, since they came from Graz, and thus we shared a constant bemusement at the stereotypical Viennese temperament and its proclivity for labyrinthine complications—the familiar

"Warum einfach, wenn es kompliziert geht?" (Why easy when it can be complicated?). Their Graz-inflected German enchanted me. She spoke emphatically, he precisely but with a gurgle at the back of his throat, and he was always interested in expanding foreign vocabulary. Trude was less patient, knowing only German, and once when I couldn't understand what the black seeds sprinkled over our strudel were, she settled the question by declaring forcefully and finally: "Mohn ist mohn!" (Poppy seed is poppy seed).

Sometimes we would adjourn to the grand piano after dinner to sing and play not Bach but George Gershwin, Irving Berlin, or Cole Porter. Our absolute favorite song was "All the Things You Are," and its beautiful melody by Jerome Kern and words by Oscar Hammerstein II resounded through the empty museum and in my head long after I'd walked home in the evenings.

Walter was particularly knowledgeable about earlier Austrian artists, and he opened my eyes to the eccentric use of flickering color optics by the late Baroque painter Franz Anton Maulbertsch. He drew my attention to the dazzling virtuosity and photographic verisimilitude of the Biedermeier painter Ferdinand Georg Waldmüller, whose unidealized portrait of the fifty-two-year-old Beethoven would later play a recurring role in my 1987 book tracking the composer's mythopoesis, *The Changing Image of Beethoven: A Study in Mythmaking*. Just as Julius Held had done before him, Walter encouraged me to collect graphic works by past and present artists—the nearby state auction house, Dorotheum, the oldest such establishment in Europe, held frequent auctions where anyone could bid on artworks. I began attending the auctions, and the often suspenseful experience ignited a new passion—the methodical collecting on a modest scale of prints and drawings by nineteenth- and twentieth-century European masters.

Heeding Walter's advice, I also began buying whatever runs or single issues I could find of turn-of-the-century art periodicals—

Austrian (*Ver Sacrum*), German (*Deutsche Kunst und Dekoration, Die Kunst*), French (*Le Théâtre*), Italian (*Emporium*), Spanish (*Pel & Ploma, Joventut*), and English (*The Studio*)—for their vastly informative articles, reproductions, foreign reports, and obituaries. Perusing their pages and studying the informative advertisements provided me with an entrée into the art and societies of yesteryear, and my small discoveries ranged from phantasmagorical train ads the young Giorgio de Chirico must have seen in Munich to assurances for German youth that, with the nightly aid of a "Kaiserbinde" (emperor binder) they too could have a ferocious mustache like that of Kaiser Wilhelm II.

On most Friday afternoons the Koschatzkys would drive off from the Albertina in a small white convertible and head south for their dark and purposefully primitive—no electricity—country house, Bettlbauer, in Mürzzuschlag, near the Alpine Pass of Semmering between Lower Austria and Steiermark (Styria). There, high in the mountains dense with fir forests, they could relax, garden, and—dressed in traditional Austrian costume—take long hikes with their cocker spaniel (FIG. 23). The Bettlbauer house was more than three

FIG. 23
Trude and Walter Koschatzky at their Bettlbauer house with their cocker spaniel. Semmering (Mürzzuschlag), 3 August 1969. Photographer unknown.

hundred years old, constructed entirely of wood, and boasted a large, picturesque roof overhang that afforded shade in the summer and protection in the winter. I was occasionally invited along to taste the pleasures of this simple country life in which one immediately fell into the rhythms of nature. Many years later, in homage to those special times, I was able to dedicate a music-minded article, "The Visual Brahms: Idols and Images," to Walter, taking care to have the final footnote end with the word Mürzzuschlag (Brahms had also visited there)—just the sort of oblique nod in which he so delighted.

In the 1980s when I returned to the Albertina as leader of an SMU museum tour of Austria, Walter spoke to my group in the Studiensaal before a display of prime examples from the collection, followed by tea and pastries served upstairs in his elegant private quarters. After three decades of distinguished and innovative leadership he retired from the Albertina, and in 1991 I visited him and Trude in their new Schönbrunn flat, filming them with a brand-new video camera. Shortly afterward came the terrible news that Trude had died suddenly of a mysterious virus contracted while they were traveling abroad. My last visit to Walter, in 2000, was not a sad one, however, because a consoling new presence had entered his life: he met and married the biographer of *Never on Sunday*'s Melina Mercouri. Gabriele Elias was a luminous, articulate woman placed by a kind destiny as one of Walter's neighbors. When a card arrived from Gabriele Elias-Koschatzky in June 2003 announcing the death of Walter at the age of eighty-two, I could only think how comforting it was that his last years had been spent with a loving, stimulating companion.

The Nebehays

There was another Austrian home to which I was invited because of my dual attraction to art and music. In the narrow Annagasse

at No. 18 stands the Antiquariat Nebehay—an "old and rare bookstore," as its sign says, but much more, since it was also a gallery with changing exhibitions. I found my way to this magical site often and was soon passed on by the well-informed staff to "der Chef"—a tall, overwhelming man in his mid-fifties with longish dark hair combed straight back and penetrating brown, owl-like eyes.

Christian Nebehay had a commanding voice, spoke an antiquated but fluent English with thick British accent, and steepled with his fingers as he talked. He was the owner not only of the bookstore and gallery but also of the capacious building in which they were housed. A workroom on one of the upper floors was devoted to the steady production of geographically historic or antiquely astrological globes.

Nebehay's family had come to Vienna from Leipzig, and his father had been the dealer for Gustav Klimt. When I first met Christian he had just begun work on what would become a massive tome on that artist, the lavishly illustrated *Klimt Dokumentation* of 1969. I was able to add something to his work right away, since I had just made a modest discovery of my own in the bowels of the Kunsthistorisches Museum while examining the "permission to copy" records to see whether or not Schiele might have copied a famous work of art—an assignment standard in the art schools of his time. I found nothing for Schiele, but leafing back through earlier pages of the ancient record book, I suddenly spied a familiar name: on 3 June 1885 young Gustav Klimt was given permission to make a copy of Titian's portrait of Isabella d'Este!

Christian was astounded at this sort of American archival research and soon asked me to read what he had already written for Klimt's biography. I felt as though I were reading a Thieme-Becker entry, so bland and catalogue-like was the writing. After I

dared to tell him so, he asked if I would kindly continue reading what he wrote and offer editorial suggestions. This was a magnificent boon, and not only did I learn a great deal about Klimt—resulting in a book of my own on the artist in 1975—but I learned a lot about Schiele's forerunners and contemporaries.

Like the Koschatzkys, with whom he was good friends, Christian owned a cocker spaniel, and so he would reappear about eight o'clock to walk the dog and accompany me to my favorite inexpensive restaurant, yet another Chinese one, in the nearby Jasomirgottstrasse. This street, my knowledgeable guide informed me, was named after an Austrian minister who prefaced every phrase with "Ja, so mir Gott helfe" (Yes, if God helps me). Christian was appalled at my ignorance of such local lore and plied me with remedial tidbits, all of them memorably narrated.

He had two beautifully mannered teenage sons, Michael and Nicholas, from whose mother he was divorced. Fritzi Beer-Monti had worked for Christian's father at the Galerie Nebehay in Vienna's Hotel Bristol, where her first duty had been to attend to the stamping of all Klimt drawings for a memorial exhibition. As a young boy Christian had called her "Tante Hühnchen" (Aunt Chickie), because her way of giggling reminded him of a hen.

A few years later, when I returned for another summer's research in Vienna, Christian had remarried, linking up with a spunky, intelligent Englishwoman who was not only his match in masterful narration in several languages but also an enthusiastic musician. When we discovered we had music in common I became a regular member of the family, working in Christian's back office until seven o'clock, then going upstairs to the four-sided flat, which took up a whole floor of the building, to play flute and piano with Renée for an hour before adjourning for dinner in their cozy kitchen. The dinners seemed to prepare themselves while Renée and I worked up an increasingly ambitious

repertoire fortified by sips of slivovitz—a plum brandy so powerful that in Hungary the following story is told: a timid mouse, always on the lookout for cats, takes one sip of slivovitz, looks around challengingly, and demands: "Wo izt Katze?" (Where is the cat?). Slivovitz's effect on us was that we massacred old chestnuts like Beethoven's *Turkish March from the Ruins of Athens* with double-quick embellishments.

After dinner we would linger in a library lined with black cabinets full of precious Wiener Werkstätte objects—each with a story—or admire the gold-framed Klimt drawings in the music room and the black-framed Schiele watercolors in the bedroom beyond. But we would always end up around the fireplace in the living room, graced by newly created oil portraits of the hosts, for coffee, cheroots (the only time in my life I ever tried tobacco), and conversation.

Over the years many guests were invited to Renée's legendary "Tuesday lunches" that brought together music and art students from a variety of foreign countries. We crowded together on two banquettes framing the big kitchen table and chatted merrily away in several languages while devouring everything set before us. Afterward the music students would offer chamber music, and once a puppeteer put on an entire show. For Christian's eightieth birthday this same puppeteer—the American Norman Shetler, now turned professional—staged a magnificent spectacle for his old friend.

One summer I accompanied Christian and Renée on a far-ranging search for a country house. Like the Koschatzkys' Bettlbauer, it had to be within comfortable driving distance from Vienna, but far enough away to be of a different world. Above the tiny, somnolent village of Pulkau the dream dwelling came into view (FIG. 24). It was an ancient, crumbling farmhouse bounded on two sides by high walls with a formidable entry gate

FIG. 24
*Christian and Renée
Nebehay in front of
their country home.
Pulkau, 18 September
1971. Photograph by
Michael Nebehay.*

opening into a grassy courtyard dominated by an old mulberry tree. So dear did the place become to them that Christian celebrated it in oil painting after oil painting, while Renée wrote an illustrated children's book about it that became the Book of the Month in Germany in 1979.

For forty years the Nebehays have played an instructive and caring role in the professional and personal chapters of my life—even visiting me in Texas—and it was poignantly appropriate that the last time I saw them it was not in Vienna but out at Pulkau, in 2000. Christian, still penetratingly owl-eyed at the age of ninety-one, had suffered a devastating stroke and was confined to a wheelchair with Renée in attendance. Upon seeing me he murmured: "As you see, I am greatly diminished." No self-pity; simply a truthful and hence heartrending observation.

The Fogarassys

Almost as soon as I met them that first summer of research in Vienna in 1963, both Koschatzky and Nebehay had been urging me to make contact with "Baron" Viktor Fogarassy in Graz, as I could not think of writing authoritatively about Schiele without studying the superb paintings and watercolors in Fogarassy's collection. I

had already visited most of the private collectors in Vienna, and now, toward the end of my stay, it was time to see what treasures Graz held. I wrote Fogarassy asking if I might see his collection, and on 11 September a letter arrived from him inviting me to come to Graz for a day; his wife Dollie would meet me at the railroad station. Three days later I boarded the 8:05 a.m. train to Graz—a trip of three hours via Alpine Semmering.

The Fogarassys lived in a long, three-story yellow manor house filled with artworks on the side of a hill in Wetzelsdorf with a commanding view of Graz. The terraced grounds contained another yellow building, the guesthouse in which there were also works of art, and on a higher plateau, a swimming pool. Frau Fogarassy showed me five stunning oils by Klimt and Schiele before lunch, but it was during lunch that I realized this was not going to be exclusively an art history visit, for four vivacious daughters were at the dining room table with us: Marion, Sivvy, Ildiko, and Iris. Ranging in age from twenty-one to eleven, they loved puns, word games, sleight-of-hand tricks, and ridiculous jokes.

I was urged to stay overnight but cringed at dinner when I saw what was being so generously piled on my plate: two items I detested, liver *and* mushrooms. With great consternation I timidly announced that there were two foods I could not eat, one was liver, the other mushrooms. Viktor immediately rose from the table, disappeared into the kitchen, and a few minutes later reappeared with a steaming hot omelet he had made himself, laced with diced onion and cheese and a side of thick brown bread and butter. Afterward we retired to the library at the farthest end of the house where a bronze Schiele self-portrait bust rested next to one by Käthe Kollwitz. We spent the whole evening looking at Schiele drawings while listening with a piano-vocal score to *Le nozze di Figaro*. Dollie's dignified mother, the Omama, hummed along.

The next day, a Sunday, combined art and play, new acquaintances, and more music:

> Slept in lovely guesthouse with a Klimt landscape over me and a Schiele Self-Portrait at my feet! Sivvy drove me over to home of Dr. Fritz and son Peter Böck for lunch and a look at their Schieles and Klimts.
>
> At 4 the Böcks dropped me at the Fogarassys and I was alone with 40 Schiele drawings laid out for me on the dining room table to go through. Wrote up descriptions of them 4–7 p.m. Dollie invited me to stay till Tues. or Wed. Photographed the Schieles. Played guitar, Viktor tightened strings with pliers.

It was almost impossible to fall asleep that evening since I had the run of a guesthouse not only equipped with a modern bathtub but also serving as a storehouse for dozens of large, framed oil paintings, many stacked behind doors, others hung on the walls, like the 1909 staring Schiele *Self-Portrait* with rigidly outspread fingers contemplating me from the foot of my bed (it would become the cover for *Egon Schiele's Portraits*).

The luxury of an automobile ride back to Vienna was offered me by Dollie on Wednesday morning, and by midafternoon I was not only in Vienna but at a Dorotheum auction, bidding for graphic works. That day I acquired a lithograph by Franz Marc, a Picasso struck-through etching, an early Emil Nolde etching on blue paper, and, for $40, Schiele's large color lithographic poster *Tafelrunde* (*Round the Table*) of 1918, for which I had found a preliminary sketch at the Albertina.

When I arrived back at my pension that evening, a hand-delivered package awaited me from Viktor, who had offered to have made for me at his firm photocopies of three slim but important books on Schiele published in the 1920s by Arthur Roessler. I opened the package, and there were the three books themselves

along with a humorous note from Viktor complaining that these copies were taking up too much room in a Graz bookstore!

The following day I met Dollie for lunch, and she invited me to return to Graz with her as a surprise for the children. I didn't need to be asked twice, even though I would be heading for America in one week. Before leaving Vienna the next day, Dollie and I made an "art stop" to talk to Viktor's special contact, Frau Luise Kremlacek, at the Galerie Würthle. There I was introduced to whimsical yet powerful graphic works by one of the contemporary artists collected by Viktor: Hans Fronius. When Dollie saw how intrigued I was by his work, she arranged with her Kastner cousins in Vienna to take me out to meet him when I returned to the city.

Back in Graz, the next day was a workday, as Viktor introduced me to the scope of his collection beyond Klimt and Schiele, showing me unusual artists like Anton Lehmden, who, although partially paralyzed, managed to create his densely lined etchings by holding the burin in his teeth. We looked through works by Kokoschka and then turned to Hans Fronius. Many of his images were inspired by literature or history, and I saw that one of the artist's favorite themes was "my" Byzantine emperor Justinian of the Ravenna mosaic.

Late the following afternoon, after more assiduous note-taking on the collection and playing with the children in the garden, I reluctantly returned to Vienna. As Dollie was backing the car out of the garage to take me to the station, Viktor telephoned from the office to say I was to pick out any single Fronius print I would like to have. But there was more: not only did the whole family pile into the car to see me off, but Viktor appeared at the station with a train ticket in first class for me, and Dollie hung a hand-printed sign around my neck with the text: "Dieses Kind heisst Sandra Fogarassy. Falls sie sich verirrt hat, bitte zurückschicken Familie Fogarassy, Wetzelsdorf/Graz" (This child's name is Sandra

Fogarassy. In case she becomes lost, please return her to the Fogarassy Family, Wetzelsdorf / Graz).

Could any further extraordinary events have occurred before I left Austria that first Schiele summer of 1963? Yes. The Vienna Kastners did drive me out, per Dollie's request, to meet the artist Fronius. He was a wonderful and vibrant man who showed me his new work (an Edgar Allan Poe series). I bought four lithographs from the Justinian series, and he gave me four more.

My last day in Vienna was spent wrapping up ten-pound packages of books to mail back to America and making farewell visits to Schiele's sisters. My diary records the final event of that day. "When I came home last night there was a cardboard roll on my bed, hand-delivered. I opened it and there were 2 lithos from HANS FRONIUS dedicated to me!"

My familial relationship with the Fogarassys grew ever stronger. Marion went to work for Christian Nebehay in Vienna, and at her little apartment in the Nineteenth District we shared conspiratorial giggles over the contrast between "der Chef's" persnickety, pompous mannerisms on the job and his benevolent demeanor off-hours. After a year of exchanging letters and tapes, Megan came with me to Graz on the first of September 1964 to meet the family (FIG. 25) who had "adopted" me.

FIG. 25
Celebrating a Fogarassy wedding anniversary (from left to right): Marion, Iris, Dollie, Viktor, Ildiko, and Sivvy Fogarassy. Graz, 6 September 1964. Photograph by the author.

On the afternoon of our departure, while I was busy packing in the guesthouse, Dollie and Viktor knocked at the door, then entered carrying a mysterious piece of white cardboard about three feet high and two feet wide. Speaking in concert they said, "Don't forget to pack *this*." It was a mat framing one of the gems of Viktor's collection—Schiele's 1913 black chalk and watercolor likeness of himself at work before an image of Klimt he has just drawn, and entitled by him *Erinnerung* (Remembrance)! My hosts said it was a reward for writing a dissertation on the artist. I packed up the precious gift—a gift twice precious, as it was a double-sided drawing with, on the verso, a black chalk study of a rowboat, seen from above, done about 1912. A detail from *Remembrance* adorns the cover of a second paperback edition of my *Egon Schiele's Portraits*, published in 1990 on the centennial of the artist's birth.

I was able to thank the Fogarassys for all they had done by dedicating *The Fantastic Art of Vienna* to them, since it featured some of the artists I had first learned about in their collection. During two decades of almost yearly visits to Graz, I witnessed weddings, learned of births, and sorrowed over deaths—the fragile Omama, then gentle Viktor, and finally dear Dollie, but not before we had shared our multifaceted biographies many times together.

I last visited Dollie in September 1991 and brought along with me a video camera to film her as—despite advanced emphysema— she animatedly reminisced while looking through seven photograph albums spanning the family history. I had also brought along with me a cherished former student, Egga von Gemmingen, a young German girl then studying cello in Berlin. We played duets for Dollie and were taken around town by Marion. I was sorely aware that it would be the last time I ever saw my beloved Dollie. Egga intuitively understood our sadness that final evening and serenaded us into a more cheerful mood with a lively Hungarian czardas on her cello.

Dollie saw us off at the railroad station the next day and once again had a surprise for me—a large umbrella with my name stitched on it in big Kurrentschrift. Recently I gave the Fogarassy Schiele drawing *Remembrance* to the Dallas Museum of Art in remembrance of the two sets of parents in my life—Megan and Tino, Viktor and Dollie. Now every year students in my Twentieth-Century Art class are assigned to go to the museum and draw a copy of the Schiele, regardless of talent—a useful ploy for getting them inside an art museum and perpetuating appreciation for a long-dead artist whose work still speaks so clearly to later generations.

16

A PRESIDENTIAL SCHOLARSHIP had taken me from Berkeley to Columbia University in the fall of 1964. This meant that I just missed the riots rocking the University of California that year. But I was at Columbia for the strikes in April and early May 1968, and having been exposed to the 1956 Hungarian Revolution with its widespread disruption of education, I boycotted the activities at Columbia, deeming them ineffective (taking over whole buildings and barricading the entrances).

Barnard alumna Margaret Mead felt the same way, for in a heavily attended address to Columbia students who at first cheered her entrance onto the university's McMillan Theater stage, she chastised us roundly for such a "puny" demonstration. "Do you think cramming a lighted matchbox into a United States mailbox is brave or heroic?" she asked with heavy sarcasm, thumping her walking stick on the stage floor. She cited what *real* revolutionaries had done to change the world for *real* causes. Then she told us to go home. The strikes ended a short time later, but not before a dramatic faculty spilt pro and con and a ruthless police bust (it was

rumored that between 500 and 800 policemen were gathered in the underground tunnels connecting the buildings on campus).

Upon arriving at Columbia I concentrated in courses covering modern art taught by French expert Theodore Reff, Spanish scholar George Collins, and erudite Meyer Schapiro, who rarely got beyond the first black-and-white slide image. I also attended lectures on earlier art periods given by courtly Otto Brendel, fastidious Robert Branner (who held up two styles of paper clips to illustrate the difference between rounded Romanesque arches and pointed Gothic ones), and kindly Rudolf Wittkower, whose heavy German accent made us think he was talking about the "great apes" ("apses") of Renaissance churches. And two former mentors—my Barnard instructors Marion Lawrence and Julius Held—offered graduate courses.

Being back in New York offered other benefits as well. My mother, who by then had been teaching Italian at SMU for a decade, decided to begin work on her Ph.D. and joined me for two semesters at Columbia, subletting a room in Butler Hall on the other side of campus from my three-room apartment at 140 Claremont Avenue, right next to the old Julliard School of Music.

Isabelle, my former Barnard classmate who married the folksinger Patrick, had returned to America from an extended stay in Germany. Having parted company with Patrick, she arrived in New York with two small, beautiful children—Du and Benjamin—determined to earn a master's degree in sacred music and advance her career as organist. They lived in the Union Theological Seminary dormitory just across the street, so suddenly I had a family. Over a period of seven years we shared Sunday picnics across the Hudson with a doting Marion Lawrence, and we were all invited up to Marion's cozy country house in Maine on Little Deer Isle one summer, where we acquired a German shepherd puppy whom we named Mozart. It was at Little Deer Isle that I first began

to apprehend the attraction of Maine's rugged coast as subject matter for the great American watercolorist John Marin, who liked to, as he said, "recharge" his batteries in New England.

After my first year of graduate study at Columbia I was offered a preceptorship, which meant that I would be entrusted with teaching the introduction to art history class to evening students in the School of General Studies. This was a time-honored course on highlights of painting, sculpture, and architecture, entitled something like Key Monuments of Western Art. We were encouraged to sit in on the classes presented by our senior professors, including "legends" like Giotto scholar Howard Davis, learning in some cases almost as much about how *not* to teach as what to teach. In those days before remote control and slide carousels we were simultaneously slide projectionist and lecturer, which meant we had to stand behind two noisy hot projection machines in the back of the classroom and hand-load each pair of slides before attempting Socratic discussion of the images.

At our first class meeting each semester it was necessary to establish who was actually the teacher, since most of the students were older than I, but soon, and with the help of a beehive hairdo kept intact for weeks at a time, I got the hang of an authoritative demeanor. I combined this with compelling images and pithy questions to which I had scrupulously worked out ever-expanding ripples of answers—facts and theories we all seemed to discover together.

Apparently this method was successful, for upon my return to Columbia from the 1966–67 research year in Vienna, I was promoted to the status of instructor. It was exciting to see my name listed in the yearly course catalogue. I shared an office with a senior faculty member, the no-nonsense, always-in-a-hurry Edith Porada, an expert on Assyrian cylinder seals, who astonished me and other female colleagues by the rapidity with which she used

the woman's restroom. In a memorable routine, she would rush into the room, push open the door to a booth with her right hand (piles of books and letters were in her left), storm in, make her contribution, then exit like a projectile, right hand extended toward a sink, turn on the faucet, pass her hand quickly under it, turn off the faucet, and, still with the right hand extended, summarily brush against a paper towel on the way out. The left hand never came into play; there was simply no need or time.

There followed several years of teaching in the night-school trenches, attending prickly faculty meetings in which the senior faculty took turns sniping at the business of the day, and slowly writing my thesis. Megan edited and Isabelle retyped the text for me when I couldn't cope with the multiple carbon copies required.

After successfully passing the Ph.D. oral and written examinations, I defended my dissertation on Schiele's portraits in February 1969.

Arthur Danto, Columbia University's eminent professor of philosophy, was one of the examiners on my defense, and according to my diary, he told me just before the committee met that my work was the "finest dissertation inside or outside the Philosophy Department," he had ever read.

The Austrian member of the committee, Heinrich Schwarz, former curator at the Belvedere Museum in Vienna, declared his approval, reading aloud from prepared remarks, and Joseph Bauke, a thoughtful professor of German literature, quietly declared my work "perfect." Then, after a few creative questions and suggestions for minor methodological changes on the part of my sponsor Ted Reff, I was asked to leave the room while the committee deliberated. Ten minutes passed, then the door opened and a beaming Reff beckoned me back in: "Congratulations! It's a first column pass with minor revisions, and in addition we have voted unanimously to award you a pass 'with distinction'—that's only the third time in departmental history."

FIG. 26
Vladimir Ussachevsky and Benjamin Emerson at the author's Ph.D. award ceremony. Columbia University, New York, 1 June 1969. Photograph by Isabelle Emerson.

Vladimir Ussachevsky, with whom I was still quite close, and Isabelle and her children merrily attended the degree-granting ceremonies that spring (FIG. 26).

After receiving the doctorate, I was promoted to the rank of assistant professor and was permitted to offer graduate-level lecture courses and seminars in my own field of nineteenth- and twentieth-century Northern and Central European art. There were very few images pertaining to this area in the Columbia slide library with its vast Italian and French holdings and one of my great pleasures was the task of having slides made up to add to the general collection. Emulating the system I'd come to admire at Berkeley under Herschel Chipp, I ordered photographs of artists as well as images of their works and so was perturbed to hear from an older colleague that what an artist looked like was "hardly germane" to the teaching of art history. From my own experience I had learned quite the contrary: witness Schiele's fascination with the changing facade of his countenance as he plumbed his psyche.

Or the French sculptor Antoine Bourdelle's lifelong conviction that he looked remarkably like Beethoven and hence his bombastic series of more than forty-five sculpted and drawn images of the composer.

The seminars on Germanic and Scandinavian art I presented at Columbia attracted like-minded scholars, and I am gratified to have encouraged graduate students like Horst Uhr, Barbara Buenger, Charles Meyer, Alison Hilton, and Janet Kennedy, who later became pioneering experts in their chosen fields of German or Russian art. My own approach to teaching was best expressed by an interdisciplinary method—not yet in academic vogue—and one memorable semester Patricia Carpenter, a musicologist who had studied with Arnold Schönberg in California, and I offered a groundbreaking *joint* graduate seminar entitled "Schiele and Schönberg."

Although my classes seemed to be successful, I had developed a somewhat haughty manner, one learned from my elders, who were experts in pulverizing student egos in the wittiest of ways. Sudden revelation of just how ungiving and critical I had become occurred when I was teamed up with a visiting professor from Vassar College to teach a pro-seminar on modern art. Genial, knowledgeable Linda Nochlin was not much older than I, and she was not at all embarrassed to admit her nervousness at facing graduate students for the first time during our brainstorming lunches in the elegant Terrace Restaurant atop Butler Hall. I found such frankness disarming, since until then I had thought professors were supposed to cloak their uncertainties, and surely I had many of those.

A few weeks of informative introductory lectures to an angst-ridden batch of first-year graduate students was followed by student reports, complete with slides. Things went well, and our critiques were incisive and constructive, but I noticed that Linda always wrapped her more significant points in linguistic velvet.

During the second week of reports one of the students slated to perform that day arrived with her slides and text, but she was suffering from laryngitis and very near tears. "Oh well, that's all right," said Linda right away. "I'll read it *for* you." With that she strode to the podium and gave an earnest sight reading of the student's text while conscientiously timing the slide changes. As I watched in awe, I heard an urgent voice inside me saying over and over again: "I want to be like *her*, not like *them*; nurturing, not knifing!"

My new sweeter manner at Columbia brought me unexpected new friends—fellow graduate students and other young instructors. Wayne Dynes was a wry colleague whose black humor concerning human foibles got us through many bleak times, and gentle Richard Martin, the classmate who let me photograph Fritzi Beer-Monti's "Klimt" dress at the Metropolitan Museum, became the innovative editor of *Arts Magazine* and for over a decade faithfully printed a number of articles I wrote that had as much to do with cultural or music history as art history.

17

T HE BIBLE FOR SCHIELE RESEARCH, when I began my investigations in Vienna in 1963, was the thick oeuvre catalogue published by Otto Nirenstein-Kallir back in 1930. Dr. Kallir had relocated from Europe to New York on the eve of Hitler's rise to power and had founded the Galerie St. Etienne on West Fifty-Seventh Street. One of the city's most respected art galleries, it was noted for high-quality exhibitions as well as its informative catalogues—a tradition carried on today by the owner's granddaughter Jane Kallir and by Dr. Kallir's primary assistant and later, partner, Hildegard Bachert. Although I had encountered some official foot dragging in Vienna when it came time to assemble photographic materials for my first *Albertina Studien* article, Dr. Kallir's permission to reproduce a work in his collection arrived with lightning speed.

One of my first priorities after beginning graduate study at Columbia had been to make personal contact with Dr. Kallir, who seemed atypical—for a Viennese—in *not* making simple things complicated. I met him on 15 October 1964: "To Galerie St. Etienne & talked with Dr. Kallir from 11–2 re Schiele things—he has 2 new

1908 paintings on hand, and in one I recognized the little elephant I've seen in Schiele's landscape drawings." I was taken by Dr. Kallir's immense knowledge of a variety of topics (even aeronautics), his precise manner, and mischievous blue eyes. We sat in the gallery's small conference room surrounded by exquisite Wiener Werkstätte objects.

"Do you realize how often you exclaim 'hum?'" he asked me, and I was enchanted that for once the tables were turned and someone was noting *my* mannerisms. Intimidated by graduate adviser Robert Branner into canceling my flight home for Christmas that year ("What? Leaving the library and taking time off for a holiday when you're preparing seminar reports?"), I expressed my dismay to Dr. Kallir. After a lonely Christmas slaving away in the library in Columbia's Schermerhorn Hall, a parcel arrived for me: it was a book on the Austrian artist Alfred Kubin, written and published by Dr. Kallir! Through the years he and Hildegard, to whom this memoir is dedicated, gave me information, editorial help, and moral support.

My work on Schiele brought me into contact with the new director of the Solomon R. Guggenheim Museum that first year in New York, as a large Klimt/Schiele exhibition was in the planning stages. Thomas Messer, originally Czech, had studied and then worked in Boston, where as director of the Institute of Contemporary Art he had staged the first American museum show of Schiele's works. Now he was planning a truly ambitious one for the Guggenheim, to open in February 1965. After a brief interview he asked me to help in the selection of works, to contribute a catalogue essay on Schiele's landscapes, and to deliver one of the educational lectures during the exhibition.

In those days before a bookstore area was added to Frank Lloyd Wright's unwinding snail of a building, I was able to leave my car right in the tiny entrance courtyard, and this facilitated my getting

to the frequent meetings called by Tom Messer and his staff. The Guggenheim had an ingenious method for determining the placement of exhibition items: miniscule reproductions of all the works selected were mounted on tiny magnets, and we moved them around on the curving walls of a scale model of the museum's circular interior. I still have some of those little magnetized Schieles, now superseded by three-dimensional computer graphics. (One of my former graduate assistants at SMU, Vivien Greene, is now associate curator at the Guggenheim and has kept me up-to-date on the museum's technical advances in exhibition planning.)

Back at Columbia a seminar on connoisseurship anchored by Julius Held brought me into contact with a collector who was possibly New York City's most avid pursuer of Schiele, Serge Sabarsky. At that time he had not yet opened his gallery of Expressionist artists at 987 Madison Avenue and was still in the interior decorating–construction business, driving a large pickup truck expertly through the city streets. A transplanted Viennese, Serge took me with him on one of his design jobs and told stories from his checkered past, including the fact that his sister, who had survived concentration camps in Europe, had been run over and killed by a New York City bus. I met his wife, Vally—once a student of Mahler's favorite stage designer, the painter Alfred Roller—on visits to their apartment on West Eighty-Third Street off Riverside Drive, where dozens of important Schiele works lined the walls.

One of Serge's new friends about this time and a fellow fanatical Schiele collector was Ronald Lauder (Estée's son), and on one occasion in the 1970s I was summoned to Lauder's office overlooking the Plaza Hotel. At the end of a lively discussion, Ronald swiveled his chair around to face two open storage closets: one was filled with attractive, brown faux-crocodile travel kits, and the other contained straw baskets stuffed with cosmetic creams, wrapped in pink cellophane. He amiably handed me one of the pink concoc-

tions and never noticed how my face fell at not getting one of the nifty crocodile kits.

The Schiele talk I gave at the Guggenheim inaugurated what would become almost a second vocation: lecturing in various museums and at universities around the country. One of the reasons I took up this activity was that I had read a feminist analysis of academia that pointed out that female professors tended to be "mothers," acting as advisers and staying on campus whereas male professors represented their universities and earned wider reputations by lecturing at other institutions.

It took a long time to get rid of the tremor affecting my hands at these lectures, but now, after forty years of public speaking at more than a thousand venues and surviving a formidable array of mechanical breakdowns, I am no longer nervous. After all, a carefully crafted and much rehearsed speech text is always right there in front of me—although the words did melt away before my eyes once during a heavy rainstorm in Denver when a leak in the auditorium ceiling targeted my paper with acidic accuracy.

Getting the jitters now only plagues me just before each classroom lecture. There, because I must ad lib and cover a topic in a set amount of time, anxiety sets in. Pamela Askew, a visiting colleague from Vassar, once pointed out that I was "hyperventilating." I do wish I'd never heard that term because now, driving over to school before class, I have to tell myself repeatedly out loud: "I am NOT hyperventilating, I am not, really not!" But the minute the lights go down and the slides come up, the captivating material for that session takes over and I relax.

When I was a beginning graduate student it never once occurred to me that long, arduous hours were involved in selecting the slides for every lecture. Those illuminating pairs of images just dropped into the carousels by themselves as far as I was concerned. And as experienced as I am now, it still takes four to six hours to pick and

practice a single classroom lecture and two hours to file the slides afterward. This daily deconstruction of something that took so long to prepare could be likened to a theater production, except that one single person is responsible for writing the play, directing, constructing and painting the sets, handling the lighting and sound, and, most importantly, reaching the audience.

Stints at Berkeley, Princeton, and Yale

Only too soon did I learn how fraught with unexpected problems teaching could be. An invitation from Herschel Chipp to teach a general survey course at Berkeley during the summer of 1967 brought me back to California and in front of a class of 456 students. Because of the size of the class I was outfitted with a lavaliere microphone that was easy to wear and gave one freedom of movement. The second week of class, in the middle of a lecture on Egyptian tomb painting, I was surprised to see the screen grow dark and the projectionist approaching me down the aisle. "I'm sorry, but I turned your slide box upside down by mistake," he said, showing me a jumble of sixty glass slides he had rescued from the floor.

Attempting to appear calm, I tried to put the slides back in some sort of chronological order, even though Old Kingdom hunting scenes suddenly looked alarmingly like much later Eighteenth Dynasty ones. All the while an irritating air conditioning noise was filling the room with a loud heaving sound—*my* heaving sound, I suddenly realized, as the lavaliere mike amplified my panicked breath, faithfully broadcasting every internal sigh and gasp for air!

Presenting a single public lecture was the only task required of me in the academic year 1972–73, when I became the first woman scholar to be awarded Princeton University's Charles John Gwinn and Alfred Hodder Memorial Fellowship. Princeton put me up in a two-story apartment, and all I had to do was think! And I did so,

thankfully, as I was still preparing *Egon Schiele's Portraits* for publication and also working up a lecture on the turn-of-the-century Swiss artist Ferdinand Hodler for a large Guggenheim retrospective.

During this halcyon year I was introduced to the delights of collecting turn-of-the-century American Arts and Crafts objects by my friend Robert Clark, then an assistant professor of art history at Princeton. His apartment was furnished with handsome Arts and Crafts items ranging from Gustav Stickley furniture to William H. Grueby vases. Our antique hunting forays into neighboring towns extended to Pennsylvania. I found the studied austerity of some of the American work akin to the Wiener Werkstätte subtleties, and my own collection advanced apace.

My collecting interests progressed from the refined peacocks of American Art Nouveau to the cheerfully crass parrots of Art Deco. That streamlined style of the 1920s and 1930s spoke to me long before I discovered it was a vernacular expression of high Bauhaus principles. The jauntily geometric cover for songs from George Gershwin's 1935 *Porgy and Bess* seemed to me quintessentially American, however, and I was gratified to learn later that the august Bauhaus had a student jazz band in residence, of which Lyonel Feininger's son was an enthusiastic banjo-strumming member.

Memories of my secretarial days at the Columbia/Princeton Electronic Music Center were revived during my year at Princeton whenever I encountered the composer Milton Babbitt and found some time for flute and folk music with friends. Nor had I neglected amassing more records. My LPs stretched for twenty feet, two of them opera.

Just before receiving the Alfred Hodder Fellowship, I had accepted an invitation to guest-teach a course on Expressionism at Yale University in New Haven, and so the spring semester of 1973 found me commuting between New Jersey and Connecticut. I

happily bypassed my dark apartment in New York which had become uninhabitable, as I had punctured the Freon tube of my freezer with an ice pick while trying to hasten its defrosting. No repair-service man would or could remove it for repair until I had cleared out the hundreds of books and LPs lining the entry hall, which ran half the length of the building and contained my art gallery of prints.

My Yale colleagues were far more evident and friendly than the mostly invisible Princeton ones, and stimulating scholars like Ann Hanson, Robert Herbert, Walter Cahn, and Egbert Haverkamp-Begemann befriended me and directed my attention to one of the region's most prized country locales: the Book Barn. There I found the first edition of Roycrofter craftsman Elbert Hubbard's writings printed on handmade paper with deckle edges, and a twenty-two volume leather-bound edition of all of August Strindberg's writings translated into German. My library almost doubled that year, thanks to this inexhaustible country resource.

Back in New York with a repaired refrigerator, I was well into another teaching year at Columbia when Walter Koschatzky telephoned me from Puerto Rico, where he had gone to see the Ponce Museum collection of paintings Julius Held had put together for J. Paul Getty. Walter would be coming to New York for a week and was being put up by an absent patron of the arts in a downtown penthouse complete with butler—wouldn't I please come and share it with him and be his translator?

The timing of Walter's invitation was perfect. The week before, my apartment had been broken into and ransacked (the burglars took costume jewelry but left my silver flute) and four days later I had been mugged on my own doorstep as I arrived home early for once from Columbia's slide library. As I fumbled in my wallet for cash, one of the muggers threatened: "Quick, or I'll knife you!" to which, losing my temper and stamping my foot, I

retorted: "Just a minute! This is the *first* time I've been mugged and you're making me *nervous*!" The fellow actually apologized as he took my dollar bills.

So when Koschatzky's invitation to quit my neighborhood for a few days came, my answer was an immediate yes. For the next week I made the rounds of New York landmarks and museums, serving as Walter's interpreter and guide. We spent several afternoons at the Pierpont Morgan Library, examining manuscripts, books, and rare drawings of specific interest to Walter, and in the evenings we luxuriated in the comfortable penthouse.

It was a wonderful week and an uplifting conclusion to my apprenticeship years in New York. An end-of-the year summary in my diary reads:

> I have hung my new Japanese prints in the kitchen next to the Kokoschka Wiener Werkstätte postcards—the only things they can stand up against. My visual sensitivity is infantile compared to what it should become in another 30 years! I am frustrated not to be painting myself these years. But hope to set up a studio in California some happy day.

It would not be California to which I would return, however, but rather a place that had never crossed my mind—Texas!

18

ALTHOUGH I HAD BEEN TEACHING at Columbia University for almost ten years, my sense of security had been shattered by the burglary and mugging during the winter of 1974. A few days after Walter Koschatzky left New York and I returned to my ransacked apartment, I received an exploratory telephone call from William Jordan, a colleague at SMU, inviting me to join the fledgling art history department there. I had guest-taught a seminar on Viennese Expressionism at this, my hometown university, two summers earlier at his request. The salary would be "Texas size," the rank would be associate professor, and I would be located in the Meadows School of the Arts, then housing the Meadows Museum with its impressive collection of Spanish art.

What was particularly enticing was the idea that I would be teaching at the same university where my mother had founded the Italian Department, where she still taught, and where my sister Adriana was now studying. It took several weeks of soul-searching before I resolved to make the switch, but—twenty-nine years later—I have never regretted the decision. From the very begin-

ning I was allowed complete freedom to fashion courses of my own choosing and to include parallel movements in music, ballet, theater, and cinema. I described my new university surroundings to Melanie Schiele on our final visit, and she rejoiced with me in my unfettered sense of creativity.

A second art historian was induced by William Jordan to leave the East Coast and join SMU at the same time I was. Eleanor Tufts, of later feminist fame, came on board as new chair of the division of art, which included studio and art education in addition to art history. Every inch a New Englander who dropped her *r*'s where they belonged and inserted them where they didn't, Eleanor was a capable pianist, and we had begun playing flute and piano together, visiting back and forth between New York and New Haven, where she was teaching at Southern Connecticut State College. "I'll go to Dallas if *you* go," we encouraged each other almost daily over the telephone.

Supportive as always, my parents offered to help us acquire a house near SMU. Just two blocks from the university we found an old two-story house at 2900 McFarlin with ten small rooms offering plenty of wall space for books. At the end of the summer a Bekins moving van picked up household and book loads, one in Connecticut, the other in New York, and we flew down to Texas, stopping over at Durham, North Carolina, to photograph the local museum's important collection—initiating what would eventually become a sizable collection of slides for the department. Eleanor's first official act upon assuming the job at SMU was to have the word "Chairman" on her office door repainted to read "Chairperson."

A delightful colleague with one of the most erudite yet up-to-date vocabularies I have ever encountered was already in place when we arrived. Tall, cat fancier Annemarie Weyl Carr was a medievalist whose fervor for things Byzantine has swept dozens of graduate students into the wake of her discerning scholarship. In

her capacity as chairperson, Eleanor quickly hired more promising specialists: Karl Kilinski, an expert in Egyptian and Greek art joined us, and his first article, "Classical Klimtomania"—published in Richard Martin's *Arts Magazine*—was prompted by my urging him to explore the multiple borrowings from classical art I had noted in the work of Klimt. Another classicist, the Florentine-born Greg Warden, was added to our departmental core, and his field of Etruscan and Roman art brought the experience of archaeological excavation to our students. Eleanor also hired the first woman faculty member to be added to the studio department in years, Debora Hunter, a photographer of discriminating talent and originality. All these colleagues had one thing in common: in addition to active scholarship, they were hardworking, effective classroom teachers, and our division enrollment began to blossom.

During my first teaching year at SMU I was able to audit my mother's seminar on Dante's *Divine Comedy*. Despite advanced emphysema and osteoporosis, Megan's eyes sparkled with love for her subject as she made every word of each canto come alive. She attended my large lecture course as well, sitting discreetly in the back row of the auditorium, and I still treasure the emphatic notes she made correcting my pronunciation or urging better enunciation.

As for the students attending my new institution, I found them as eager and capable as their New York counterparts, only with different accents and gentle Southern manners. (At first I kept looking behind me to see who the "Mahm" was.) Shortly after I'd learned to slow my gait and spend more time chatting with students in the corridors, I was invited to a dinner party honoring the British sculptor Henry Moore, in Dallas to witness installation of a gigantic sculpture in front of the new I. M. Pei–designed City Hall. My hostess seated me next to him, and he proved to be a riveting conversationalist, demonstrating with his water glass how he used a small maquette to judge the final effect of his sculpture. "First I

hold it up high, slowly turning it around to scrutinize the bottom, then I align it sideways to see the angles [a few drops of water escaped onto the table], and finally I turn it upside down to check the top [cascade of water inundated the table]."

Sir Henry was most surprised to hear that in America we taught art history using pairs of slides, rather than the single-slide format to which he was accustomed. Half closing his limpid blue eyes speculatively, he asked: "Well then, what were the images of the final pair you showed your class today?" I answered: "On the left, a bust of Hitler turned upside down in a wheelbarrow amid the rubble of bombed-out Berlin, and on the right, a photograph of Anne Frank, to convey the idea that good can triumph over evil." Clasping my arm in excitement, Moore exclaimed: "Yes! Oh, indeed yes! Always tell your students that good *does* triumph over evil."

Spanish art was Eleanor's field of specialization—she had earned her Ph.D. at New York University's Institute of Fine Arts with a dissertation on the eighteenth-century still-life artist Luis Meléndez. While my original area of expertise was nineteenth- and twentieth-century European art, our burgeoning interest in the work of women artists, past and present, European and American, gave us a new field in common and many mutual travel goals. Little could we have imagined at the beginning of what turned out to be dozens of research trips together that our quests and finds in this "revisionist" field would result not only in frequent guest lectures at museums and universities around the country but culminate in joint participation at the opening of the first museum in the world devoted to women artists—the National Museum for Women in the Arts in Washington, D.C.

Art History Forays around America in Search of Women Artists

Spearheaded by the unstoppable Wilhelmina Holladay, zealous collector of works by women artists, the National Museum for

Women in the Arts began to take shape in the mid 1980s. The first director of this nascent museum was a colleague of ours, Anne-Imelda Radice, and it was she who invited Eleanor to curate the NMWA's April 1987 inaugural, traveling exhibition: "American Women Artists 1830–1930"—a grand event featuring not only painting but also sculpture. I was asked to contribute a catalogue essay on the sculptors Harriet Hosmer and Elisabet Ney. The show became a controversial event extensively covered by press and television with all the pros and cons of "isolating" women artists (or, conversely *exhibiting* women artists) heatedly tossed about not only by the general public but also by feminist art historians of opposing ideologies.

Several years of preparatory research and travel to public and private collections to select items for the exhibition took Eleanor and me across America, but our greatest finds were in New England, one even in Eleanor's hometown of Exeter, New Hampshire, where we were able to admire Marie Danforth Page's portrait of a slim young boy in a sailor suit. His resolute features were instantly recognizable in the sitter, now a respected local physician who graciously agreed to lend the painting for all five of the far-flung venues of Eleanor's exhibition, the last stop of which was Dallas. The groundbreaking show provided SMU's Meadows Museum with a didactic opportunity and raised the self-esteem of our female studio students.

We had witnessed the same thing when lecturing on Judy Chicago's traveling, three-dimensional feminist statement, *The Dinner Party*, at its Houston showing in March 1980. By then our ferreting out of works by women artists of the past had brought us into stimulating contact with women artists of the present, and we began inviting some of them to lecture at SMU: the vigorous New York sculptor Lila Pell Katzen, who presented the university with one of her large wavy couplings of molded steel (her work would later grace Lincoln Center), and the figural painter Ruth Weisburg of Santa Monica, a

FIG. 27
Eleanor Tufts and the author in front of Kyra's 1986 Double Portrait of Two Art Historians and Their Attributes. *Dallas, 15 April 1986. Photograph by Fannie Kahn.*

philosopher in paint who is an eloquent elucidator of her own art.

And we both began buying from artists we admired: Janet Fish in New York, who inscribed a large luminous watercolor of translucent drinking glasses to us, and an artist who went simply by the name Kyra—born in China, raised in Argentina, and resident of Florida. She in turn created a large double portrait of us from our photographs, hand-drawn with colored pencils and reproducing two attributes symbolic of our respective research: for Eleanor, the nineteenth-century American sculptor Ann Whitney's life-size *Lady Godiva* statue, which after diligent investigation we had located languishing in an upstate New York backyard, rescued by speedy purchase, and transplanted to our Dallas living room; and for me, a two-foot-high colored plaster statue of *Beethoven Enthroned* I had brought back to Texas from Vienna (FIG. 27).

Art History Forays Abroad

My diary pages for the summer of 1974 document a first joint European research itinerary that became typical of the travel routine that Eleanor and I shared. In forty days we pursued multiple

projects from Amsterdam and Vienna to Bologna and Rome. Some of the missions were mine, some Eleanor's. Some took us to out-of-the-way churches or chapels, remote cemeteries, and almost inaccessible private collections. Others led us to archives, libraries, restorers' laboratories, commercial galleries, local academies of art, and major museums.

In Italy our archival and photographic documentation of paintings (and in one case a carved peach pit) by Renaissance and Baroque women artists—Sofonisba Anguissola, Lavinia Fontana, Artemesia Gentileschi, and Elisabetta Sirani—was richly reflected in Eleanor's 1974 book, *Our Hidden Heritage: Five Centuries of Women Artists,* the first serious coverage of women artists in modern times. Soon, following this example, our SMU colleague Annemarie Carr published a groundbreaking article on medieval women artists. Art history at SMU was beginning to be known not only for its strength in Spanish art but also for encouraging feminist research.

Over the years—until Eleanor Tufts's untimely death from ovarian cancer in 1991—we formed what our students called a "dynamic duo" in which I functioned as persistent, if sometimes surreptitious, photographer, and Eleanor as tenacious recorder of data. As our reputations grew, we reveled in the task of affording past and contemporary women artists greater visibility—sometimes in public lectures and symposia, sometimes in print through articles in various journals and catalogue essays for one-woman exhibitions, and sometimes in person at commercial art galleries ("What? You don't have any works by *women* artists?"—indignant exit).

Occasionally we effected minor changes even in major museums, instigating, for example, the relabeling of certain paintings so visitors could know the artist was female. In one case it was necessary to distinguish *which* of six painter-*sisters* had done the Prado's "Anguissola" portrait of *Pietro Maria, Doctor of Cremona.* After some agitation on our part the museum obliged by placing the name Lucia in front of the

surname Anguissola. And sometimes we were able to cajole curators into bringing works by women artists out of "reserve collections" (i.e., the basement) for display in the main galleries.

Bothering about Bonheur

During a research stay in France, the fuss Eleanor and I made over some Rosa Bonheur canvases languishing in storage at Fontainebleau's royal château apparently caused French curators to rethink their priorities, with the result that the artist's large 1848 scene *Plowing in Nivernais* (see front cover) was given a permanent home on the ground floor of Paris's newly opened Musée D'Orsay. Now hundreds of visitors could admire the almost palpable veracity of the artist's vision, which in this particular instance included individual tufts of grass freshly overturned by a heavy plow, a twisting young cowherd wielding a switch while his wooden shoe begins to slip off one heel, and even the drooling saliva of the hardworking oxen.

Our feminist fervor led me to my own Bonheur acquisition—an exquisitely detailed, close-focus depiction of a ewe at rest. This appealing painting is displayed to my nineteenth-century art class every year as inspiration for students to go forth, hunt, and collect likewise. And in fact one did! On a trip to San Francisco in 1982 senior art history major Wendy Woods triumphantly purchased the inexpensive painting of a goat she had identified as by Bonheur in a Geary Street gallery where it was on exhibit attributed to the ever popular "anonymous."

To be in pursuit of Bonheur meant arranging several visits to the secluded village of By in the Fontainebleau Forest, and gaining admission to the painter's imposing château-cum-atelier. Her pictures of animals had brought her financial independence as well as fame. Our first visit to By was a disappointment, as the estate's walled-in premises were closed up tight, but I was able to scale the tall entrance gate for a look. Wrought iron decorations forming the

monogram "RB" decorated the studio facade—welcome confirmation that I was at the right place.

Another year, after finally tracking down the owners of Bonheur's property, I was permitted to photograph every corner and artifact of the studio. The artist's small darkroom, in which she developed photographic studies of the animals she kept (ranging from monkeys and gazelles to a tame lion), was stacked with wood-framed glass negatives as yet undeveloped. Bonheur also owned and had on prominent display a replica of Beethoven's scowling life mask. This gave the *animalier* Rosa Bonheur something strikingly in common with the authors August Strindberg and Gabriele D'Annunzio, in whose fascinating domiciles at Stockholm and on Lake Garda, respectively, I had also photographed plaster copies of the composer's grim life mask.

Impressive as Bonheur's oeuvre and career were, I wondered how, other than for purely feminist reasons, to justify the inclusion of Bonheur in a canon that up to that time in the 1970s admitted only the likes of Gustave Courbet and Honoré Daumier as representatives of Realism. I considered the political and cultural context: as a result of the widespread revolutions of 1848 (birth year of the retrospective, self-absorbed Pre-Raphaelite movement with its rejection of the Industrial Revolution's mass production), many people yearned for a reality different from the ugly one facing them. One escape was the alternate reality present in what could be called Bonheur's rejection of the chaotic world of humans for the noble world of animals. The German Expressionist painter Franz Marc would follow suit at the beginning of the twentieth century.

Hunting Down More Female (and Male) Artists

Early in the joint campaigns of Comini-Tufts, a decision to trace the nineteenth-century American portrait sculptor Margaret Foley took us to the spa of Merano on the southern slope of the Italian

Alps near Bolzano. We were leading a group from SMU and hoping to find time to search for Foley's grave (she reputedly died under mysterious circumstances after having gone to Merano for her health). When the tour bus stopped at the cemetery gate, the members of our group fanned out to look for her tombstone, but in vain—the cemetery was too large. Just as we were about to give up, a very Texan shout of jubilation was heard from tour member Jo Fay Godbey: "Ah *fo-und* it, ah FO-*UND* it!" The mystery of her death was not solved, but at least the annals of art history now have confirmation that Foley's grave is in Merano.

During the almost twenty years of research trips with Eleanor Tufts it was always exhilarating to be in on each other's projects. Because of Eleanor's continuing interest in Hispanic art, we visited museums, churches, and private collections in Portugal (tracking the seventeenth-century artist Josefa de Obidos) and throughout Spain. We flew to the Balearic Island of Minorca to examine a privately owned Meléndez still life—admiring the phenomenological weight of the artist's close-up grapes, melons, and cheeses—and then on to the Canary Islands out in the Atlantic for me to photograph the quaint Museo Néstor at Pueblo Canario, Las Palmas, on Grand Canary. This intriguing collection of works by the early twentieth-century artist Néstor Martín-Fernández de la Torre gives visitors the sense of being in an aquarium rather than a museum. The hexagonal rooms are lined with underwater vistas of giant fish with gaping mouths, playing with or battling against human swimmers, and all depicted in scrupulous, almost overwhelming detail as perceived through changing color layers.

Back in Madrid the accommodating staff of the Prado Museum granted our photographic or archival requests on every visit. We both taught Goya in our classes at SMU, where the Meadows Museum owns several fine examples of the artist's work, including *The Madhouse at Zaragoza*, with its symbolic downward progression

from sunlit sky to the dark shadows of a courtyard below in which inmates deprived of the light of reason flounder about. We visited and revisited every Goya site in Spain including Zaragoza, and in France we imbibed the sobering atmosphere of Goya's city of self-imposed exile, Bordeaux.

Pursuing Picasso

Spain—site of my first two years of life—kept calling me back because of seminars I offer on Picasso. I had already photographed *Guernica* in scrupulous detail when it was still one of the great attractions at the Museum of Modern Art in New York, but it was helpful to study and photograph it again in its new Madrid setting. It is fascinating to note how certain details of the huge work take on additional resonance when studied closely through the camera lens, such as the uncanny parallel between separately painted vertical black hairs on the dying horse's body and those perpendicular black letters in contemporary newspapers reporting the bombing of the defenseless Basque market town of Guernica.

In the city of Guernica a rebuilt large public market still follows the circular pattern of the original bombed-out area indicated in Picasso's painting of the horrors of war. One summer in the nearby town of Burgos—like Guernica, still a hotbed of Basque independence agitation—I came across an awkward but eye-catching mural created by an anonymous artist on a public wall near the old cathedral, updating the imagery of *Guernica* to project separatist sentiments. It was an eloquent testimony to the incendiary power of the original.

Pursuing Picasso also led me to the important sites of his youth. I visited gloomy La Coruña, in northwest Spain facing the cold Atlantic Ocean, with its portside honeycombs of glassed-in balconies to catch the infrequent sun. The fierce rainstorms there regularly cancel Sunday bullfights, and this increased the descending

melancholy of Picasso's painter father, who was slowly losing his eyesight (the boy Picasso's sympathetic drawings of his glum father can be admired in Barcelona's Picasso Museum).

At Picasso's birthplace, Málaga, the academy in which Picasso's father had taught contained a plaster cast for student copying of the German sculptor Max Klinger's once wildly popular *Beethoven Monument* of 1902. This imposing, polychromatic ensemble of marble and gilded bronze inspired my book on Beethoven imagery, and here on the Mediterranean was unexpected confirmation of the monument's international repute.

To follow young Picasso's footsteps around Barcelona, where he passed happy days hanging out with his fellow painters at Els Quatre Gats, brought me into the orbit of the innovative Art Nouveau architect Antoni Gaudí. I realized that the anarchy of Picasso's later Analytical Cubism—which scrutinized, then dissected objects into facets in order to reformulate them from the inside out—had a legacy not only in the pyrotechnical political protests rocking Barcelona in those early days of the twentieth century, but also in Gaudí's use of glass and ceramic fragments imbedded in the undulating benches of his fanciful Parque Güell high atop the port city.

Such connections can help convey the phenomenon of Cubism to those wary of any sort of deviation from photographic realism, and an assignment students always respond to enthusiastically is to make a careful copy in color of the Meadows Museum's 1915 Cubist painting by Picasso, *Still Life with Landscape*. One student created a three-dimensional "cubed" replica of the painting, and my slide of that ingenious treatment now encourages new students in their museum assignment.

Annual Conventions: Lessons, Challenges, Regrets

Attending and presenting papers at the College Art Association (CAA) annual national convention every February was something

both Eleanor and I had been doing long before relocating to SMU. A memorable practice session in 1965 with my two most stringent critics Megan and Tino saved me from delivering a pompous first speech. My long-winded opening sentence for a talk entitled "From Façade to Psyche" began: "In the year 1900 in the city of Vienna, the Austrian critic and publisher of the satirical magazine *Die Fackel*, Karl Kraus, declared that the city was 'an isolation cell in which one is allowed to scream.' "

No sooner had I finished reading these initial words, than both my parents threw up their hands. "No, no, no, Sandrina!" objected Tino, shaking his head in exasperation. "You must begin dramatically, like this." Shrinking into his chair, he suddenly thrust out his arms and legs and let loose a frightening shriek, followed by the urgent declaration complete with Italian accent: "An ISOLATION cella, in whee-cha one is allow-ed to SCR-RRRREAM!" Now it was Megan's turn to shake her head and roll her eyes heavenward. "Not THAT dramatically, dear, but certainly with a good short sentence like that, followed by an explanation of context." And so the revised beginning ran: " 'An isolation cell in which one is allowed to scream.' So Karl Kraus, publisher of the satirical magazine *Die Fackel*, characterized Vienna at the beginning of the century."

Some of my CAA panel topics were considered unusual at the time: "Artists as Authors," "The Atelier as Autobiography," and one, "Homosexuality and Art: Classical to Modern Times," attracted a record audience, but only after the auditorium lights had gone down. Held in different major cities in the United States and Canada, the conventions also gave us a chance to catch up with valued colleagues from across the country, including our staunch feminist allies Ann Sutherland Harris and Linda Nochlin (FIG. 28).

Many of our pals were at the 1980 CAA convention in New Orleans providing moral support for a convocation address I'd been

FIG. 28
*Four early feminist art historians
(from left to right): Eleanor Tufts,
Ann Sutherland Harris, Linda
Nochlin, and the author at
the annual convention of the
College Art Association.
Los Angeles, 3 February 1977.
Photograph by Richard Martin.*

invited to deliver. Menacingly entitled "Art History, Revisionism, and Some Holy Cows," the argument was that a lot of former sacred cows in art history were now pure bull. The first pair of images presaged what was to come: on the left, ninety-year-old art history legend Bernard Berenson admiring Antonio Canova's sensuous marble figure of a seminude Pauline Borghese, and on the right, a diminutive May West happily ogling a group of posturing muscle men in G-strings. The feisty audience chortled and cheered for a full minute.

Arguing that the male mode of seeing had been elevated to universal principle, I asked for a *whole* history of art, one that would include the accomplishments of both sexes. That didn't seem like a very radical demand in 1980, but here is Cindy Lyle's description of the conclusion of the event as published in *Women Artists News*:

> Before Comini's address, I had spied Horst Janson himself,
> author of the most influential art history text in America
> today, *The History of Art.* Although Comini never mentioned
> him or his book by name, each time she catalogued another
> instance of sexism in art history, one's thoughts could not
> but drift to the man who stubbornly resisted mentioning
> the name of even one woman artist in a volume covering
> 3000 works. Janson sat through the speech, smoking con-
> tinuously, his face expressionless. At the conclusion, the
> crowd gave Comini a wildly enthusiastic standing ovation;
> he hesitated, then stood and, without registering his own
> reaction, exited.

There was one annual CAA convention I still to this day fer-
vently wish I had *not* attended. The year was 1981 and the locale
was particularly enticing, for it was San Francisco—where my
Danish friend Lili Jensen, now an American citizen, was living.
Both Eleanor and I were serving on the CAA board of directors that
year, and in addition to lectures we were each presenting, we were
expected to attend the board's business meeting.

But one week before our California flight, seventy-three-year-
old Megan suffered a collapsed lung and was rushed to the hospi-
tal. In between classes I watched with a distraught Tino my
mother sink in and out of consciousness. She was diagnosed with
double lung cancer, and yet she still begged us to sneak in ciga-
rettes for her. Megan was put on a respirator, and then, in the
attending physician's phrase, there was "a slight turn for the bet-
ter." Tino and levelheaded Adriana urged me to go to the conven-
tion. On my last visit to the hospital we played bits of Megan's
favorite opera on a tiny recorder, and I managed to bring a
bemused frown to her face by deliberately misquoting *With Rue My
Heart Is Laden.*

The next morning I flew to San Francisco and gave my speech,
keeping in anxious telephone contact with Dallas. Megan died

early the next morning. I flew home on the first available plane. That very night we worked out a plan to establish a Megan Laird Comini Italian Scholarship, and this positive action, plus having to teach class the next day, helped sidetrack my rage at her cigarette-induced death and restore some equilibrium.

In an astonishing twist of fate Megan spoke to me again from beyond the grave. Unbeknownst to me, she had written a condolence letter to Lili when her mother passed away some years earlier. Lili mailed me that letter and so, incredibly, just a few days after Megan died, I was reading and hearing from my very own mother these consoling words of wisdom on how to handle death:

> Those we have loved and who have died would tell us, if they could speak to us from beyond death, not to lose ourselves in grief, but in memory—good memories of the tranquil, or good, or happy, or serene times that we had together while they were alive. It is *those* memories that keep them alive for us, not our own grief.
>
> And remember, don't feel guilt. All human relationships are uneven and clouded at times, and there is always, with everyone, the word not said and the gesture not made, no matter how much you love the person involved. This guilt feeling is a very large part—an inevitable one—of grief. If you don't come to grips with it, you are only feeding your own grief, *not* remembering with love. This may seem incomprehensible to you right now, but perhaps someday you will be helped by it.

A few weeks later I had to give several lectures in the Los Angeles area and was the houseguest of Robert Gore Rifkind, one of America's most discriminating collectors of German Expressionist art (his holdings now reside in a special wing bearing his name in the Los Angeles County Museum of Art). When Bob saw me and learned that my mother had just died, his reaction was remarkable.

"Fuck art!" he declared vehemently. "You look tired and pinched; why don't you just go out to the swimming pool, relax, and get some sun!" I did so, and for the first time in my life was relieved *not* to be examining works of art. Bob joined me in the late afternoon to tell me about his father, a distinguished Los Angeles judge, and his protracted death at home from liver cancer. Ever since, any time I manage to visit the Los Angeles County Museum of Art and its superb Rifkind collection, I relive the thoughtfulness of Judge Rifkind's son.

Multiple Missions: Egypt, Rome, Madrid

Two Christmases later, between semesters, Eleanor and I planned an ambitious trip that would take us to London for one day to see the imposing, black granite Rosetta Stone in the British Museum, and then on to Egypt to link up with a commercial tour group for twelve days; after that we went to Rome for ten days, and finally Madrid for three.

Not only did we see Pompey's Pillar and the extensive collection of the local Greco-Roman Museum in Alexandria, but we were also taken to El Alamein, site of "Desert Fox" General Rommel's World War II defeat by the British. Nearby we visited three separate cemeteries—the German one, austere, forbidding, and fortresslike; the Italian, dramatic and sheathed in lustrous marble; and the English one, framed by a low wall and laid out like a country garden with fresh flowers defiantly growing in the desert surround.

Our entertaining guide Mohammed dispersed the gloom with the following story: a pharaoh unable to sleep at night because of the sound of eucalyptus tree branches thrashing in the wind around his palace gave the command that they all be cut down—a feat accomplished in one day. That night when the pharaoh retired, the eucalyptus trees sounded louder than ever, whistling, "You-clipped-us, you-clipped-us!"

We flew to Luxor, wandered around its impressive sites and the ram-headed sphinxes at Karnak, then boarded a boat that would take us up the Nile to the great shrines of Dendera, with a side trip to the Abydos temple of Seti I. When we reached Aswan—entering *Aida*'s Nubia—and were treated to mint tea at the Old Cataract Hotel, I suddenly recalled the late nineteenth-century account of a tourist who reported hearing torrents of piano music issuing from the hotel's grand ballroom. The pianist was none other than the renowned conductor Hans von Bülow, who had gone to Egypt in hopes of restoring his failing health. I located the very piano on which Bülow had played—still in good working condition.

A packed plane flight and precarious bus trip brought us to the raised temple of Ramses II at Abu Simbel, where we needed to wear face masks because of the dust and wind. We returned to Cairo loaded down with colorful little stone scarabs and filled with such an appreciation of Egyptian culture that the first thing we did upon arrival in Rome the next day was to linger reverently in the Egyptian section of the Vatican Museum.

The allure of Egypt continued to cast its spell on me, even though I had several research projects to pursue in Rome—including finding and photographing Nathaniel Hawthorne's tower setting for *The Marble Faun*, in which the free-spirited character of Miriam was modeled on the nineteenth-century sculptor Harriet Hosmer. I also wanted to make slides for my classes of the studios of Antonio Canova and Augustus Saint-Gaudens, of the Brownings' Hotel Inghelterra and Goethe's house on the Corso, and the Villa Medici above the Spanish Steps where Jean-Dominique Ingres had been a long-time director of the French Academy. We visited the Villa Albani to see Cardinal Alessandro Albani's rare sculpture collection and spent afternoons in the American Academy in Trastevere, where we were treated to a deadly serious, unintentionally hilarious film documenting Mussolini's visit to the academy.

Haunting my memory of this productive Roman visit are two vignettes that have nothing to do with art history but which have stayed with me. In the elegant Hotel Hassler above the Spanish Steps where we decided to treat ourselves to dinner, we encountered a birdlike American woman with a bald head: we surmised correctly that, eaten up by cancer, she had come to Rome to die.

The other memory, more pleasant, is equally poignant for its searing sound: every night on the Spanish Steps, which because of the Christmas season had a large crèche set up, shepherds from the Campagna dressed in flowing robes gathered to play their shrill oboes and ancient bagpipes. No wonder Hector Berlioz, for two years a Prix de Rome student at the Villa Medici, incorporated such affecting oboe sounds in the "Shepherds' Farewell" chorus of his oratorio, *L'enfance du Christ.*

In Madrid, Eleanor's teacher José López-Rey appeared for the opening of a Meléndez exhibition, and I recorded in my diary that we were given two hours before the public was admitted in which to make notes and take slides of all forty-four magnificent canvases.

There were many other study trips just as packed with multiple projects that Eleanor and I were able to schedule. Sometimes we were joined by my sister if the itinerary included Italy, or by Lili if our travels took us to France or Scandinavia. We also led yearly summer tours to Europe for devoted SMU patrons of the arts such as Fannie and Stephen Kahn, who, chancing upon a complete run of the important turn-of-the-twentieth-century periodical *Jugend* in Innsbruck, immediately purchased the entire collection for SMU's art history department. Our favorite travel companion was the petite, knowledgeable Juanita Bromberg—a tireless trooper and insatiably curious at age eighty. And once we toured Germany with Eleanor's seventeen-year-old nephew, Kevin Ring, who sent out thirty boasting postcards to friends when the out-of-stock Volkswagen we had contracted for the

summer was apologetically upgraded by the Munich rental agency to a Mercedes-Benz.

Although already experiencing the slight stomach upsets that prefaced but did not indicate cancer, Eleanor's last European research tour with me, in the summer of 1990, was as full of diverse projects and shared goals as ever. We went from Berlin up to Lake Siljan and Mora in Sweden, then down along the coast of Brittany, following artists ranging from Sofonisba Anguissola to Anders Zorn, and from Paul Gauguin to Mary Bradish Titcomb.

But that fall Eleanor's advanced ovarian cancer was discovered, and despite grueling regimes of chemotherapy she had less than a year to live. A few weeks before she passed away she gave a final public lecture in Washington, D.C., at the scene of her greatest scholarly triumph, the National Museum for Women in the Arts. The talk was attended by another one of her favorite nephews, Thad Ring. Despite nausea and recurring edema, Eleanor continued to teach ("The unsinkable Dr. T," her students called her) right up to nine days before she died—her last class was on Titian.

The day after she was hospitalized we set about establishing an Eleanor Tufts Distinguished Visiting Professorship endowment as a surprise, and when SMU officials visited her bedside to announce the fund's creation, her reaction was not only one of pleasure but, practical New Englander as ever, "Mayn't I contribute to it?" She wrote out a check for $10,000 on the spot. Five days later she was gone.

The first "ET" distinguished visiting scholar was our old comrade-in-feminist-arms, Ann Sutherland Harris, then Linda Nochlin, Mary Garrard, Thalia Gouma-Peterson, Eunice Lipton, and others followed. Today all of Eleanor's three decades-worth of index cards, bulging files, slides, and books are part of an extensive Dr. Eleanor Tufts Archive on Women Artists at SMU, and the division of art history carries on her feminist, Spanish, and American research.

19

Determined and eager to carry on Eleanor Tufts' legacy, I redoubled my own research and promotion of women artists in the interest of revising the art historical honor roll, publishing an essay on the sculptor who had given one of her pieces to SMU, Lila Pell Katzen. For the most part, however, I dealt with past rather than contemporary artists.

Artists of the Far North

These revisionist forays within my own field of nineteenth- and twentieth-century art strengthened my interest in Scandinavian artists such as the talented turn-of-the-twentieth-century Danish portraitist Bertha Wegmann. Her engaging portrayal of the Swedish artist Jeanna Bauck in a light-filled Paris studio had been used as the eye-catching poster for a pioneering exhibition at the Liljevalchs Museum in Stockholm, "*De drogo till Paris*" (They journeyed to Paris), featuring Nordic women artists of about 1880. I had previously lectured at this attractive museum in a park and was given carte blanche to take slides during the show's run for my new seminar on Scandinavian art back in Dallas.

Traveling around Norway to photograph pertinent sites, I gained greater admiration for the artists Asta Nørregaard (creator of a large pastel portrait of a dreamy twenty-two-year-old Edvard Munch), Harriet Backer (whose concert pianist sister was to become Edvard Grieg's favorite interpreter of his piano concerto), and the mood painter of secluded lakes, Kitty Kielland. Sweden yielded up an overlooked artist, Karin Larsson, whose Arts and Crafts cottage at Sundborn became synonymous with Swedish national character and décor. In Finland I became familiar with Helene Schjerfbeck, a long-lived artist of monumental simplicity whose concentration and economy of form also characterize the music of her countryman, Jean Sibelius. Some of Schjerfbeck's harrowing self-portraits from her eighties challenge Picasso's old-age self-portraits for unmitigated reductive intensity.

This research on Scandinavian artists bore unexpected fruit when my colleague Norma Broude invited me to contribute a chapter to her ambitious 1990 book, *World Impressionism*. My fellow explorer of Scandinavia some three decades earlier, Lili Jensen, patiently helped me translate from Dano-Norwegian and Swedish sources, and I managed to include eight women artists along with their better-known male colleagues. Scandinavia's late evening light during the summer months and the resultant blue "mood" played a determining role in my essay. After an on-the-spot education concerning the look of Impressionism in the shadow of the sixtieth parallel, I titled my chapter "Nordic Luminism and the Scandinavian Recasting of Impressionism."

Germaine de Stäel

Not all my revisionist work in women's history has dealt with the visual arts. Authors and actresses have also lured me to locations associated with them. A recently opened museum in Paris, the Musée de la Vie Romantique, highlights George Sand and her stim-

ulating circle, but I have been even more interested in Sand's famous precursor, the prolific author and salon-hostess Germaine de Staël. She was as renowned for her intelligence as was her close friend Julie Récamier (of couch reclining fame) for her beauty. De Staël's outspoken opposition to Napoleon forced her into several exiles in Switzerland, where she retreated to her family's imposing château outside Geneva. "Her salon at Coppet was a veritable arsenal against me," Napoleon would later reminisce.

Touring the ornate rooms at the Château de Coppet where the most brilliant conversationalist of Europe had reigned, I was most intrigued by the solitary black bathtub in a small room on the ground floor where, I imagined, she held forth in splendid isolation. De Staël's protofeminist novel of 1807, *Corinne*, is pertinent to my Romantic Century class, for when we study Jacques-Louis David's Neoclassical painting *The Lictors Bringing to Brutus the Bodies of His Sons*, I am able to quote de Staël's description of it, written just eighteen years after the canvas was completed.

Eleonora Duse

Every year when teaching Auguste Rodin, whom she once favored with a visit, I seize the opportunity to speak about Eleonora Duse, the great Italian interpreter of Henrik Ibsen and mesmerizing rival of Sarah Bernhardt. Within this context I also have a chance to expound upon Duse's playwright lover D'Annunzio, in whose turn-of-the-twentieth-century novel, *The Flame of Life* (*Il fuoco*), she is described in excruciating detail as the aging actress, although she was only four years older than he.

It was my mother who reverently introduced me to "la Duse," contrasting the emotional power of her minimalist acting with Bernhardt's more theatrical artifices, but it was my father who delighted in expounding on D'Annunzio—another short Italian with whom, I suspect, he greatly identified. He often quoted the

provocative slogan we had once come across on the entrance gate of the poet's villa at Gardone: "Io ho quell' che ho donato."

I had already visited Duse's birthplace, Vigevano, to the southwest of Milan, but I was eager to see her residence of choice and last resting place, Asolo, above Venice at the foot of the Dolomites. As I crouched down to photograph the inscription on her tombstone I again speculated on how unnecessary her death had been that April of 1924 at Pittsburgh, Pennsylvania. In a drenching rainstorm a taxi driver had dropped the fragile, sixty-five-year-old actress at the wrong entrance to the theater where she was to perform. For over an hour she pounded in vain at the locked door with the result that she caught pneumonia and died a few days later.

Exploring the attractive little town of Asolo, I soon found myself in animated conversation with a clerk at the town hall who remembered that all of La Duse's belongings were stored there somewhere, awaiting cataloguing and display. Eagerly, I made an appointment to return and meet the curator of this collection after lunch. After hearing I had come from Texas on a Duse pilgrimage, the obliging custodian began unpacking box after box of the actress's belongings, including Franz von Lenbach's portrait of her and some of the actress's magnificent stage costumes. I got to photograph her collection of photographs from fellow artists. One of them was inscribed to her by Brahms's friend, the great violinist Joseph Joachim, whose bust a young Elisabet Ney from Meissen had once sculpted.

Paula Modersohn-Becker and Gabriele Münter

It has been Ney's Germany, rather than Schiele's Austria, that has yielded up the most rewarding material on women in the visual arts. Researching the short-lived Expressionist Paula Modersohn-Becker took me north one summer to Bremen and the nearby village on the moors, Worpswede, with its thriving art colony, where still today dis-

tinctive handmade pottery is produced. There I photographed the artist's sites and motifs—the sturdy peat boats and silvery canals—all of which she had drastically simplified in her paintings. An admirer of Gauguin, she sought a "primitivising" line and worked in a consciously nonpicturesque manner, one characterized by her painter husband as: "in her intimacy she is monumental."

Investigation of Gabriele Münter—partner of Vasily Kandinsky during the crucial Blaue Reiter (Blue Rider) years of German Expressionism—led me south to Munich's Lenbachhaus, the museum where much of her work is preserved, and then on to the old market town of Murnau in the foothills of the Bavarian Alps. There in 1909 Münter (*not* Kandinsky, as earlier literature presumed) bought the yellow country house where they would paint every summer until the outbreak of World War I. It is a spacious, four-story, cozy home that has recently been turned into a museum preserving objects and paintings from Münter's tenancy.

As a young woman Münter spent 1898 to 1900 in America visiting relatives in Texas. And so one of my shortest research trips was to the town of Marshall, Texas, that former "gateway to the West" on the transcontinental railroad. There, facing the train station, I found a Gothic monstrosity of a building, the Ginocchio Hotel and Restaurant, completed two years before Münter arrived. Exploring upstairs, I discovered that the hotel corridors were still decorated with old oil paintings on glass—that Hinterglasmalerei folk tradition which would later so intrigue the Blaue Reiter painters in Murnau. This lucky find resulted in my article, "A Minute with Münter or How On-Site Research in German Expressionism Can Be Done in the Good Old US of A."

Käthe Kollwitz

The Käthe Kollwitz self-portrait bust next to that of Schiele's in the Fogarassy library had long haunted me. I could not forget that

unwavering countenance, lined with a lifetime of sorrow. This greathearted artist, who saw her son and later her grandson perish in the insanity of two world wars, used the resolute features of her own aging face as a spiritual topography for courage and resignation. Inspired by her spiritual strength as well as her art, I embarked upon a decades-long involvement with Kollwitz, one that culminated in lecturing on her for the National Gallery of Art's 1992 retrospective of her work in Washington, D.C., and at the Käthe Kollwitz Museum in Berlin the following year.

That speech taught me the importance of titles. In addition to the contextual material I'd pulled together, Kollwitz's complete diaries had just been published. Although I needed help from Hildegard Bachert—my constant muse for things German—to understand some of the more out-of-date colloquialisms, I had assembled copious quotable statements from the diary with which to season the narrative I was undertaking. Every night my writing advanced, but so too did the publishing deadline. I had only gotten halfway through the artist's long life. What to do?

The solution presented itself one morning: retitle the essay! I'd already named it "Kollwitz, Rebel with a Cause," but there was no time left to discuss her pacifist and humanitarian causes. And so I devised a new title reflecting the text already written: "Kollwitz in Context: The Formative Years." Sometimes I use this example to encourage graduate students who, forgetting to leap from one insight to the next, have become mired in the mud of their thesis topics.

Frequent trips to Germany during the late 1980s and early 1990s in search of Kollwitz yielded some helpful finds, one of which was the Berlin setting that inspired the artist's compelling lithograph, *March Cemetery*. Its theme is the annual wreath-laying visit of Berlin laborers on the anniversary of an ill-fated workers' uprising of 18 March 1848—a revolt that resulted in the burial of 183 fallen workers in a graveyard in Friedrichshain, one designated ever after

as the Märzgefallenen Cemetery. Although my search took place during Communist times, none of the workers in Friedrichshain had any knowledge of the existence of such a place. Finally, at a convent, an elderly nun was able to give me directions to the neglected cemetery. There, overlooking four long rows of graves, I found a large, moss-covered memorial tablet to the dead of 1848, and among the list of martyrs engraved on it were the names of seven women. I imagined Kollwitz's heightened empathy as she, too, made the same discovery ten decades earlier.

Would I also be able to locate and photograph Weissenburgerstrasse 25—Kollwitz's address in the drab workers' district of Prenzlauer Berg for fifty-two years? Finding the street (now renamed Kollwitzstrasse) was no problem, but the corner apartment house with third-floor balcony overlooking the traffic hub of Wörther Platz had been leveled by bombs in 1943.

Yearning to gaze upon the view Kollwitz had contemplated for more than half a century, I entered the adjacent building and climbed a staircase to the third floor where several doors faced me. I began knocking on them. Silence. Then a child's voice answered from behind one of them—her parents were out, nobody was home. I explained that I'd come all the way from Texas to look out the window of her apartment to see what the famous artist Kollwitz had seen. "Who is Kollwitz?" "But you *live* on the street named after her!" Long pause. If I were really from Texas did I know what was going to happen next in the television series *Dallas*? "Natürlich!" I prevaricated, immediately affecting a Texas accent. The door opened a crack; I saw a large window across the room facing Wörther Platz. Inventing some astonishing incidents in J.R.'s devious dealings, I worked my way toward the window and took photographs of the triangular park upon which seven streets converged—Kollwitz's microcosm in the macrocosm that was Berlin. Just why *Dallas* was being shown on East German television

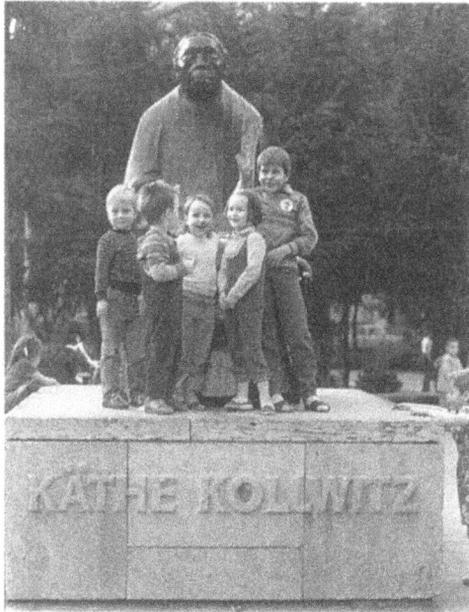

FIG. 29
*Children posing before
Gustav Seitz's 1958
bronze memorial statue
of Käthe Kollwitz.
Kollwitz Platz, Berlin,
5 October 1989.
Photograph by the author.*

I could not imagine, but I was thankful to Larry Hagman for my Kollwitz success that day.

Appropriately, Wörther Platz had also been renamed—it was now Kollwitz Platz, and a children's playground within the park contained Gustav Seitz's 1958 bronze memorial of Kollwitz seated. Gravitating toward the larger-than-life-size statue, I observed that one of the children's favorite climbing spots was the lap of the motherly effigy of Germany's most committed pacifist (FIG. 29). Through the years I have attempted to convey to students the admonition in Kollwitz's most famous poster: "Nie wieder Krieg!" (Never Again War!), yet I have watched the world ignore her plea.

20

I OWE MY INTEREST IN MUSICAL ICONOGRAPHY to Klimt, rather than Schiele. Klimt provided introductory icons in the form of a colossal *Beethoven Frieze* based on Friedrich Schiller's "Ode to Joy" for the 1902 Vienna Secession salute to the painter and sculptor Max Klinger. Klinger's life-size, polychromatic marble effigy of Beethoven on a bronze throne was the centerpiece in an extravagant exhibition dedicated to Vienna's adopted musical idol. And it was Klimt's friend the composer Gustav Mahler who conducted the Vienna opera chorus and wind players in his arrangement of Beethoven's finale of the Ninth Symphony. All Vienna had joined forces in an apotheosis of Beethoven.

My first chance to see and photograph Klinger's compelling cult statue came in July 1975 in Communist-controlled Leipzig. Out of sync with the current political system, the once celebrated monument was languishing in the basement of the city museum. The museum's director, Gerhard Winkler, lent me a flashlight and a flood lamp to illuminate the sculpture that had been brooding so many years in the dark. At first I saw what looked like a pale ship

coursing a straight line through veined marble waves. Then I saw the white marmoreal composer, his gleaming bare torso thrusting forward from a figurated throne, his head raised and gazing ahead in the direction vectored by the thrust of his crossed right leg. His fists were clenched, his staring eyes fixed upon an inner vision. At the level of Beethoven's foot my flashlight suddenly caught the glinting amber eye of an empyrean eagle, attribute and companion of the king of the gods. What a crime that politics had confined this extraordinary mythopoesis—autobiography of an entire epoch— to a moldy basement!

Eight years later, upon completion of Leipzig's new concert house (the city's third Gewandhaus), Klinger's multicolored monument once again saw the light of day. With appropriate pomp and civic euphoria it was installed in the elegant small foyer of the auditorium. Later I was privileged to witness at Leipzig manifestations of the first fissures in East Germany's political wall. The courageous director of the Gewandhaus orchestra during the 1970s and 1980s, Kurt Masur, would be among the first of the city's prominent citizens to challenge the faltering regime in 1989.

Little could I have predicted when beginning the Beethoven book (written in longhand on yellow tablets over a period of ten years) that it would end up addressing not so much the subject of drawings, lithographs, paintings, and sculptures, but rather the *interior* image of Beethoven held by those who added to his mythmaking mystique. The lengthy list of contributors ranged from contemporaries such as Czerny and Rossini and co-opting admirers Berlioz and Wagner to worshipers like Brahms, Bruckner, and Mahler.

In mapping out the changing cultural mythopoesis of Beethoven, I had engaged in Rezeptionsgeschichte (reception history) before it became a staple of musicology. The 480-page book was being used in Beethoven seminars around the country, and as

its reputation grew, invitations arrived to participate in national and international symposia on the composer.

Kurt Masur and the Gewandhaus Symposia

Kurt Masur was conducting Brahms's Fourth Symphony at SMU in 1982, and he attended an illustrated lecture I was presenting, "The Visual Brahms: Idols and Images." Tino, now a widower but as sociable as ever, invited him over to the Beverly Drive house for dinner. My former mentor, Julius Held, was visiting, too. We talked about how language was deteriorating, and my father gave his favorite example of that ancient stone tablet found in Spain bearing the indignant Latin inscription *"mensa,* non mesa!" (roughly, *"table,* not tabe!").

Later Masur told Held he intended to invite me to give my Brahms slide lecture at one of his biannual Gewandhaus symposia. A symposium devoted to Brahms was scheduled for the following October, Masur's invitation arrived, and I scampered to have my text translated into German. The Gewandhaus' official translator took on the task but did not finish his work until the evening I arrived in Leipzig. I had been hoping to have weeks to practice the phrasing and pronunciation, not hours! My diary picks up the tale:

> After a private dinner party given by Masur, I was handed the translation at the door, so this morning I got down to work on it in my hotel room. Over to Gewandhaus at 1, met the translator Lothar Fuchs & we worked on the 21 pages in the projection booth until 5. I ate dinner with cassette player earphones on, hearing my speech in German. Continued practicing till 3 a.m.
>
> Up at 7, listened to speech through ear plugs one last time over brkfst & then took the plunge! Slides & speech went well. When one projector lamp blew they even brought me coffee, which I ad libbed into the speech as we'd just been looking at Brahms' special Kaffee set.

FIG. 30
Max Klinger's 1902
Beethoven Monument
*in the marmoreal flesh
and on the cover of the
author's 1987 book* The
Changing Image of
Beethoven. *Gewandhaus
foyer, Leipzig, 11 October
1989. Photograph
by Kurt Masur.*

When the Brahms symposium concluded, Kurt, having learned of my vital interest in Max Klinger, arranged for a car and driver to take me on a four-hour tour to the sculptor's summer studio and grave amid vineyards at Grossjena. We went by way of Naumburg Cathedral with its wonderful medieval portal sculptures. Thus began a stimulating, decadelong association with Gewandhaus symposia.

On a return visit to Leipzig for an Anton Bruckner symposium in October 1987, I was able to bring along a pertinent gift for my growing circle of friends behind the Iron Curtain (all avid watchers of *Dallas*)—copies of my new Beethoven book. Its jacket, front and back, featured two dramatic color views of the three-dimensional treasure so recently ensconced at the Gewandhaus—Klinger's unique monument of Beethoven (FIG. 30).

In Quest of Vivaldi, Mozart, Schubert, Wagner, and Grieg

Predecessors of Beethoven have come my way as well. A symposium on Vivaldi's opera *Orlando Furioso* necessitated delving into how in both music and art the once-mighty maritime republic of Venice was charting a course backward through the Grand Canal of Escapism toward a seductive world of fantasy inhabited by princesses, knights, Moors, and magicians. My presentation became an article titled "The Mirror of Venice: From Titillation to

Tiepolo." Participation in a Dublin musicological conference on Mozart produced an intriguing gallery of legitimate and falsely attributed images of the composer: "The Visual Mozart: Mimesis, Myths, and Mistakes." This was a multipronged lecture that transported me deep into some intriguing medical articles about the supposed anatomical phenomenon of the "Mozart ear."

More fascinating medical literature awaited me when I received an invitation from the Philadelphia Symphony Orchestra to participate in its 1997 Schubert-Fest-Woche. Attempting to establish whether the composer's death was the result of syphilis, I encountered the nihilistic attitude toward disease held by the Vienna Medical School at the time, with its absolute fixation on *description* over healing. This unsettling component shaped the title of my contribution: "Franz Schubert's Vienna: City of Dreams and Nightmares."

Regarding later masters, my exploration of Richard Wagner's far-flung cultural reach produced a book chapter on "The Visual Wagner: Environments, Icons, and Images" and lectures for the New York and Northern California Wagner Societies. As for the more than "minor master" Edvard Grieg, gathering material on him has directed me several times to his atmospheric Troldhaugen (troll hill) house and composing hut outside Bergen. Soon after my last visit there, a large preparatory drawing by the Norwegian artist Erik Werenskiold for his much-reproduced oil portrait of a diminutive Grieg contemplating the vastness of nature was displayed at a Copenhagen auction house. I acquired the work, and it now hangs in my own music room.

Santa Fe Opera Assignments

Challenging invitations from *Stagebill*, the English National Opera, and local institutions like the Dallas Symphony Orchestra have launched me into creating essays and lectures on topics I would never, in my earlier career, have had the courage to address. I especially relish commissions from the Santa Fe Opera to speak for its

summer season. Topics vary according to the themes of the works performed. One year, because Ingvar Lidholm's new opera *A Dream Play* was based on Strindberg's 1907 play of the same name, I composed a lecture that delved into the Swedish playwright's uneasy universe. Only after I had spoken did I learn that Strindberg's grandson, a nuclear physicist living in New Mexico, was in the audience—he had come in case foolish things were said about his grandfather.

Another year, Francis Poulenc's operatic masterpiece *Dialogues of the Carmelites* gave me an opportunity to highlight the galaxy of painters and poets from Marie Laurencin and Juan Gris to Guillaume Apollinaire and Paul Eluard who were the composer's intimates in Paris. Like his friend Picasso, Poulenc's life and style seemed to be affected by these determining factors: the place where he lived, the one with whom he was in love, the poets who served as a catalyst, the circle of friends who provided admiration, and the dog who was his inseparable companion.

And recently, under the impetus of addressing Gaetano Donizetti's *Lucia di Lammermoor* for Santa Fe, I explored various dimensions of madness in the arts. The speech was called simply: "Madness and Opera; Insanity and Art," and it remains one of my favorites. The conclusion dealt with Nijinsky's slip into psychosis at the beginning of 1919, as documented in a torrent of drawings and the diary he kept hidden from his wife for six and a half weeks. Writing in the Swiss Engadine, the great dancer was painfully aware of the other famous person who went mad there, Nietzsche. The diary is a harrowing, stream-of-consciousness record of a person going insane—interspersed with astonishing detours into common sense—and is signed: "God Nijinsky."

Shortly after presenting this lecture at Santa Fe, a letter arrived for me from Nijinsky's daughter Romola. I wondered if something I'd said about her father displeased her. Quite the contrary: it was an invitation to chair an international symposium in honor of

Nijinsky. I declined, but a lively e-mail correspondence ensued, and last year I flew to Arizona to visit the eighty-one-year-old Romola and her daughter Kinga—a gratifying follow-up to teaching Franz Kline's two portrayals of Nijinsky in class all these years.

Schönberg

My pivotal early Berkeley encounter with Schiele's mesmerizing portrait study of Arnold Schönberg would engender more musical iconography. For, as an amateur painter of merit and originality, the Viennese creator of twelve-tone music had participated in his own image making through the creation of a strange series of self-portraits and "Visions." The atonal images he saw in his reflection were those of intense, existential concentration, parallel to the seething forces of politics about to shatter the 1000-year-old Habsburg Empire. Another component was the fact that Schönberg, unlike his pupils Anton Webern and Alban Berg, was a Jew in a land where anti-Semitism flourished. The somber isolation of Schönberg's decapitated self-portrait heads is prescient if one thinks of Hitler's campaign of vilification against so-called degenerate Jewish artists. In fact, the Nazi propaganda machine used a passport photograph of Schönberg to make its point about the "Jewish threat." The print, crudely and maliciously retouched, accentuates the composer's asymmetrical features, causing him to appear to glower with evil intentions, whereas Schiele's capitalization upon those same asymmetrical features had amplified the composer's habitual analytical expression. I addressed this in an *Arts Magazine* article, "Through a Viennese Looking-Glass Darkly: Images of Arnold Schönberg and His Circle."

The Mahlers and Henry-Louis de La Grange

At the 1985 Gewandhaus symposium on Mahler, I proposed bringing a more feminist balance to the program and spoke on Alma as well as Gustav in a speech entitled "Alma Mahler und *ihr* Wien"

(Alma Mahler and *Her* Vienna). Also participating in the symposium was a tall, distinguished, white-haired musicologist with boyish face who was to become a dear friend: Henry-Louis de La Grange, the French scholar who has devoted his life to serving as Mahler's ultimate biographer. We got along instantly, met at other Mahler symposia in Europe and America through the years, and regularly visit one another, taking turns now and then at critiquing each other's work.

I was allowed to make his house and library, the Médiathèque Musicale Mahler, my headquarters when researching in Paris, and I have four times stayed with Henry-Louis in the villa he rents every summer outside the village of Toblach, site of Mahler's final three summers of composing. Toblach, ringed by the high Dolomites, was renamed Dobbiaco when that part of the Austrian Tyrol was lost to Italy in 1918, but any true Mahlerite visiting the town loyally persists in calling it Toblach. Henry-Louis, always accompanied by a German shepherd, has conducted me on extensive walks and breathtaking cable car ascents to all the sites Mahler knew intimately (FIG. 31).

FIG. 31
Mahler biographer Henry-Louis de La Grange, his dog Vito, and the author. Fischleinboden, South Tyrol, Italy, 25 August 1995.

No matter how many guests Henry-Louis has, he never deviates from his early morning schedule of writing, nor does he omit his half-hour yoga exercises in front of the news on television. Evenings in Toblach are devoted to meals of intriguing local specialties prepared by chef Hassan Toungara from Mali, with spirited conversation in several languages, music making, and watching old movie videos.

I have attempted to make Henry-Louis's visits to me in Dallas equally diverting: on one visit to SMU's music library, to which years ago Mahler's summer composing desk was bequeathed, I prepared the desk so that when one of the two stubborn front drawers was pulled out full length—something I urged Henry-Louis to do—a piece of fully scored manuscript paper wedged in the back was just visible—and the handwriting seemed to be that of Mahler! This extraordinary discovery lasted all of three seconds before Henry-Louis realized a devilish joke was being played on him.

We have shared sad times as well—the drawn-out ordeals of several mutual friends with cancer or AIDS—and the death of my eighty-year-old father. Returning from an International Congress of Art Historians in Vienna in September 1983, I was met at the Dallas airport by my sister with bad news: Tino had had a massive stroke, was paralyzed, and couldn't speak. He remained in that state for two years, attended at home by round-the-clock nurses. Trying still to involve my father in my life, I would read parts of my expanding Beethoven manuscript aloud to him, asking his advice on Italian translations. I discovered that although he could not talk, he could hum, so we hummed all the old Neapolitan songs we had once played together on mandolin and guitar. There came the terrible day when Tino somehow managed to fling himself from his bed onto the floor in a suicide attempt, which, after a few hours of emergency resuscitation, had the desired effect.

I now strove with all my might to follow Megan's sage advice: not to feel guilt, and to remember only the good times, not the bad. It had been Megan and Tino, after all, who instilled in me the passion for music, languages, art, and travel, and it is consoling to know they still exert a vital influence on my life, as scholarly pursuits continue to propel me around the globe.

21

ISLANDS HAVE ASSUMED A SIGNIFICANT ROLE in many of my research trips. Of course, so many of the persons whose sojourns I strive to retrace were enthusiastic travelers. To be able to photograph the same locales experienced by these figures, be they artists, composers, authors, scientists, politicians, generals, tyrants, or royalty, allows me, as a teacher pulling slides from an ever-expanding trove, to transport students instantly to distant locales. One of Sigmund Freud's more attractive admonishments concerned the three things in life upon which one should never be reluctant to spend money: health, education, and travel (students doggedly note down this useful nugget), and it is droll to think that the extra effort and expense of traveling to remote isles has the blessing of the father of psychoanalysis.

Corfu

Island-hopping has taken me, for example, to Corfu off the northwest coast of Greece. It boasts tiny Mouse Island, made famous by the Swiss-German painter Arnold Böcklin. His haunting picture of

the 1880s, entitled *Isle of the Dead*, was so popular that he created five different versions of it. The work depicts a coffin-laden small boat with oarsman and standing sentinel shrouded in white silently approaching a mysterious, cypress-clad island. This evocative image inspired tone poems by Sergei Rachmaninov (1909) and Max Reger (1913) and moved Strindberg to direct that the brooding scene be projected on stage at the end of his 1907 Expressionist play, *A Ghost Sonata*.

There were other compelling reasons to visit Corfu. Its museum contains the famous sixth-century B.C. pedimental carving of a gigantic flying Gorgon set swastika-style within her frozen orbit— a fascinating early attempt to convey motion in sculpture. The island was once a haven for the peripatetic Austrian Empress Elizabeth—beautiful, anorexic "Sissi," whose son Archduke Rudolf had committed suicide at Mayerling. Inspired by her court reader, the learned Greek Constantin Christomanos (of whom Kokoschka would paint a hallucinatory, self-clutching portrait), she erected in 1890 on Corfu the Achilleion Castle, a hodge-podge Neoclassical refuge with manicured gardens and sweeping views.

Nine years after Sissi's assassination by an Italian anarchist in 1898, blustering Kaiser Wilhelm II purchased the Achilleion, adding a tasteless thirty-eight-foot-high bronze statue of Achilles at the end of the gardens, and installing an adjustable saddle-seat in the study—enabling him to maintain his impeccable horsemanship while reading his beloved archaeological reports.

Napoleon: The Islands Left Behind

Pursuing Napoleon, whose interaction with David, Ingres, Goya, Goethe, and Madame de Staël we trace in class, has taken me to two different islands. Although he only remained at Elba ten months before escaping back to France to march on Paris, he had time not only to bottle the local mineral water (still sold today

under his moniker) but to set up winter and summer residences. The small ballroom of the latter is covered with ingenious trompe l'oeil frescoes of windows framed by papyrus columns with a distant view of the sphinx, in remembrance of his Egyptian campaign.

On that campaign Napoleon had read Goethe's *Sorrows of Young Werther* in French translation, and when, as conqueror of Germany, he met the famous author at Erfurt in 1808, he offered him a critique of one of the passages in the book (as Goethe himself reported).

Visiting Napoleon's birthplace took me farther westward to Elba's much larger and dramatically mountainous neighbor Corsica and the port of Ajaccio—caressingly pronounced "Ai-*ac*-ciu" in the songs of its golden-voiced native son, tenor Tino Rossi. Here, in the old quarter, Napoleon's commodious birthplace is preserved. But not far away in the city's oversized main square is plenty of chauvinist compensation in the form of an overwrought bronze memorial to the emperor and his four brothers—all in togas. This ensemble is sneeringly referred to as "the big inkstand." But the pervasive fragrance of the island's ubiquitous local shrub—*le maquis corse*—is unforgettable, and Napoleon's deathbed longing to smell once again the odoriferous maquis of his childhood is poignant.

In Corsica I heard the haunting polyphonic singing in minor mode—mournful melismatic odes with drawn-out open fifths in what sounds like medieval Tuscan. The words convey uneasy but wondrously evocative homage to the island's "weeping winters, blood-tinged sunsets, uneasy granite mountains, cold desert nights, sudden thunderstorms, and endless sea."

I met Corsica's avid historian, Dorothy Carrington, author of *Granite Island*, and she steered me to the mysterious Neolithic site of Filitosa, where seventy granite menhirs glare at unseen enemies—a perturbing sight that shed new light on the effectiveness of large-scale abstract sculpture.

Distance and a dash of common sense have so far deterred me from flying to the windswept setting of Napoleon's final exile, the isolated island of Saint Helena—a British dependency 1,200 miles off the west coast of Africa. But I have visited Waterloo, twelve miles south of Brussels, and have taken pictures of the reverse sloping so cleverly utilized by Wellington to screen hundreds of troops.

In Egypt I photographed French soldiers' graffiti left in the wake of Napoleon's conquest. The yearlong occupation of that country by the French—Napoleon had brought 165 scientists and scholars with him in addition to his soldiers—led not only to the accidental discovery of the Rosetta Stone, but to the popularity of an Egyptian Revival style in art and architecture throughout Europe and America. My students readily absorb this each year as we observe how warfare can relate to and affect art history.

Sardinia and Caprera, Madeira and the Channel Islands

The twenty-six-year-old German-born sculptor Elisabet Ney launched her career by charming Arthur Schopenhauer into posing for a portrait bust (FIG. 32). Breathlessly, the philosopher and celebrated hater of women described his new routine: "She works from morning till evening by my side. Then, when she has finished, she comes and sits on the sofa beside me and we drink our coffee together. Why, by God, I almost feel like a married man!"

Following in Ney's wake I traveled to the island of Sardinia and, off its northwest coast, the six-square-mile rocky island of Caprera once owned by the Italian freedom fighter Giuseppe Garibaldi. At his modest farmhouse the irresistible "Miss Ney," plaster of Paris and sculpting tools in her boat, abruptly appeared to persuade the astonished warrior-turned-gentleman-farmer to pose for his bust. The devoted caretakers of Garibaldi's house, now an austere museum, had no knowledge of Ney's arresting portrayal of their hero, and I hastened to mail them photographs of it.

FIG. 32
*Daguerreotype of the sculptor
Elisabet Ney with her bust of
Arthur Schopenhauer.
Hanover, March 1860.*

The retracing of Ney's European itinerary has led me from mad King Ludwig II's castles in Bavaria, where she sculpted flattering effigies of the young monarch, to the multitiered city of Funchal on Madeira, the Portuguese island in the Atlantic Ocean. Ney spent a year at this subtropical retreat so favored by nineteenth-century victims of tuberculosis. She had been preceded there by her "best friend," the handsome Scottish physician Edmund Montgomery, who was treating the son of a wealthy English art patron. They were secretly wed in a civil ceremony—the ledger with their signatures still exists—but she would stubbornly never admit to being married, not even when the couple finally settled down in Texas and had produced a son, permanently scandalizing local society. Ney's Austin house and studio are now the Elisabet Ney Museum, with works from her European and Texas careers

(life-size images of Stephen F. Austin and Sam Houston number among her later work).

Tracking down another independent woman, I visited the Channel Island of Jersey, birthplace of the stunning actress Lillie Langtry for whom Oscar Wilde wrote *Lady Windemere's Fan*. A small museum in the town of Saint Helier documents "the Jersey Lily's" rise to fame. The nearby smaller island of Guernsey held even greater attraction for me, for there in its picturesque capital, Saint Peter Port, is Hauteville House, where Victor Hugo lived in exile for fifteen years until 1870. Banished from France by Napoleon III, it was at Guernsey that the author completed *Les Misérables*. The simple white bedroom and lookout porch on the top floor of Hugo's house have a view not only of his beloved France but also of the house of the mistress who joined him and his wife during his exile.

Rugged Rügen and the Baltic Coast

My desire to experience the German Romantic painter Caspar David Friedrich's austere landscapes propelled me to the Baltic island of Rügen, with its dramatic chalk cliffs and their sheer drop-offs. It is here that the painter's rapt figures commune in awe of nature as manifestation of the divine. Cautious exploration of the perilous physical setting for Friedrich's *Chalk Cliffs at Rügen* of about 1818 (FIG. 33) showed me that the artist had merged two separate vistas—the long view out to sea underneath a cathedral of arching tree branches, and the gleaming white edge of the precipice that plummets to the beach below. In spite of being able to match the location to the work, I was aware of Friedrich's dictum: "The artist should not only paint what he sees before him, but also what he sees within him." And that is why he needed to be alone when roaming the wild sites of Rügen.

I got to visit Rügen twice, once in 1975 while it was under Communist rule, and again in 1992. Freedom had filtered down to the fishing boats, which were identified by numbers when I pho-

FIG. 33
Caspar David Friedrich,
The Chalk Cliffs of Rügen,
1818–19, oil, Museum Oskar
Reinhart am Stadtgarten,
Winterthur, Switzerland.

tographed them previously, but now had personalized names like "Trude" and "Zephir."

Back on the mainland, near Friedrich's hometown of Greifswald, I returned to the towering cloister ruins at Eldena, the rectilinear reach of which the artist had depicted in meticulous, almost hallucinatory detail as a symbol of transience. A sign erected during Communist times designating Eldena as a national monument gives credit to Friedrich for drawing attention to the site as an icon of German Romanticism.

The harbor town of Wolgast, birthplace of Friedrich's contemporary, Philipp Otto Runge—painter of allegorical images of flowers and children—is about twenty miles east of Greifswald. Driving there through flat, verdant countryside I hoped to find an example of the distinctive white picket fence that frames the three earnest youngsters captured at play in Runge's winsome *The Hülsenbeck*

Children of 1805–6. I came upon a credible facsimile and learned from the owner that the German term for such a fence is *Palisadenzaun*. A few moments later a woman approached the Palisadenzaun pushing a baby stroller from which a child stared out solemnly at me—his almond-shaped elf eyes remarkably similar to those of the baby in Runge's picture. The resulting photograph joined my growing gallery of look-alikes.

Martinique and Tahiti

On the French island of Martinique in the Caribbean, Gauguin worked for a year, developing that escapist taste for life in the tropics which would ultimately take him to Tahiti. There he hoped to find a new basis for art by living in "amorous harmony with the mysterious beings" around him. Forty years later, the sixty-year-old Henri Matisse, for whom the quality of light was supremely important, spent three months in Tahiti absorbing the island's luminous contrasts and drinking from a "golden goblet" of light.

To see with the eyes of Gauguin *and* Matisse I made my way to the South Seas. Yachts from all over the world, large and small, elegant and battered, were tied up along the promenade in Papeete. After an enchanting drive halfway around the rim of the volcanic island I finally reached the Musée Gauguin—containing no original paintings but featuring a re-creation of the artist's last bungalow with his harmonium, severely corroded sewing machine, and books. In my excitement I completely forgot to photograph these items, and after a sleepless night, I returned the next day in another rental car, my camera at the ready. This time the curving coastal road did not seem so enchanting, only arduous.

Of Mountains (Magic and Otherwise)

While gathering material for the 1989 Gewandhaus symposium on Richard Strauss, I made a pilgrimage to his villa (built in 1908 with

proceeds from his opera *Salome*) at beautiful Garmisch-Partenkirchen, in the Bavarian Alps. Strauss had died there forty years earlier, but his daughter-in-law still lived in the house. I took a chance and knocked on the villa door. A startled but gracious Alice Strauss, eighty years old, granted me entry. I was allowed to photograph portraits of Strauss I had known from reproduction only. The insights gained during that visit were singularly beneficial for the Gewandhaus presentation three months later in which I was able to contrast the giganticism of Strauss's music with the self-aggrandizing building program of his Kaiser patron.

Although the painter Ernst Ludwig Kirchner, one of the founders of that first Dresden cell of Expressionism, Die Brücke (The Bridge), had begun his career in Germany, his nervous sensibilities, exacerbated by the horrors of World War I, propelled him to relocate to Switzerland in 1917. One of my goals was to visit the rustic log cabin he had built for himself at tiny Frauenkirch on a mountain slope facing the larger town of Davos tucked into the valley below. I found and photographed the hut, noting that one could hear but not see the active Alpine stream featured in several of the artist's depictions of the house. I also located Kirchner's gravestone in the nearby Waldfriedhof (forest cemetery), with the dates 1880–1938— sad reminder of his panicked suicide upon hearing the Swiss militia exercising and mistaking it for a German invasion.

Above Davos sits Haus Berghof, the sanatorium that figures so prominently in Thomas Mann's novel *The Magic Mountain*. Mann's image of those veteran sanatorium patients who could, to Hans Castorp's passive admiration, snap their blankets about them on their chaises longues in a single throw, came vividly to mind when I was put up by Colorado College in a bed-and-breakfast—formerly a private sanatorium—with chaises longues on my balcony.

One more mountain site awaited me back in Germany: the flattened remains of Hitler's palatial residence near Berchtesgaden.

There was little to see, but a spacious elevator makes the steep assent to Obersalzberg, a wooded plateau about half a mile up where tea was served to the Führer's intimates. On a clear day they could gaze over into Austria and see Salzburg, only fourteen miles away. I got goose bumps upon realizing that the burnished surfaces of the elevator walls and ceiling had once reflected the living, breathing image of Hitler. Concentration camps at Dachau and Buchenwald had brought me into contact with his vile handiwork, but never had I been this close to the ghost of the man himself!

Some Alluring Lakes

Several Austrian lakes have been stops on my art historical or music iconography pursuits. As early as 1963, on the track of Schiele, I had made my way to the Traunsee in Upper Austria's Salzkammergut. My destination was Gmunden with its chestnut-tree-lined esplanade and Schloß Orth, the lake's small island castle in front of which Schiele had posed with his art critic patron Arthur Roessler for a photograph in 1913. To determine the exact spot where Schiele stood on the long wooden footbridge leading to the onion-shaped dome of the castle tower was challenging but possible. Here, I emulated the image of the artist, with clenched fist and lowered gaze, in an attempt to understand his posturing self-portraits. In this particular photograph Schiele's shy, uneasy demeanor contrasts with that of his friend, who stands with arms akimbo, expansive and confident. Even Gmunden's charms could not ameliorate Schiele's perpetual Angst.

Klimt had spent several summers painting at the blue green Attersee in the Austrian Alps. Sometimes he depicted the shoreline from a rowboat, as in *Church at Unterach on the Attersee* of 1916, exquisite in its tessera-filled articulation. I rented a boat and pushed out to photograph the same vista. All the elements in the painting were there, but once again I found myself encountering

the phenomenon of the artist's eye—a composing eye that had gone beyond photographic verisimilitude to create the finely stacked condensation of church, town, water, and landscape elements that constituted Klimt's unique vision.

The Attersee was also one of Gustav Mahler's lakes, as was later the Wörther See down in Carinthia. At both sites he had composing huts built to work in silent isolation. Although Mahler's composing hut at Maiernigg on the warm Wörther See is no more, a facsimile has been built on the original site, but it is located in a crowded trailer park, full of shrieking children and barking dogs. A similar fate has overtaken Mahler's third composing hut outside Toblach. It stands within the confines of a popular animal park stocked with peacocks, turtles, donkeys, and boars.

In the Italian-speaking part of Switzerland the stunningly situated waterfront town of Ascona, nestled on the Swiss side of mountainous Lake Maggiore, has attracted visitors for decades. Lenin visited the spot. Artists like Paul Klee and Alexei Jawlensky, and Bauhaus masters like Oskar Schlemmer and Walter Gropius sojourned there, and the town's small museum has a whole floor devoted to the paintings and sketchbooks of the mystical Expressionist painter Marianne von Werefkin. Abandoned by Jawlensky, she lived out her days in proud poverty at Ascona, responding to the awe-inspiring locale with works like *Via Eterna* of 1929—a vista contemplated by a miniscule figure atop a mountain peak, which is itself dwarfed by towers of sheer rock.

The Hungarian dancer Rudolf von Laban (creator of Labanotation) founded his School for Art in Ascona, holding his classes outdoors on the beach, and attracting the modernist Mary Wigman to his cause. Her jerky, angular dance movements found resonance in the works of Kirchner (who sketched her at work) as well as his fellow German Expressionist Emil Nolde. Even Isadora Duncan paid a visit to this Swiss outpost of modern ballet. And Rudolf Steiner, the Austrian

founder of anthroposophy—that arcane offshoot of theosophy so important to Mondrian and Kandinsky—spent time in Ascona.

And so did Erich Maria Remarque, author of World War I–inspired *All Quiet on the Western Front,* the pacifist novel condemned by Hitler's book burners. In the little mountainside village of Ronco a quaint cemetery shares Ascona's view of the lake, and that is where I came upon the graves of Remarque and actress Paulette Goddard, learning only then that they had been married.

A Sprinkling of Cemeteries

Lectures and research projects in European locales have helped gratify my desire to visit memorials and graves of some of the artists, musicians, and authors who float through my classroom. After all, pilgrimages to cemeteries are mandatory destinations for those in pursuit of the final resting places of their heroes or villains. In Berlin's Prenzlauer Berg district, for instance, lies the neglected Jewish Cemetery where Kollwitz was one of only two or three persons courageous enough during the dawning Hitler era to attend the burial of the city's premier painter Max Liebermann. He was known not only for his fine portraits but also for his mordant Berliner wit: he complained of needing dark glasses for Wilhelm II's pretentious Siegesallee, lined with thirty-two gleaming white marble effigies of his Hohenzollern ancestors.

Not so accessible is the strange rock tomb crowned with thick sea grass and nestled into a sand dune of windy Skagen beach on the northernmost tip of Denmark. There in 1908 the body of the country's eulogizer-poet (Grieg set some of his verses) and gifted marine artist Holger Drachmann was laid to rest with appropriate pomp. Equally off the beaten track, in the German countryside near Regensburg, is a multistepped but rewarding memorial. I have twice made the climb to inspect the instructive if uneven assemblage of Germanic (male) greats represented by marble busts inside

Ludwig I's white Walhalla temple, raised high above the surrounding fields. In Weimar's small Fürstengruft (Princes' Vault) I have descended into the gloom to where the sarcophagi of Goethe and Schiller lie side by side, and just behind Wagner's beloved Villa Wahnfried in Bayreuth it is possible to meditate at not only the composer's but also his dog's private burial lot.

Over the years, I have haunted Paris's Père-Lachaise Cemetery to pay respects to Theodore Géricault, whose *Raft of the Medusa* in bronze relief decorates his tomb, to Frédéric Chopin, and to Edith Piaf (avoiding the crowds thronging around Jim Morrison's grave). From atop the Tour Montparnasse there is a stunning view of the sprawling cemetery below with the grave of Alfred Dreyfus. (Grieg once refused to conduct in Paris because of the Dreyfus scandal so stirringly indicted by Émile Zola in his daring public letter of 1898, "J'accuse.")

Hoping to photograph Vincent van Gogh's grave in the cemetery at Auvers-sur-Oise, I came upon the simple tombstones, side by side, of not one but two Van Goghs. I remembered that Vincent's devoted brother, Théo, had died in Holland within six months of his suicide, but I did not know that twenty-three years later Théo's body had been reburied alongside Vincent. Some woven stalks of wheat had been carefully laid atop Vincent's gravestone—an anonymous tribute to the artist who had vainly sought peace in the French countryside.

In St. Petersburg I headed into the crowded Alexander Nevsky Cemetery to photograph the compelling gravestones of Pyotr Ilich Tchaikovsky and Nikolay Andreyevich Rimsky-Korsakov. The ornate sculptural iconography provided me with fodder for further explorations in mythopoesis. And in Vienna's vast Central Cemetery, where long ago I had admired Fritz Wotruba's upended cube marking Schönberg's grave, I revisited the graves of Beethoven, Schubert, Johann Strauss Father and Son, Brahms, and Hugo Wolf.

One cemetery, Milan's huge Cimitero Monumentale, holds a double attraction for me—one inspiring respect, the other just plain spooky. For not far from where Arturo Toscanini was buried in 1957 stands an old rectangular mausoleum crowned by the life-size statue of a heroic-looking woman striding forward and leading two small boys by the hand. She is the bereaved widow Bresaola, mother of my Italian step-grandfather Mario, future minister of agriculture under Mussolini. Within the narrow building are marble-faced slots for present and future occupants and incised on two of them are the names and birth dates of my brother and me. *No, grazie!*

On the trail of Giacomo Puccini I visited his villa, just south of Viareggio on the west coast of Italy, where the composer's coffin is placed in a miniature chapel between his study and his bedroom—an unexpected sight. Puccini, who accurately described himself as a chaser of beautiful melodies and beautiful women, was also an avid huntsman who loved to roam the gloomy reaches of Lake Massaciuccoli. After the success of *La Bohème* he built himself a cozy lakefront home there at Torre del Lago. My trip to Viareggio was rewarded by locating the simple beachside monument to Percy Bysshe Shelley. His body was washed ashore in front of a villa then under construction for Napoleon's sister Pauline during a storm that overtook the poet's sailing vessel.

The book of poems by John Keats found in Shelley's jacket pocket is safeguarded at the Keats-Shelley House in Rome just off the Spanish Steps, and it is to Rome's fascinating Protestant Cemetery that students and I travel, once a year by way of slides, to pay homage to the two English poets who elected to live in Italy and are, indeed, eternal Italians—Keats with a tombstone that, as he directed, identifies him only as "here lies one whose name was writ in water." Shelley's ashes are under a white marble slab that quotes Ariel's song from *The Tempest*: "Nothing of him that doth fade, but doth suffer a sea-change into something rich and strange."

Forming an imposing part of the containing walls of the Protestant Cemetery is the ancient pyramid of Caius Cestius, built in 330 days in the first century B.C. and faced with white marble—a luminous apparition that Shelley wrote "might make one in love with death to think that one should be buried in so sweet a place." It was this romantic pyramid that the thirty-seven-year-old Goethe portrayed in a dramatic moonlit scene. Within the pyramid's shadow the grave of Goethe's wayward son August who predeceased him can be found: "GOETHE FILIUS PATRI ANTEVERTENS OBIT ANNOR. XL MDCCCXXX"—an inscription students realize with surprise they can actually translate with just a little effort.

Adjournment to Caffé Greco

Lest these same students become dismayed by so many cemetery encounters we also pay a yearly visit, again via slides, to one of Rome's most vibrant locales, the Antico Caffé Greco, just off Piazza di Spagna on the famed Via dei Condotti. Divided into smoking and nonsmoking rooms even at its inception in the eighteenth century, this popular spot in the foreign quarter of the Eternal City acted as a sort of early American Express for meeting friends and picking up mail. (Franz Schubert addressed his letter to a painter friend in Rome simply in care of the café.) Artists paid for meals there with paintings that today crowd the paneled walls, and the stimulating atmosphere attracted everybody who was anybody, beginning with the father of classical archaeology, Johann Joachim Winckelmann, and including a dazzling array of notables: Goldoni, Piranesi, Casanova, Goethe, Leopardi, Keats, Schopenhauer, Hans Christian Andersen, Berlioz, Mendelssohn, Liszt, Wagner, Gogol, and Ibsen. Even Buffalo Bill (William F. Cody) made a mandatory stop—his framed autographed photograph of 1903 hangs on one of the walls.

FIG. 34
Renato Guttuso, The
Caffé Greco, *1976, oil,*
Wallraf-Richartz-
Museum, Cologne.

From the 1950s until his death at ninety in 1978, Giorgio de Chirico, whose apartment adjoined the Keats-Shelley House on Piazza di Spagna, was a Caffé Greco habitué. This is documented not only by photographs of the gloomy metaphysician at his favorite table, but also in Renato Guttuso's amusing painting of 1976 showing an omnium-gatherum of Greco glitterati (FIG. 34). On the far left against the wall sits, in recognizable hedgehog profile, a somber Giorgio. And on the far right just below two nuzzling beauties is Buffalo Bill.

22

T HE SOLEMN DE CHIRICO in Guttuso's painting of Caffé Greco sits underneath a plaster copy of the *Belvedere Torso*—that antique fragment in the Vatican made legendary by Winckelmann's famed description, which combines a philologist's literary references with a sculptor's feeling for tactile effects and a poet's imagery:

> The first glance may show you no more than a misshapen stone. But if you can penetrate its secrets, you will discover a miraculous example of art, provided that you contemplate it calmly. Then Hercules will appear to you as if in the midst of his labors, and the hero will become visible along with the demigod. Just as the hitherto calm surface of the sea begins to stir in the fog, with wavelets playfully swallowing one another and giving birth to new ones, so does one muscle softly swell here and pass into another while a third one, issuing from between them and seemingly enhancing their motion, disappears again and draws our eyes after it beneath the surface.

No wonder Goethe would testify that "by reading Winckelmann one does not learn anything, but one becomes somebody."

So famous had the father of archaeology's authoritative readings made certain masterpieces of classical statuary, that upon occupying Rome Napoleon gave orders to have the *Laocoön* and the *Apollo Belvedere* carted back across the Alps to Paris as trophies (modestly outfitted for the trip with fig leaves). A cultural itinerary could be mapped by following the routes of famous lootings in art history—for instance, the galloping circuit of the bronze quadriga crowning Berlin's Brandenburg Gate. It too was claimed by Napoleon for France, but later triumphantly escorted back to Berlin by General von Blücher, one of the victors at Waterloo.

"Edle Einfahlt und stille Grösse" (noble simplicity and serene grandeur) is what Winckelmann believed emanated from the world of classical antiquity, and this concept was passed on by him to the composer Christoph Willibald Gluck when they met at Cardinal Albani's villa in Rome in 1756. Six years after that meeting Gluck composed the work that reformed Italian opera—*Orpheus and Eurydice*—in which, in Gluck's words, "a beautiful simplicity" prevails.

How ironic that the champion of serenity would meet a violent end. Winckelmann was murdered in the port city of Trieste while sitting at a desk in his hotel room correcting page proofs for a new edition of his much-celebrated *History of Ancient Art*. The assassin was a convicted young felon whom the author had befriended while dallying at the Locanda Grande awaiting a ship back to Italy. The murderer had listened to Winckelmann's boasting allusions to gold medals just awarded him by the empress of Austria. In the ensuing life-death struggle Winckelmann sustained multiple stab wounds. The homosexual element in this death by the sea served as inspiration for Thomas Mann's *Death in Venice* and Benjamin Britten's opera of the same name.

The desire to visit Trieste became irresistible. Not only was it the site of Miramar Castle—sumptuous hideaway of Kaiser Franz Josef's brother Maximillian (the later-to-be-executed emperor of

Mexico), but Mahler, Freud, James Joyce, Ezra Pound, and Egon Schiele had visited Trieste. Schiele had traveled there twice. Once, as Melanie told me, while still a teenager with his younger sister copying their parents' wedding trip, and again in 1912 soon after his release from prison. A craving to return to Austria's major seaport had intensified during his imprisonment: "I dreamt of Trieste, of the sea, of open space. Longing, oh, longing! For comfort I painted myself a ship, colorful and big-bellied, like those that rock back and forth on the Adriatic. In it longing and fantasy can sail over the sea."

It was heartening to discover, after driving into Trieste and exploring its waterfront, that "colorful, big-bellied" fishing boats still rock back and forth in their protected slips. I took many photographs that day, attempting to match them to the image Schiele had wrought from memory.

A much grander hotel than Winckelmann's Locanda Grande now stands at the scene of his murder on the Piazza Grande, lined with pleasant outdoor cafés. The hope of finding Winckelmann's grave led me to the Cathedral of San Giusto and its cemetery atop one of the highest hills of the city. There I found not Winckelmann's grave but his cenotaph, donated by patrons in Rome who had had the mutilated body taken there. The Trieste memorial is an elaborately inscribed, white marble sarcophagus adorned with a black profile of Winckelmann. It is just visible, nowadays, inside a fenced-off temple in the lapidary beside the cathedral. And for once the author's name, which the Italians never got quite right, is spelled correctly!

23

ONE OF MOST AFFECTING MOMENTS in Edvard Grieg's setting of Henrik Ibsen's *Peer Gynt*—a moment tenderly captured in several color lithographs by Edvard Munch—is the scene in which, facing the fjord up which Peer disappeared years earlier, his mother, Asa, sits huddled in resignation while Peer's abandoned sweetheart, Solveig, sings her song of faithful waiting:

> Kanske vil der gå både Vinter og Vår,
> Både Vinter og Vår,
> Og naeste Sommer med, og det hele År,
> Men engang vil du komme,
> Det ved jeg visst, det ved jeg visst,
> Og jeg skal nok vente, for det lovte jeg sidst,
> Det lovte jeg sidst.

> Perhaps both winter and spring will pass by
> Both winter and spring,
> And next summer too, and the whole year
> But one day you will come,

That I know for certain, that I know for certain,
And I shall indeed wait, for I promised that then,
I promised that then.

Although I grew up in Texas for the most part, and no Nordic blood courses through my veins, I have always felt as though I've come home again when—ever since that long car trip through Scandinavia forty-odd years ago—I return there. How can that be? The answer is simple: the overwhelming presence of nature—nature in its mild aspects and awe-inspiring dimensions.

In that far northern clime raw nature prevails, even in the cities where white birches, green firs, and rocky outcropping are everywhere, offering its artists, writers, and musicians irresistible thematic inspiration. Sibelius told a fellow Finn: "When we see these granite rocks we know why we can treat the orchestra as we do." About the psychological realism of his plays, Ibsen advised: "Anyone who wishes to understand me fully must know Norway. The spectacular but severe landscape . . . the lonely, shut-off life . . . so that [people] become reflective and serious, they brood and doubt and often despair."

And Grieg, thinking of the cultural isolation and poverty of his country, could exclaim: "Yes, Norway! Norway! Good Lord, anybody can be rich and practical; but not everyone can be *serious* and *introspective!*" Munch and Strindberg, both of whom lived and traveled abroad for many years, ultimately returned to their respective countries—Munch to paint "not what I see but what I saw," and Strindberg to mesh with the skerries of his native Stockholm.

Over the years I had absorbed and held dear this potpourri of Nordic sensibilities while deepening my knowledge of Munch and researching the work of Scandinavian women artists. So I was delighted when in the fall of 1993, a tall, blond graduate student at the Institute of Fine Arts in New York, where I was lecturing, introduced

himself as Janne Gallen-Kallela, great-grandson of Finland's leading painter at the turn of the twentieth century, Akseli Gallen-Kallela.

Janne was pleased to learn that I had a more than passing interest in his relative's works. I had recently encountered Gallen-Kallela while collecting material for a lecture on Mahler at Amsterdam's Concertgebouw. But there was precious little available on the artist in American libraries, I complained. Within weeks Janne had his parents mail me several sizable volumes on Gallen-Kallela from Finland, books so rich in material that I reshaped my speech to focus on five exciting days in Mahler's life: his visit to Helsinki in the late fall of 1907 and his meeting not only with Sibelius but with Gallen-Kallela, who whisked Mahler off in a motorboat to Hvitträsk—log-and-stone forest castle home and studios of the young architects Herman Gesellius, Armas Lindgren, and Eliel Saarinen, perched on a forested ridge by the shore of Lake Vitträsk.

A permanent souvenir of this welcome abduction was contributed to Mahler iconography by the sudden inspiration of Gallen-Kallela to begin an oil sketch of the composer as he sat by the open fireplace, "lit up only by the fire, quite à la Rembrandt" (as noted in Gustav's letter to Alma). The result, the likeness of which "astonished" Mahler, provided me with the theme and title for my speech: "By a Finnish Fireside: An Evening with Mahler and Gallen-Kallela."

Finland

Janne and his parents, Aivi and Matti, invited me to spend several weeks with them in Finland, holding out the prospect of staying not only in Helsinki, but also visiting Gallen-Kallela's wilderness atelier, Kalela, on Lake Ruovesi north of Tampere. In August 1995 I was finally able to accept this wonderful invitation.

Every detail of Kalela was designed by the artist. The large two-story A-frame log house is surrounded by fir trees and stands on a low granite outcrop overlooking the lake. Boatloads of tourists dock regu-

larly at the pier below, because the famous atelier is open for tours during the summer months. A book-lined library with grand piano and inviting reading/banquet table, and a capacious painting studio boasting a music rostrum complete with organ make up the public rooms on the main floor, while a long, cozy kitchen and small laundry room constitute the private part of the house. Upstairs a wooden balcony hung with brightly woven rugs frames the space below.

I did not stay in the main house (the only area with electricity and running water) but rather in a charming sleeping hut with its own stone fireplace. In front of the sleeping hut a small sandy cove led to the second most important building on the grounds—Gallen-Kallela's original steam sauna—a complex of small rooms facing the lake for bathing, firing up the stones in a wood-fed stove, and taking the sauna. Being a Texas sissy when it comes to cold water lakes, I never dreamt that I would get into the water, but after going through the full sauna routine I could hardly wait to plunge in. Soon I was rising at 5:00 a.m., merely to have a chance to experience the hot sauna and then stand chin deep in the cool lake to watch the sun rise.

The family made sure I was driven to all the important studios and art collections in the region. In Mänttä I got to study and photograph Gallen-Kallela's flickering fireside portrait of Mahler. And in the evenings we had delicious simple meals garnished with pea pods lightly fried in lemon butter.

I watched the tours of Gallen-Kallela's atelier being given by Janne and his brother Pontus and soon felt competent enough to be briefly in charge of the entry room, where tourists bought tickets, postcards, and posters from me (FIG. 35). I even temporarily learned to count in Finnish. But no matter how often Janne patiently repeated the two words, I could never really distinguish between the pronunciation of Kallela and Kalela.

It did seem as though every other Finnish word began with *K*, as the family showed me Gallen-Kallela's dramatic illustrations to the

FIG. 35
*The author running the
ticket office at Akseli
Gallen-Kallela's
wilderness atelier.
Kalela, at Ruovesi,
Finland, 9 August 1995.
Photograph by Janne
Gallen-Kallela.*

Finnish national epic, the Kalevala, featuring the adventures of Kullervo—all images that in their painted versions had stunned Austrian artists like Klimt at the Vienna Secession's exhibition of 1902. Attempting to convey the reclusive Finnish personality to me, Janne offered the following anecdote. Two Finns meet in a bar and order drinks. "Skol," says one, raising his glass. The other Finn glares at him and says: "Did we come here to talk or to *drink*?"

Saying good-bye to my generous hosts was difficult, but they were all on hand the following summer when I returned to Helsinki at the invitation of the Ateneum Museum of Finnish Art to give the "Finnish Fireside" lecture. Adriana had traveled with me this time, and when we visited Hvitträsk she had the nerve to do what I had been afraid to: cross under the velvet cord roping off the furniture by the great living room fireplace and turn the carved oak chair Mahler had sat in around to face the fire! I quickly photographed it, and she restored it to its original position in the twinkling of an eye.

Denmark

Another Scandinavian destination was the carefully preserved studio-home of the Impressionist painters Anna and Michael Ancher. This

was part of the famed artists' colony at the northern tip of Denmark. The enchanted world of the Cape of Skagen, where two seas—the Skagerrak and the Kattegat—continuously crash into each other, giving off a particularly intense light, had been discovered by Hans Christian Andersen as early as 1859. "Are you a painter?" he wrote challengingly after visiting Skagen. "Then make your way up here, for there are motifs enough for you, here is scenery for poetry; here in the Danish landscape you will find an aspect of nature which will give you a picture of Africa's desert, of the ash heaps of Pompeii and of sandbanks in the great ocean above which birds soar."

The lonely, magnificent Skaw (where raw amber can still occasionally be picked up on the beach) attracted a group of Scandinavian plein-air painters and nature poets who by the end of the nineteenth century had formed an important settlement. Peder Severin (Søren) Krøyer's sparkling canvas of 1888 *Hip, Hip, Hurrah!* showing a group of friends hoisting champagne glasses under a shimmering canopy of sun-spotted greens in the garden of Michael and Anna Ancher sums up the exuberant spirit of Skagen.

Nevertheless, even in this idyllic spot all was not what it seemed. Tensions usually credited to Munch are just beneath the surface in the older Krøyer's work. All the ingredients for presenting human harmony would seem to be present, for example, in that painter's idyllic *Summer Evening on Skagen Beach* (FIG. 36), painted in 1899—ten years after his marriage to the strikingly beautiful fellow artist Marie Triepcke, sixteen years his junior. An elegantly dressed couple— Marie and Søren—stroll with their dog at the "blue" hour along Skagen's smooth shoreline. The twilight imagery projects the quintessence of oneness—merger with nature, union with one another.

And yet this is time of unrequited longing. Husband and wife do not look at each other, but rather out toward the sea and distant boats, neither of which they really see. Søren's arm is linked lightly but insistently through Marie's; her arms hang leadenly, unrespon-

FIG. 36
Peder Severin Krøyer,
Summer Evening on
Skagen Beach, *1899,*
oil, The Hirschsprung
Collection, Copenhagen.

sively at her sides. Søren's facial expression is tense, Marie's is remote, self-absorbed, and melancholy. A study and a posed photograph for the painting bear out this interpretation, but more important evidence is the history of their life together. Peder Severin Krøyer did not inform his young bride when they married that he had contracted a chronic venereal disease. From 1895 on—the year Marie gave birth to their daughter—his manic-depressive attacks plagued their marriage. A few months after completing this image of impasse the artist had himself temporarily admitted to a mental hospital, where he was diagnosed as having dementia paralytica—a manifestation of the final, deadly stage of syphilis.

Summer Evening on Skagen Beach is thus not only an irresistibly romantic portrayal of a couple in nature, but also a revelatory reflection on a tormented and failed relationship. (Marie asked for a divorce three years later, and Søren died from syphilis in 1909.) How many other unsuspected dramas have been played out on Skagen's shores, I wonder each time I revisit Denmark's sandy apex.

Sweden

Strindberg's spatula-laid-on "slash" paintings—pigmental mirrors of his agitated psyche—demand return visits to Sweden. There in

Stockholm's Gamla Stan (Old Town) is the Art Nouveau apartment house at Drottninggatan No. 85, christened the "Blue Tower" by the playwright, who spent his last years there. The rooms are preserved as the Strindberg Museum, and one must visit two separate floors to get an idea of the existence he led. His telescope, writing desk, and an esoteric library of dog-eared volumes are on the top floor, where an undulating motif of his own design runs across the wall moldings.

The living quarters are in three rooms on a lower floor—a small, plain bedroom, another book-lined study, and a sitting room equipped with an upright piano and a copy of Beethoven's life mask on the wall.

Strindberg's friend of his earlier Berlin days was Munch, who was "shy in person, but dared all in art." In Munch, Strindberg met his match. The twenty-eight-year-old Norwegian was open to psychic phenomena and hallucinatory portents, enslaved by frustrated relations with the opposite sex, and, like Strindberg, misunderstood in his home country. His self-imposed mission to paint the terror of existence and the torment of love excited Strindberg tremendously.

But Munch's lover at the time, the beautiful, free-spirited Dagny Juell, soon entered the mix, "allowed herself to be mounted by four different nationalities within thirty days" (Strindberg's vindictive après-affair description), and initiated some art historical collateral damage of her own. Munch's telling lithographic image of his rival created three years after the fact (FIG. 37) contains the evidence. Strindberg's leonine head is set against a black void encased by a broad frame within which, on the right, a nude woman turns toward to her hapless prey, her hair floating in a zigzagging spider's course around the imprisoned image.

Was it a Freudian slip or intentional slight that caused Munch to identify his famous sitter at the bottom of this frame as "STINDBERG" rather than "Strindberg"? (*Stind* in Norwegian means "thick,"

FIG. 37
Edvard Munch, Portrait of August Strindberg, *1896, lithograph.*

"swollen," or "fatso.") Whatever the answer, we know that Strindberg despised the portrait and henceforth considered Munch one of his many enemies.

Norway

Munch got along considerably better with Scandinavia's other famous playwright, his fellow Norwegian, Ibsen. The artist's famous portrayal of the formidable author, *Henrik Ibsen at the Café of the Grand Hotel,* shows the hoary bard in his favorite haunt across the street from his theater reading the newspaper by a window that overlooks Oslo's best stage set, Karl Johan's Street. This main avenue of what was until 1924 called Christiania rather than Oslo, provided the artist with a dramatic setting for his own painted statement of alienation, *Spring Evening on Karl Johan's Street* of 1892, in which promenading pedestrians with skull-like, staring faces wedge forward, while a lone dark figure (a surrogate Munch) thrusts out into the street in the opposite direction past the mysterious swelling

trees of the Studenterlund (students' grove) and toward the glowing window-eyes of the yellow Storting (Parliament).

It took several trips before I found the site of Munch's house overlooking Oslo's Filipstad harbor at Ekely, where he lived in seclusion the last three decades of his life. Now only his winter studio stands, leased out to modern artists by the government, and the day I was there the artist-tenant kindly let me explore and photograph to my heart's content. Again I experienced the joy of standing in the same spot where my prey had stood, of contemplating the same vista he had once surveyed.

Better luck in pursuit of Munch abodes was in store when I drove south to Åsgårdstrand, the small beach town where the painter spent twenty summers in the same humble fisherman's cottage. The boulders and throbbing linden trees in his paintings and in his Oslo University frescoes line the shore. In the cottage all has been preserved as it was, right down to the artist's vest, bone toothbrush, fully stocked medicine shelf, and a yellow Kodak box of film with the (then) impressive number of six exposures.

Continuing south to austere Skien, Ibsen's riverside birthplace, I proceeded the next day farther south to Grimstad, the small port town where the teenage Ibsen apprenticed for several years in an apothecary shop, listening to all the town characters who provided the boy with material for his later plays. I located the pharmacy and was permitted to photograph some of the landscape drawings by Ibsen on display.

After the playwright's final dwelling in Oslo near the National Theater had been opened as a museum, I experienced one of the most exciting encounters of my career. There, prominently hung on a wall in Ibsen's study opposite his writing desk, was Christian Krohg's 1893 large portrait not of him, but of Strindberg! Twenty-one years the Swede's senior, and painfully aware of the younger author's antagonism toward him, Ibsen had purchased the dramat-

ically cloaked, frontal image of an intensely staring Strindberg as a talisman. He explained to astonished visitors: "The man fascinates me because he is so subtly, so *delicately* mad," and adding that he especially liked the "demonic" eyes.

Strindberg's attacks on Ibsen were indeed deranged; he even accused the "decrepit old troll" of plagiarizing *Hedda Gabler* from him, utilizing a sexual metaphor better reserved for women: "Do you now see that my seed has fallen into Ibsen's brain-pan—and fertilized! Now he carries my seed and is my uterus!" Reacting to a portrait of Ibsen painted by Julius Kronberg in Munich in 1877, Strindberg wrote in a more confessional mode: "The face [has the] high forehead of a fanatic . . . so repellent, so attractive!" As irony would have it, Kronberg's portrait now faces that of the demonic Swede in Ibsen's Oslo study.

Perhaps it is the unending drama behind these only too human tensions that—in addition to the marvels of nature—keeps bringing me back to Scandinavia. And perhaps, too, the Nordic temperament with its brooding, introspective sensibilities, exerts an endless appeal in a reversal of what Goethe and so many other northern Europeans called the "Drang nach Süd" (yearning for the South).

24

Recently I experienced my own Drang nach Süd, wondering what Italy—from which scholarly projects had not beckoned for years—might hold for me; how returning there might feel to someone approaching her seventieth year. Would I be disillusioned, yearn for vanished epochs and people, perhaps long to be transported back to an earlier time in my own life? When passing by Via Pergolesi would I still remember the Nonna shrieking "SUONA il telefono"?

I decided to find out in the summer of 2002 by doing something I rarely do: joining a tour. It was a specialized trip for military enthusiasts of both world wars ambitiously visiting sites in southern and northern Italy in fifteen days, and encouragingly titled, "Italy in War and Peace." Off I went, with a musicologist colleague, Diane Penney, and her history-buff brother and his wife.

As soon as a bus had whisked us from the busy Rome airport to a quiet hotel in the heart of the city, I scampered off to the Corso. There I passed a blissful three hours photographing every item, artwork, and view in (and from) Goethe's House, but this time using a *digital* camera.

Then I engaged in more intense digital recording of items at the treasure house of Caffé Greco, whence by now so many former students had sent back postcards or photographs of themselves posing before icons on the crowded walls. Once again I studied the written and pictorial traces of illustrious visitors: Winckelmann, Goethe, Schopenhauer, Wagner, Ibsen. Jet lag disappeared. I was alone in Rome, yet surrounded by that constellation of favorite cultural figures who seem ever more vividly to constitute my extended family.

Early the next morning as our tour bus sped by the Caius Cestius pyramid, I borrowed the sleepy local guide's microphone and, ever the professor, gave an impromptu lecture on the fascinating people buried in the Protestant Cemetery. Another cemetery *was* on our itinerary—the peaceful, green-lawned burial grounds south of Rome near Anzio, American beachhead south of Rome during World War II. There, row after row of lovingly tended identical white marble gravestones identify the American soldiers who never returned home.

After adroitly bypassing Naples, we lodged for several nights at a modern hotel high up on a bluff in Sorrento overlooking the town, its pellucid bay, and distant Vesuvius. This was our base for excursions to Pompeii, Herculaneum, and—a site I had pined to visit since learning that Goethe had—Paestum. My spirits leapt at the sight of three well-preserved, large Doric temples standing in a green field with their white masses etched against the blue sky, the pronounced entasis of each swelling column defying the nibbling inroads of the sun. Nearby was the museum with its fifth-century B.C. amusing, multiscened Tomb of the Diver, with a small brown figure suspended over blue water for all eternity.

A hydrofoil trip to Capri gave me a chance to wander through the Krupp Villa gardens looking for the monument marking Lenin's visit to the island. Back on the mainland in Ravello, overlooking ravines and the Tyrrhenian Sea, I traced the footsteps of Wagner

through Villa Rufolo's lush gardens, the terraced grounds of which suggested Klingsor's magic garden in the second act of *Parsifal*.

But for me the climax of this lightning tour of southern Italian sites was Amalfi. Just visible from the tour bus as we passed the Hotel Luna—the last waterfront hotel overlooking the little port before the highway winds out of town—was a plaque imbedded in the facade stating that both Wagner *and* Ibsen had sojourned there. I raced down to the Hotel Luna and prowled around, striking up a conversation with one of the older chambermaids who nodded her head knowingly when I asked about Ibsen. "Sì, sì, il drammaturgo norvegese!" Conspiratorially she led me to Room 15, prefaced by a little private balcony, and I was able to contemplate (and photograph) Ibsen's view of the bay and the ancient Saracen tower remains. My helpful guide had never heard of Wagner, but I was too happy to have found Ibsen's room to be disappointed. It was here, in Amalfi under the influence of Italian sights and sounds, that he had written the tarantella scene in *A Doll's House*. Now it all made sense.

Concerning Italian sights and sounds: when I finally exited Hotel Luna, I ran smack into an extraordinary aquatic celebration. It was 13 June, feast day of St. Anthony of Padua. Firecrackers and a fleet of festooned fishing boats accompanied a large statue of the saint as it was transferred with tremendous enthusiasm from ship to shore. From there a cheering crowd lugged it triumphantly up the steep steps of the cathedral. How redolent of my earlier times in Italy as a teenager, when popular street celebrations of saints' days seemed to be an everyday phenomenon and life an unending spectacle.

25

For the past forty years the most constant, meaningful home has been right in front of me—my classroom. It is here that, without realizing it, I have been enacting the truth of D'Annunzio's dictum: "I have that which I have given away." And the surrogate children with whom I have shared the fruits of travels and discoveries—the two generations of students who have come my way. When I first came to SMU, I would occasionally encounter a pupil whose name was Megan—three of them had been named after my mother. Recently I've noticed an Alessandra or two in class roll books.

Because my classes and seminars have always been interdisciplinary, a number of my students have come from the fields and disciplines of theater, dance, music, studio, journalism, advertising, history, law, business, arts administration, and languages. And having graduate students from studio arts in my classes not only keeps me on my toes technically but gives me opportunities to visit campus studios and offer critiques from an art historian's point of view.

A yearly contingent of premed students (they always seem to sit in the second row) has inspired me to insert medical connections

whenever possible, such as Goethe's discovery of what he believed to be the presence of the intermaxillary (premaxilla) bone not just in animals but in human beings. My pursuit of Goethe's discovery of the Zwischenkieferknochen resulted in a lecture and article: "The Age of Goethe Today: Of Plum Trees, Painters, Pianists, and Pamphleteers," in which we follow visitors to Goethe and Weimar ranging from the irresistible pamphleteer Sulpiz Boisserée—charming advocate for the completion of Cologne Cathedral—to the twelve-year-old Felix Mendelssohn and, a decade later, another twelve-year-old piano prodigy, Clara Wieck—future wife of Robert Schumann.

Continuing my medical allusions: when we come to Madame de Stäel, I mention that the inventor of the stethoscope used it for the first time on this distinguished patient. And while studying Ingres's and Delacroix's depictions of Niccolò Paganini I have a chance to discuss the Marfan syndrome, an inherited anomaly of the connective tissues with hypermobile joints believed to be responsible for the violinist's extraordinary dexterity. When we examine Paul Klee's anxious, unremittingly intertwined final line drawings, I refer to the progressive disease that overtook him in his final years—scleroderma—in which the skin becomes progressively hard and thickened, like armor.

Sometimes a bevy of players from our SMU Symphony Orchestra takes my lecture classes, their instrument cases lining the aisles (reminding me of Interlochen). When we come to German Romanticism's cult of the forest, students help me sing out the orchestra score flashing across the screen as we listen to the spooky Wolf's Glen scene from Carl Maria von Weber's 1821 opera *Der Freischütz*. Having different instrumentalists in class can be uniquely effective: one time I conspired with a trumpet player, David Alpar, to blare out the *Marseillaise* from the back of the auditorium just as we began to enact the French Revolution

FIG. 38
*Students in the author's
Romantic Century
class demonstrating French
revolutionary fervor.
Southern Methodist
University, Dallas,
7 September 1984.
Photograph by their teacher*

(FIG. 38)—producing a result as electrifying as that moment in *Casablanca* when French sympathizers drown out the singing of German officers in Rick's café.

Such antics have taken place over the years in the same classroom—a large auditorium on the third floor of the oldest building on campus, Dallas Hall, and it is there that I have been taking snapshots of my classes from the mid-1970s right up to today, inadvertently capturing changes in fashion along the way. A treasured souvenir from this consistent documentation instilled in me by my photographer father shows a cluster of four students named Horn—all brothers who have studied with Comini. And when, after final exams, small groups of students come to the house to experience Rosa Bonheur and Ann Whitney close up, they cheerfully submit to being photographed with their teacher (FIG. 39).

Schönberg wrote in the introduction to his textbook on harmony that "this book I have learned from my students." I feel the same way about various methodologies, honed through the years, that help make information passed on in class more memorable. Sometimes students ask if I ever studied for the theater. I assure them any drama in the classroom is only the result of an Italian

227

FIG. 39
*After the final exam:
SMU students Elliot Horn,
Richard Schklair,
Nicolette Ocheltree, and
Tyler Gusich visiting
the author and her
Maltese puppy. Dallas,
10 December 2003.
Photograph by Elisa Foster.*

temperament tempered by Anglo-Saxon timing. And like so many educators I've come to realize that dashes of humor can enable one to approach extremely serious subject matter without intimidating listeners.

The "nurturing" role characterized by feminists during my Columbia days as hampering female professors, now seems to come naturally to me as I attempt to share my craft of *seeing* where others only look. And yet sometimes not all the fostering in the world can prevent student tragedies. A few days after I'd photographed him sitting in the front row of one of my public lectures, a favorite student committed suicide. To this day his girlfriend and I have no answer for it, and I grieve that there may have been distress signs to recognize, were I only more perceptive.

Over the years, as I made the transition from typewriter to the world of Macintosh computers, a host of students have become my gurus, inspiring my admiration for calmness under electronic stress. The instant functions of cutting, copying, and pasting have allowed me to follow Winckelmann's wise dictum: "Sketch with fire; execute with phlegm." And the advent of e-mail has enabled cyber contact with former students that might otherwise have petered out with the effort and time of snail mail.

Two students who studied with me in the 1970s—Shelley Salem Stevens and Ralph Broadwater—have not only kept in touch but have established art history scholarship stipends in my name, one for undergraduates, the other for graduate students. Shelley founded a European antiques gallery and Ralph, after resisting a once-desperate temptation to flee medical school and write a thesis on Gabriele Münter, became a professor of surgical oncology.

Teaching recognition still comes my way from students, even though I continue stubbornly to insist on "old-fashioned" grammar, such as "As I said," instead of the now all-too-common "Like I said." On the first day of class, midway through the caveats, a slide of the lyrics from a Beatles' song aids me in conveying the difference between *as* and *like*: "Yesterday, all my troubles seemed so far away; now it looks as though they're here to stay. Oh, I believe in yesterday." Generation gaps disappear when I invite students to sing the lyrics along with me, and the nostalgia with which two hundred students, who haven't even had time to meet each other, quietly sing the song never fails to give me goose bumps.

The presence of older auditors in my classes—people who nod knowingly when I refer to World War I or II—reinforces my insistence on correct grammar and varied, even elegant vocabulary. The generosity of these auditors toward their younger colleagues, be it with food or financial aid, seems to fulfill John Wesley's admonition: "Earn as much as you can, save as much as you can, then give as much as you can." This, it seems to me, can be applied to teaching as well as to money, paraphrased thus: "*Learn* as much as you can, *savor* as much as you can, then *pass on* as much as you can."

Epilogue

The ART HISTORY, FEMINIST, and musical iconography projects that
have sent me on stimulating mental trips around the world lately have
been fashioned at an A-frame lake house some seventy miles north-
east of Dallas near the Oklahoma border. I had never considered hav-
ing a second home, and acquisition of the Lake Bonham house five
years ago was more by happenstance than by design. And yet my
action was an almost predetermined response to the alluring examples
I had soaked up unconsciously over time—from the country homes
of my Barnard teachers to the rural hideaways of my Austrian friends.
The exhilarating experience at Gallen-Kallela's wilderness atelier must
have crystallized things for me, for when I beheld the little beige house
facing the lake on Beaver's Point, its call was irresistible.

Last summer I decided to add a room to the lake house for a
diminutive indoor "Endless Pool," in which one can swim in place
against an adjustable current. Building took almost a year, and after
false starts with several carpenters, I found the master craftsman
Ben Gehardt, who would become not only my architectural res-
cuer but also my friend and feisty guardian.

The pool was almost completed when, toward the end of the teaching semester in the spring of 2003, the miniscule white dot picked up by my yearly mammogram turned out to be a touch of cancer. Despite my protestations Ralph Broadwater, the Münter-minded student who had become a surgical oncologist, insisted on being present for the second operation in which some sentinel lymph nodes would be removed. The boost to my morale provided by Ralph's generous gesture was enormous, although I didn't know I needed it until he arrived. Shelley Salem Stevens also insisted on coming to the hospital, and so the two donors of "Comini" scholarship funds finally met over my hospital bed, entertaining the young attending surgeon, Archana Ganaraj, with insights into her patient.

Within a few hours of my waking up from anesthesia, Ralph and I were happily ensconced at Lake Bonham, where soon a pathology report reached us with the reassuring news that the cancer had not spread. It was gone, all gone. Now all I had to do was take a particular pill every day in perpetuity and undergo seven and a half weeks of daily radiation. The sort of Romantic irony I taught to others descended upon me: the sparkling Endless Pool was ready for daily laps, but I could not get wet for seven and a half weeks because of the radiation.

A fellow patient at the radiation ward spoke only Spanish, and when she mentioned she had only one time more to come, I broke into the song *Solamente una vez.* She joined me lustily, and staff and patients turned out to see what was going on. Hugs, good advice, and camaraderie abounded in that special atmosphere, and I won't forget how lucky most of us were compared to inpatients who were rolled to their appointments prone on hospital beds. On the day of my final treatment, 9 July, I was handed a signed and dated "Certificate of Achievement," and it means as much to me as any of the professional awards on my office wall.

FIG. 40
*Revving up for takeoff:
the author in an*
Experimental *aircraft.
Jones Field, Bonham,
Texas, 10 July 2003.
Photograph by
Adriana Comini.*

The next day, back at Lake Bonham at last, my sister had a surprise for me. She knew I'd been yearning to find some way to photograph the whole five-finger shape of the lake from the air. I'd looked longingly at the private planes parked at a rural airport one mile from the lake. So had Adriana, and she'd come up with a friend who occasionally visited Jones Field in his *Experimental* craft, a tubular, two-seater single-engine plane no wider than three feet and no longer than twelve feet, the tail of which rested on the ground until it was time to prop it up for takeoff. They were waiting for me at Jones Field. Would I like to go? There was no time to be circumspect or wonder if this might be a wise thing to do, perhaps the *last* thing I'd do, since the plane was experimental indeed!

The pilot strapped me into the narrow cockpit under a transparent hatch, provided me with noise-reduction earphones, and up we flew into an immense blue sky (FIG. 40). A digital and backup camera were anchored in my lap. The view from two miles above was thrilling, with the winding Red River separating Texas from Oklahoma on the north horizon and my lake house clearly visible directly below. Like a maniac I snapped away, left and right. What a fantastic way to set aside that protracted tethering imposed by weeks of radiation!

"How my life was strong in passion, in life force, in pain, in joy," Kollwitz had written, looking back on her event-filled years. Surely I could say this as well, but there isn't much time to linger on the past. There is still so much to accomplish right now, still so much living, learning, and loving to do. I want to return to Istanbul's Blue Mosque, to Rome's Protestant Cemetery and Caffé Greco, to Napoleon's Corsica, to Goethe's Weimar, to Bonheur's Fontainebleau Forest, to Krøyer's Skagen, to Duse's Asolo, to Kollwitz's Berlin, to Werefkin's Ascona, to Mahler's Toblach, to D'Annunzio's Gardone, to Nijinsky's St. Moritz, to Picasso's Málaga, and of course always, always to Schiele's Vienna. I long finally to see Ibiza, where I was conceived.

And most of all, I hope to do what Tino wrote in my diary the year Megan died: "Sandrina, may you live each day of your life in ebullient serenity!"

Index

Page numbers in *italics* indicate photographs.